art from south africa

Museum of Modern Art, *Oxford*

distributed by **Thames & Hudson**

art from south africa

an exhibition organised by the Museum of Modern Art, Oxford in association with the Zabalaza Festival, London:

Museum of Modern Art, Oxford	17 June - 23 September 1990
The Mead Gallery, University of Warwick	6 October - 11 November 1990
Aberdeen City Art Gallery	1 December 1990 - 12 January 1991
The Royal Festival Hall, London	29 January - 24 February 1991
Bolton Art Gallery	9 March - 13 April 1991
City Museum and Art Gallery, Stoke on Trent	4 May - 9 June 1991
Angel Row Gallery, Nottingham	22 June - 27 July 1991

ISBN : 0 905836 71 5

Published by the Museum of Modern Art, Oxford,
30 Pembroke Street, Oxford, OX1 1BP, U.K.

Distributed by Thames & Hudson Ltd, London.

Exhibition organised by the Museum of Modern Art, Oxford in
association with the Zabalaza Festival, London.

Exhibition curated by David Elliott and David Koloane with
Rayda Becker, Jacqui Nolte, David Roussouw and Gavin Younge.

Catalogue production by Pamela Ferris and Janet Moore.

Catalogue photography by Bob Binnell, Port Elizabeth;
Jim Chambers, Oxford; Chris Moore, Oxford;
Bob Cnoops, Johannesburg; Irvin Mayer, Cape Town
and Gavin Younge, Cape Town.

Cover photography by Mouat Oliver for Nomad.

Designed by Mouat Blosch Oates for the GAVE foundation, London.

The Museum of Modern Art receives financial assistance from
the Arts Council of Great Britain, Oxford City Council,
Oxfordshire County Council, Visiting Arts and Southern Arts.

Printed in Great Britain by BAS.

contents

babel in south africa

David Elliott

"I can't bear their spawn, nor their stinking menfolk." She said more things about our spawn but I heard nothing of it. I lay on the ground and the guts of the crushed bird travelled down from my temple. They flowed down my cheek, winding ..., splashing, blinding me. The tender pigeon guts slid down over my forehead and I closed my solitary stopped up eye so as not to see the world that spread out before me. This world was tiny and it was awful...

Not written in a South African township, but it almost could have been. This short story of violence, discrimination, cruelty and humiliation seen through the eyes of a young child was written in Moscow by Isaac Babel in 1925, drawing on his childhood experiences in the Odessa ghetto at the time of the pogroms of 1905 and 1906. As I come now to to try to make some sense of the experience of making an exhibition in Britain of art from South Africa, for some reason Babel - his thoughts, words and life - preys on my mind.

Each country - its history, culture and peoples - is, of course, unique; that cannot be minimised. But certain motifs run through modern cultural history and it is these that help us, from outside, to perceive some order, some pattern.

Babel's most famous stories, **The Red Cavalry**, derive their edge from the central paradox of a jew, the author himself, being assigned to a regiment of Cossack Cavalry - the very people who had traditionally slaughtered his ancestors and who continued to despise him and his family. Towards the end of his life, and by force of circumstance, Babel's irony became yet more laconic: in 1934 at the First All Union Writers' Congress in Moscow he replied to the official formulation of Socialist Realism as the *single* State prescribed way of working by arguing for the right to write "badly". "Comrades", he said,"let us not fool ourselves: this is a very

important right and to take it away from us is no small thing." The alternative, which he had no choice but to follow, was what he poignantly described as "the genre of silence." Five years later he was arrested; he died shortly afterwards in a gulag.

Babel's ironies, partly based on a conflict between art and politics, between the standards of the individual and the State, find many reverberations in contemporary South Africa. Injustice breeds irony; in an unjust society some have the privilege of being born ironical while others have irony thrust upon them. With tongue-in-cheek conviction William Kentridge described "London as a suburb of Johannesburg" - they seem so close. A new T.V. film is made on the ostensible, if improbable, subject of golfing in Soweto, however, its practitioners have a Club House but no golf course. Titus Moteyane, living in a township outside Pretoria, makes a painting of the Japanese **Bullet Train** on a disgarded roof slate or constructs out of old tin cans and waste material a vast model of a **Boeing 747**. Johannes Maswanganyi, living in the countryside in Northern Transvaal, carves and paints wooden sculptures of white political leaders which, neither affirmative nor satirical, occupy an ambiguous no-man's-land in which irony is their only tangible support. But underlying all this, as for Babel too, lies the obscenity of racism.

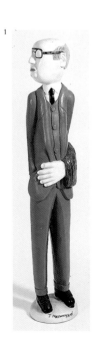

1

Crushing, inhuman and inflexible it moves too slowly to understand or anticipate the elegant side-step of the artist. This kind of work is hardly what could be described as an art of direct resistance but it is based on the aesthetics and politics of individual response.

There are other paths, however, for the artist to take. Art can be confrontational but it needs help from the outside. **Agit-prop**, another Russian echo, puts art in the direct service of politics. In such circumstances art easily becomes illustration not example, individual autonomy is willingly sacrificed for what is perceived as the general good.

It is at this point that it becomes clear why this exhibition is being initiated in Oxford rather than in Amsterdam, New York or Lagos; why Odessa, the site of the endless steps immortalised by Eisenstein is so close to Johannesburg. The Museum of Modern Art in Oxford has over the past decade, consistently, worked on a series of historical exhibitions which have examined the relationship between twentieth century visual art, culture and politics. It has focused on periods of war, revolution and dramatic social change, but in doing this it has enjoyed the historical privileges of "objectivity", and "detachment". Ideas, movements, even works of art have been analysed, contextualised and fixed in conceptual aspic on the Museum wall. Years have passed, issues have changed, artists, if they are still alive may rather forget than remember. Time may heal past hurt but hindsight gives the historian the power to decide.

In South Africa there are no such privileges; history is literally being made. This transcends recent political developments to encompass the refiguring and recording of the past in terms of the needs of the present and the future. Not only in South Africa but across the world "history" has become a plural noun as it is recognised that the story you now tell says as much about your life as it does about the past. In South Africa, where political differences can be a matter of life or death, the issue of "whose history" necessarily supplants a unitary view. Cultural history has first to be discovered before it can be written. During the past few years this pro-

cess has been in open debate in journals, symposia, museums and exhibitions. It is the present, however, rather than the past which dominates current cultural debate.

The question of history and its representation has surfaced in art. Penny Siopis's ironically entitled **The Cape of Good Hope: A History Painting** depicts embedded within its richly textured surface rival representations of black people in a morphology reminiscent of Archimboldo. Cyril Manganye's; **Hero Paintings** also synthesise representations of the past with the present by bringing together Zulu tradition with the life and death of Steve Biko within the context of pictorial modernism.

The question which is now being asked from township backyard to art college seminar room is: "what role has culture to play in the new society?" Here there are contemporary echoes of the debates with which Babel would have been familiar in Russia in the 1920s and '30s. Historically the **ANC** line on culture has been the straightforward Leninist prescription of *art as a weapon of struggle* - a familiar enough slogan. The struggle is primarily that against apartheid, yet by many in the movement, apartheid is seen as symptomatic of capitalism. A banned organisation until February this year, with members and sympathisers under the constant fear of asassination, the language and structure of the **ANC** is that of a revolutionary organisation. Not surprisingly the previous **ANC** sponsored cultural manifestations both inside and outside South Africa, which are fully described in articles published below, have tended to adopt the Russian **proletcult** model of revolutionary art as it has a strong basis of grassroots support.

Proletcult promoted the interests of proletarian culture as distinct from those of high or fine art. In South Africa today the term "People's Culture" is used to describe this manifestation as well as to make a distinction between it and "State apartheid culture". After 1917, with distinctly milleniarist zeal, members of **proletcult** took it upon themselves not only to build the new world, but to set about destroying the culture of the

past. This and the unwillingness of the **proletcults** to submit themselves to centralised party discipline led to their dissolution in 1920. The basic concept of *proletarian* or *People's Culture* harnessed to serve the needs of the Party, survived to reappear in the radically changed political circumstances of the Soviet Cultural Revolution [1928-1932 and after] ; in China and Eastern Europe during the late 1940s and early 1950s and subsequently throughout the whole communist world. Institutionalised by Stalin, *People's Culture* became an instrument of oppression rather than liberation.

It is against this background that Albie Sachs's recent **ANC** in-house seminar paper **Preparing Ourselves for Freedom** caused such a storm. The full text is published here along with some of the responses which have since appeared in the South African Press. Sachs goes against current orthodoxy by arguing for the autonomy of culture; put simply, art should not have to be either a weapon or an illustration of the struggle. It exists in a sphere separate to that of politics and although the two are not entirely unconnected, the relationship between them is not deterministic. This view does not deny the self- evident truth that culture is born out of social context but it affirms that the manifestations of culture may take many forms. Similar views are held also by a number of black artists who make both abstract and figurative work. They feel that the struggle against apartheid has been pressed into the fabric of their lives; they do not need to justify themselves or their work by constantly focusing on its literal expression.

In the discussions both within South Africa and outside with the many different groups and tendencies which have contributed to this exhibition there has been an inevitable tension between the demands of making an international exhibition of work by "professional" artists and the idea of showing a selection which was more "democratic", and in a sense representative, which would not show the work in depth of individuals but which would reflect the diversity of different kinds of cultural activity and its context.

Owing to the massive disparity of resources and educational facilities between black and white artists the issue of "professionalism" can be a sore point. Many black artists, particularly from the urban areas, feel severely hampered by lack of time, training and basic materials. Context is important but it is not always exhibitable and while work may be rooted within the community from which it has originated it can be understood and appreciated by people from other backgrounds. The knowledge that one of the most able young artists in Cape Town shares a bedroom [and bed] with two siblings in a small, depressing township, has no privacy and no place at home to work does not make the work he has made any better or worse than it actually is. Such appalling conditions are not unusual and if in spite of this talent can express itself, what tremendous potential there is for the future.

But as Babel and this exhibition have shown, the relationship between art and politics, between morality and culture, between context and production is far from straightforward. Humans are perverse creatures and they have varying talents. Work which is moving, which is experimental, which is full of joy is produced at the same time and alongside work which is enervated, which is clichéd, which has never found its own voice.

At times I had the feeling that some people felt that it was virtually impossible for "good" art to be made under the conditions of apartheid that everything was infected by it and that compromise, guilt or struggle should inform every waking act. The strength and range of the work in this exhibition shows that this is not the case.

The fact that "good" art may emerge from a "bad" system is a paradox Babel would have understood - it can only happen of course if the "genre of silence" is not too rigorously imposed.

Such designations of "good" and "bad" bring us to the central subject of criteria about which, as the articles published here make clear, there is continuing and heated debate.

It is not usual to discuss such issues in detail as even conflicting notions of quality are usually understood within a particular culture. However the effect of apartheid has been divisive in every sense and terms of reference have had to be clearly defined.

Initially there were two rules of thumb which developed out of a need to reduce the field of available work and to put emphasis on the present: the first was the decision to include only the work of living artists; the second was to choose only recent work.

The second band of criteria was more abstract and related to the fact that the exhibition was being organised in consultation with the Zabalaza Festival and the mass democratic movements within South Africa under the terms of a Selective Cultural Boycott. What this meant was that consultation had to take place with artists' organisations throughout South Africa and that work chosen should be consistent with the ideals of a non-racist, democratic culture. Overzealous enforcement of ideological purity could have resulted from this but everyone felt that it was vital that the exhibition was an open expression of creativity - inclusive rather than exclusive.

Thirdly with regard to the media represented there was a strong feeling that the exhibition should reflect the whole range of contemporary visual culture; crafts such as bead and blanket work are included along with posters, banners, linocuts, wire toys and dolls, as well as fine art - painting, sculpture and video.

The last band of criteria, inevitably subjective, centred on the issue of quality rather than eligibility. The designation of "quality" - is power; yet as Colin Richards asks in his article published below, by whose authority is it invested? Whose values does it support? What, exactly, in fact do we mean when we use the term: skill? originality? "otherness"? a relationship with Western art? use of African motifs? "authenticity"? the communication of "good" meaning? the depiction of things as they are? idealism? All these possibilities jumbled together create confusion -out of which sense - an exhibition - must emerge. It has to be an exhibition which communicates the qualities of art in South Africa.

An exhibition also has to be of finite size and it is impossible to be comprehensive. Work which is included is in a sense symbolic of a much greater body of work which it was not possible to show.

But the figure of Babel now returns like a ghost at the feast; there is another echo. Some four thousand years before Isaac's birth the ancient Assyrians had named a tower after him. The Tower of Babel is a parable rooted in fact, a metaphor for the breakdown of communication, confusion and, ultimately, for chaos. Divine retribution for human pride led to the imposition of separate languages and as the people who built the tower were unable to communicate with each other the tower fell down, Babylon was destroyed and its people were, in the words of the Old Testament, "cast abroad upon the face of all the earth".

Confusion is a not uncommon outsider's response to the complexities of life in South Africa which themselves often appear to be rooted in confusion. The crisis of legitimacy which directly stems from the apparatus of apartheid is not solely confined to the law, politics or institutions but is extended to all areas of human exchange. The result is a search for essentials, for blocks with which to build; a focusing on the structure and meanings of language itself and a combativeness which unregulated can easily become circular, self-indulgent or destructive. The rawness, the feeling of new kinds of political, cultural and social relationships being forged is both exhilarating and painful. The work in this exhibition and the articles published here clearly show this. They are the inevitable birth pangs of a new kind of South African art.

All dimensions in centimetres

1. **Johannes Maswanganyi**
P.W. and his blanket, 1988
enamel paint on primed Marula wood
134 x 20 x 17
Gavin & Glenda Younge, Cape Town

2. **Chabani Cyril Manganyi**
Hero, [Burial of a Hero [Steve Biko]
Series III], 1990
oil on incised wood panel
234.5 x 50.7

3. **Penny Siopis**
Cape of Good Hope:
A History Painting, 1990
oil on canvas
182 x 123.9

4. **Titus Moteyane**
PAN AM 747, c.1982
enamel, paint, tin, wire and plastic
bottles
c. 308 x 213
Gavin & Glenda Younge, Cape Town

5. **Unknown Artists**
Wrap around cloth [Nceka Tsonga]
Aquired 1989
textile, beads, safety pins and mirror
135.5 x 110
The Standard Bank Foundation
Collection of African Art, University
of the Witwatersrand Art Gallery,
Johannesburg

3

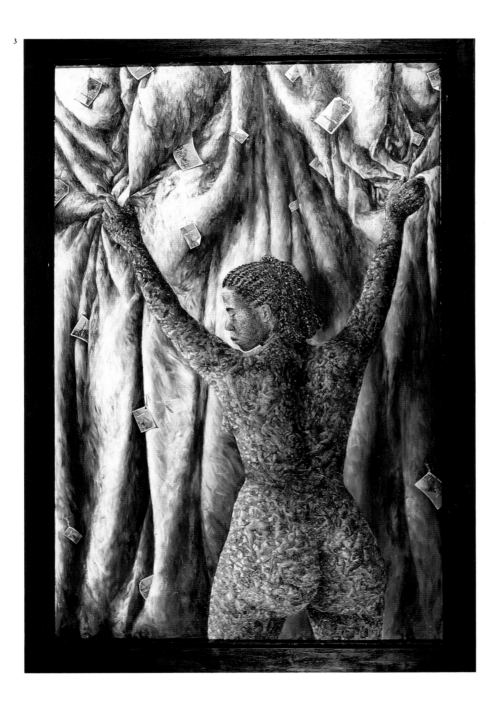

4

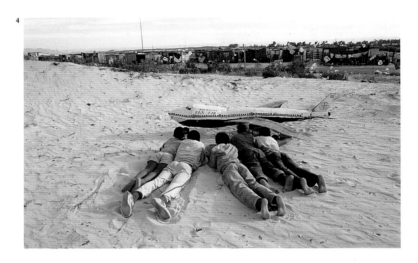

5

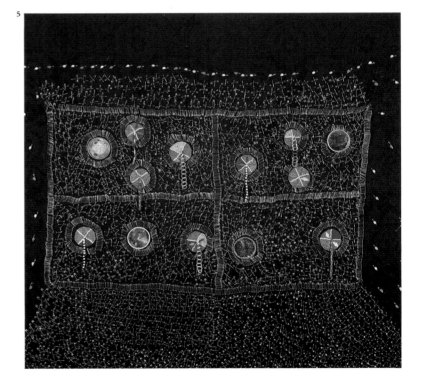

preparing ourselves for freedom

Albie Sachs

We all know *where* South Africa is, but we do not yet know *what* it is. Ours is the privileged generation that will make that discovery, if the apertures in our eyes are wide enough. The problem is whether we have sufficient cultural imagination to grasp the rich texture of the free and united South Africa that we have done so much to bring about.

For decades now we have possessed a political programme for the future - **The Freedom Charter**. More recently the National Executive of the **ANC** has issued a set of **Constitutional Guidelines** which has laid down a basic constitutional approach to a united South Africa with a free and equal citizenry. What we have to ask ourselves now is whether we have an artistic cultural vision that corresponds to this current phase in which a new South African nation is emerging. Can we say that we have begun to grasp the full dimensions of the new country and new people that is struggling to give birth to itself, or are we still trapped in the multiple ghettoes of the apartheid imagination?

For the sake of livening the debate on these questions, this paper will make a number of controversial observations.

The first proposition I make, and I do so fully aware of the fact that we are totally against censorship and for free speech, is that our members should be banned from saying that *culture is a weapon of struggle*. I would suggest a period of, say, five years.

Allow me, as someone who has for many years been arguing precisely that art should be seen as an *instrument of struggle*, to explain why suddenly this affirmation seems not only banal and devoid of real content, but actually wrong and potentially harmful.

In the first place, it results in an impoverishment of our art. Instead of getting real criticism, we get solidarity criticism. Our artists are not pushed to improve the quality of their work, it is enough that it be politically correct. The more the fists and spears and guns, the better. The range of themes is narrowed down so much that all that is funny or curious or genuinely tragic in the world is excluded. Ambiguity and contradiction are completely shut out, and the only conflict permitted is that between the old and the new, as if there were only bad in the past and only good in the future. If we had the imagination of Sholokov, and one of us wrote: **And Quite Flows the Tugela**, the central figure would not be a member of **UDF** or **COSATU**, but would be aligned to **Inkhata**, resisting change, yet feeling oppression, thrown this way and that by conflicting emotions, and through his or her struggles and torments and moments of joy, the reader would be thrust into the whole drama of the struggle for a new South Africa. Instead whether in poetry or painting or on the stage, we line up our good people on the one side and the bad ones on the other, occasionally permitting someone to pass from one column to the other, but never acknowledging that there is bad in the good, and, even more difficult, that there can be elements of good in the bad; you can tell who the good ones are, because in addition to being handsome of appearance, they can all recite sections of the **Freedom Charter** or passages of **Strategy and Tactics** at the drop of a beret.

In the case of a real instrument of struggle, there is no room for ambiguity: a gun is a gun is a gun, and if it were full of contradictions, it would fire in all sorts of directions and be useless for its purpose. But the power

This paper was written for an **ANC** in-house seminar on culture, held in Stockholm in 1989

of art lies precisely in its capacity to expose contradictions and reveal hidden tensions - hence the danger of viewing it as if it were just another kind of missile-firing apparatus.

And what about love? We have published so many anthologies and journals and occasional poems and stories, and the number that deal with love do not make the fingers of a hand. Can it be that once we join the **ANC** we do not make love any more, that when comrades go to bed they discuss the role of the white working class? Surely even those comrades whose tasks deny them the opportunity and direct possibilities of love, remember past love and dream of love to come?

What are we fighting for, if not the right to express our humanity in all its forms, including our sense of fun and capacity for love and tenderness and our appreciation of the beauty of the world? There is nothing that the apartheid rulers would like more than to convince us that because apartheid is ugly, the world is ugly. **ANC** members are full of fun and romanticism and dreams, we enjoy and wonder at the beauties of nature and the marvels of human creation, yet if we look at most of our art and literature you would think we were living in the greyest and most sombre of all worlds, completely shut in by apartheid. It is as though our rulers stalk every page and haunt every picture; everything is obsessed by the oppressors and the trauma they have imposed, nothing is about us and the new consciousness we are developing. Listen in contrast to the music of Hugh Maselkela, of Abdullah Ibrahim, of Jonas Gwanga, of Miriam Makeba, and you are in a universe of wit and grace and vitality and intimacy; there is invention and modulation of mood, ecstacy and sadness; there is a cop-free world in which the emergent personality of our people manifests itself. Pick up a book of poems or look at a woodcut or painting, and the solemnity is overwhelming. No-one told Hugh or Abdullah to write their music in this or that way, to be progressive or committed, to introduce humour or gaiety or a strong beat so as to be optimistic. This music conveys genuine confidence because it

springs from inside the personality and experience of each of them, from popular tradition and the sounds of contemporary life; we respond to it because it tells us something lovely and vivacious about ourselves, not because the lyrics are about how to win a strike or blow up a petrol pump. It bypasses, overwhelms, ignores apartheid and establishes its own space.

So it could be with our writers and painters, if only they could shake off the gravity of their anguish and break free from the solemn formulae of commitment that people [like myself] have tried, for so many years, to impose upon them. Dumile, perhaps the greatest of our visual artists, was once asked why he did not draw scenes like one that was taking place in front of him: a crocodile of men being marched under arrest for not having their passes in order. At that moment a hearse drove slowly past and the men stood still and raised their hats. "That's what I want to draw" he said.

Yet damaging as a purely instrumental and non-dialectical view of culture is to artistic creation, far more serious is the way such a narrow view impoverishes the struggle itself. Culture is not something separate from the general struggle, an artefact that is brought in from time to time to mobilise the people or else prove to the world that after all we are civilised. Culture is us, it is who we are, how we see ourselves and the vision we have of the world. In the course of participating in the culture of liberation, we constantly re-make ourselves. It is not just a question of the discipline and interaction between members that any organisation has; our movement has developed a style of its own, a way of doing things and of expressing itself, a specific **ANC** personality.

And what a rich mix it is...African tradition, church tradition, Ghandian tradition, revolutionary socialist tradition, liberal tradition, all the languages and ways and styles of all the many communities in our country; we had black consciousness [long before the Greens existed,we had green in our flag, representing the land]. Now, with the dispersal of our members throughout the world, we

also bring in aspects of the cultures of all humanity, our comrades speak Swahili and Arabic and Spanish and Portugese and Russian and Swedish and French and German and Chinese, not because of Bantu Education, but through **ANC** Education - we are even learning Japanese. Our culture, the **ANC** culture, is not a picturesque collection of separate ethnic political cultures lined up side by side, or mixed in certain proportions, it has real a character and dynamic of its own. When we sing our anthem, a religious invocation with our clenched fists upraised, it is not a question of fifty-fifty, but an expression of an evolving and integrated interaction, an affirmation that we sing when we struggle and we struggle when we sing. This must be one of the greatest cultural achievements of the **ANC**, that it has made South Africans of the most diverse origins feel comfortable in its ranks.

To say this is not to deny that cultural tensions and dilemmas automatically cease once one joins the organisation: on the contrary, we bring in with us all our complexes and ways of seeing the world, our jealousies and preconceptions. What matters, however, is that we have created a context of struggle, of goals and comradeship within which these tensions can be dealt with.

One can recall debates over such diverse questions as to whether non-Africans should be allowed onto the **NEC**, whether corporal punishment should be applied at **SOMAFCO**, or whether married women should do high kicks on the stage. Indeed, the whole issue of women's liberation, for so long treated in an abstract way, is finally forcing itself onto the agenda of action and thought, a profound question of cultural transformation. The fact is that the cultural question is central to our identity as a movement: if culture were merely an instrument to be hauled onto the stage on ceremonial or fund-raising occasions, or to liven up a meeting, we would, ourselves, be empty of personality in the interval. Happily, this is not the case - culture is us, and we are people, not things waiting to be put into motion from time to time.

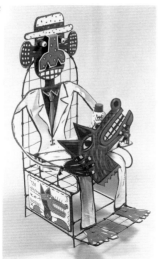

1. Dr Phuthuma Seoka
Paul Kruger, 1989
velvet corkwood, enamel paint and
nails
122.5 x 82 x 79

2. Norman Catherine
The Wolfman, 1989
wood, metal, canvas and acrylic
108.7 x 51.8 x 52

3. Dumile Feni
Untitled, 1976
charcoal on paper
[not in exhibition]

4. William Kentridge
Casspirs Full of Love, 1989
Acrylic on paper
186 x 107

5. Cally van der Merwe
God, dog, 1990
plasterprint
41.5 x 33

6. Titus Moteyane
Beauty, c.1981
ink and watercolour on ceiling board
30 x 39.5
Gavin & Glenda Younge, Cape Town

7. Philip Rikhotso
Squatting Man with Loose Hat [Boer],
1988
wax crayon and enamel paint on
Shifata wood
48 x 17 x 21
Gavin & Glenda Younge, Cape Town

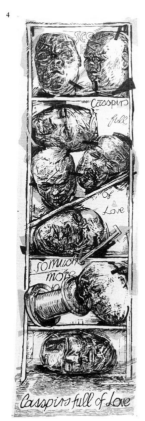

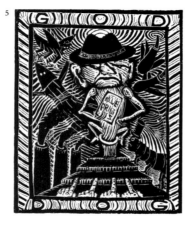

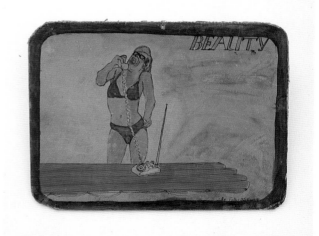

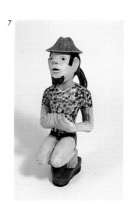

This brings me to my second challenging proposition, namely, that the **Constitutional Guidelines** should not applied to the sphere of culture. What?! you may declare, a member of the Department of Legal and Constitutional Affairs saying that the **Guidelines** should not be applied to culture! Precisely. It should be the other way round. Culture must make its input into the **Guidelines**. The whole point of the massive consultations that are taking place around the **Guidelines** is that the membership, the people at large, should engage in constructive and concrete debate about the foundations of government in a post-apartheid South Africa. The **Guidelines** are more than a work-in-progress document, they set out well-deliberated views of the **NEC** as enriched by an in-house seminar, but they are not present as a final, cut and dried product, certainly not as a blueprint to be learnt off by heart and defended to the last mis-print. Thus, the reasoning should not be: the **Guidelines** lay down the following for culture, therefore we must line-up behind the **Guidelines** and become a transmission belt for their implementation. On the contrary, what we need to do is to analyse the **Guidelines**, see what implications they have for culture, and *then* say whether we agree and make whatever suggestions we have for their improvement. In part, we can say that the *method is the message*; the open debate the **NEC** wants on the **Guidelines** corresponds to the open society the **Guidelines** speak about. Apartheid has closed our society, stifled its voice, prevented the people from speaking, and it is the historic mission of our organisation to be the harbingers of freedom of conscience, debate and opinion.

In my view there are three aspects of the **Guidelines** that bear directly on the sphere of culture: The first is the emphasis put on building national unity and encouraging the development of a common patriotism, while fully recognising the linguistic and cultural diversity of the country. Once the question of basic political rights is resolved in a democratic way, the cultural and linguistic rights of our diverse communities can be attended to on their merits. In other words, language, religion and so-called ways of life cease to be confused with race and sever their bondage to apartheid, becoming part of the positive cultural values of the society.

It is important to distinquish between unity and uniformity. We are strongly for national unity, for seeing our country as a whole, not just in its geographical extension but in its human extension. We want full equal rights for every South African, without reference to race, language, ethnic origin or creed. We believe in a single South Africa with a single set of governmental institutions, and we work towards a common loyalty and patriotism. Yet this is not to call for a homogenised South Africa made up of iden-tikit citizens. South Africa is now said to be a bilingual country: we envisage it as a multi-lingual country. It will be multi-faith and multi-cultural as well. The objective is not to create a model culture into which everyone has to assimilate, but to acknowledge and take pride in the cultural variety of our people. In the past, attempts were made to force everyone into the mould of the English Gentleman, projected as the epitome of civilisation, so that it was even an honour to be oppressed by the English. Apartheid philosophy, on the other hand, denied any common humanity, and insisted that people be compartmentalised into groups forcibly kept apart.

In rejecting apartheid, we do not envisage a return to a modified form of the British Imperialist notion, we do not plan to build a non-racial yuppie-dom which people may enter only by shedding and supressing the cultural heritage of their specific community. We will have Zulu South Africans, Afrikaner South Africans and Indian South Africans and Jewish South Africans and Venda South Africans and Cape Moslem South Africans [I do not refer to the question of terminology-basically people will determine this for themselves]. Each cultural tributary contributes towards and increases the majesty of the river of South African-ness.

While each of us has a particularly intimate relationship with one or other cultural matrix, this does not mean that we are locked into series of cultural "own affairs" ghettoes. On the contrary, the grandchildren of white immigrants can join in the *toyi toyi* - even if slightly out of step - or recite the poems of Wally Serote, just as the grandchildren of Dinizulu can read with pride the writings of Olive Schreiner. The dance, the cuisine, the poetry, the dress, the songs and riddles and folk tales, belong to each group, but also belong to all of us. I remember the pride I felt as South African when some years ago I saw the production known as the Zulu Macbeth bring the house down in the World Theatre Season in London, the intensely theatrical wedding and funeral dances of our people, peformed by cooks and messengers and chauffeurs, conquering the critics and audiences in what was then possibly the most elite theatre in the world. This was Zulu culture, but it was also our culture - my culture.

Each culture has its strengths, but there is no culture that is worth more than any other, We cannot say that because there are more Xhosa speakers than Tsonga, their culture is better, or because those who hold power today are Afrikaans-speakers, that Afrikaans is better or worse than any other language.

Every culture has its positive and negative aspects. Sometimes the same cultural past is used in diametrically opposite ways, as we can see with the manner in which the traditions of Shaka and Ceteswayo are used on the one hand to inspire people to fight selflessly for an all-embracing liberation of our country, and on the other to cultivate a sanguinary tribal chauvinism. Sometimes cultural practices that we appropriate to certain forms of social organisation become a barrier to change when the society itself has become transformed - we can think of forms of family organisation, for example, that corresponded to the social and economic modes of pre-conquest societies that are out of keeping with the demands of contemporary life. African society, like all societies, develops and has the right to transform itself. What has been lacking since colonial domination began, is the right of the people themselves

to determine how they wish to live.

If we look at Afrikaans culture, the paradoxes are even stronger. At one level it was the popular creole language of the Western Cape, referred to in a derogatory way as *kitchen Dutch*, spoken by slaves and indigenous peoples who taught it to their masters and mistresses. Later it was the language of resistance to British Imperialism; the best **MK** story to appear in South Africa to date was written [in English] by a Boer, **On Commando**, by Denys Reitz, a beautiful account of his three years as a guerilla involved in actions of armed propaganda against the British occupying army. Afrikaans literature evolved around suffering and patriotism. Many of the early books, written to find a space in nature to make up for lack of social space, have since become classics of world ecological literature. At another level, the language has been hijacked by proponents of racial domination to support systems of white supremacy, and as such been projected as the language of the *baas*. In principle, there is no reason at all why Afrikaans should not once more become the language of liberty, but this time liberty for all, not just liberty for a few coupled with the right to oppress the majority.

At this point I would like to make a statement that I am sure will jolt the reader or listener: *white is beautiful*. In case anyone feels that the bomb has affected my head, I will repeat the affirmation, surely the first time it has been made at an **ANC** conference: *white is beautiful*. Allow me to explain. I first heard this formulation from a Mozambican poet and former guerilla, whose grandmother was African and grandfather Portugese. Asked to explain **Frelimo's** view of the slogan: **Black is beautiful**, *he replied* **Black is beautiful**, *Brown is beautiful, White is beautiful*. I think this affirmation is *beautiful*. One may add that when white people started saying black was ugly they made themselves ugly. Shorn of its arrogance, the cultural input from the white communities can be rich and valuable. This is not to say that we need a White Consciousness Movement in South Africa - in the context of colonial domination,

white consciousness means oppression, whereas black consciousness means resistance to oppression. But it does establish the basis on which whites participate in the struggle to eradicate apartheid. Whites are not in the struggle to help the blacks win their rights, they [we] are fighting for their own rights, the rights to be free citizens of a free country, and to enjoy and to take pride in the culture of the whole country. They are neither liberators of others, nor can their goal be to end up as a despised and despising protected minority. They seek to be ordinary citizens of an ordinary country, proud to be part of South Africa, proud to be part of the world. Only in certain monastic orders is self-flagellation the means to achieve liberation. For the rest of humankind, there is no successful struggle without a sense of pride and self-affirmation.

The second aspect of the **Guidelines** with major implications for culture is the proposal for a **Bill of Rights** that guarantees freedom of expression and what is sometimes referred to as political pluralism. South Africa today is characterised by States of Emergency, banning orders, censorship and massive State-organised disinformation. Subject only to restrictions on racist propaganda and on ethnic exclusiveness such as are to be found in the laws of most countries in the world, the people in South Africa envisaged by the **Guidelines** will be free to set up such organisations as they please, to vote for whom they please, and to say what they want.

This highlights a distinction that sometimes gets forgotten, namely the difference between leadership and control. We are for **ANC** leadership; our organisation's central position in South Africa has been hard won and the dream of the founders of the organisation is slowly being realised. Without doubt, the **ANC** will continue to be the principle architect of national unity after the foundations of apartheid have been destroyed and the foundations of democracy laid. Yet this does not mean that the **ANC** is the only voice in the anti-apartheid struggle, or that it will be the only voice in post-apartheid South

Africa.

We want to give leadership to the people, not to exercise control over them. This has significant implications for our cultural work not just in the future, but now. We think we are the best [and we are]; that is why we are in the **ANC**. We work hard to persuade the people of our country that we are the best [and we are succeeding]. But this does not require us to force our views down the throats of others. On the contrary, we exercise true leadership by being non-hegemonic, by selflessly trying to create the widest unity of the oppressed and to encourage all forces for change, by showing the people that we are fighting not to impose a view upon them but to give them the right to choose the kind of society they want and the kind of goverment they want. We are not afraid of the ballot box, of open debate, of opposition. One fine day we will even have our Ian Smith equivalents protesting and grumbling about every change being made and looking back with nostalgia to the good old days of apartheid, but we will take them on at the hustings. In conditions of freedom, we have no doubt who will win, and if we should forfeit the trust of the people, then we deserve to lose.

All this has obvious implications for the way in which we conduct ourselves in the sphere of culture. We should lead by example, by manifest correctness of our policies, and not rely on our prestige or numbers to push our positions through. We need to accept broad parameters rather than narrow ones : the criterion being pro- or anti-apartheid. In my opinion, we should be big enough to encompass the view that the anti-apartheid forces and individuals come in every shape and size, especially if they belong to the artistic community. This is not to give a special status to artists, but to recognise that they have certain special characteristics and traditions. Certainly, it ill behoves us to set ourselves up as the new censors of art and literature, or to impose our own internal States of Emergency in areas where we are well organised. Rather, let us write better poems and make better films and

compose better music, and let us get the voluntary adherence of the people to our banner: *it is not enough that our cause be pure and just; justice and purity must exist inside ourselves* [a war poem from Mozambique].

Finally, the **Guidelines** couple the guarantees of individual rights with the necessity to embark upon programmes of affirmative action. This too has clear implications for the sphere of culture. The South Africa in which individuals and groups can operate freely will be a South Africa in the process of transformation. A constitutional duty will be imposed upon the State, local authorities and public and private institutions to take active steps to remove massive inequalities created by centuries of colonial and racist domination. This gives concrete meaning to the statement that *the doors of learning and culture shall be opened*. We can envisage massive programmes of adult education and literacy, and extensive use of the media to facilitate access by all to the cultural riches of our country and of the world. The challenge to our cultural workers is obvious.

All dimensions in centimetres

James Serole Mphahlele
Bringing African Beer, 1987
[from Dialoga series, Part 13]
linocut
31 x 86
Pelmama Permanent Art Collection,
Johannesburg

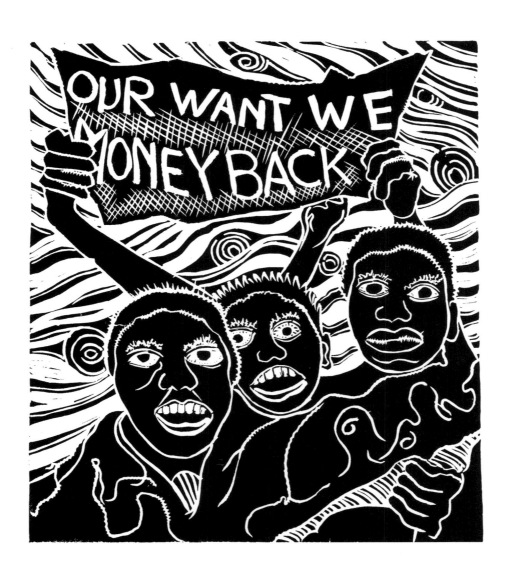

All dimensions in centimetres

Paul Sibisi
The classroom wrangle I, 1989
linocut
50.2 x 43.7

albie sachs and the art of protest

Frank Meintjies

Frank Meintjies, Executive member of the Congress of South African Writers; first published in the Weekly Mail, 2nd - 8th March, 1990

Albie Sachs's paper **Preparing Ourselves For Freedom**, comes as South Africa enters a phase of rapid transition, of unstoppable movement to democratic government. New power relations, an end to racially and undemocratically designed political structures, more equitable systems for allocation of resources and an end to the culture of conflict and violence are all in sight.

Culture organisations, as well as other community groups and service organisations, will all have to re-examine their roles critically in the light of the swiftly-changing context.

For as long while we have spoken of a Culture of Resistance [in the same way we used terms such as "alternative", "oppositional" or "anti"]. The priority was to rouse and embolden the oppressed. Now we need a new language, one imbued with the promotion of life, a celebration of democracy building on creative grassroot energy.

Cultural workers need to extend the debate brought sharply into focus by Sachs's paper.

In his paper, Sachs debunks the idea that progressive culture is by definition direct, propagandistic and confined to reflex responses to oppresssion - but he warns political organisations will be practising regimentation, Stalinism, and the suppression of cultural democracy if they issue rigid instructions to artists.

This does not mean that Sachs believes that art can absolve itself from facing the ugly social realities of South Africa today. We must remember that Sachs's paper was presented at an **African National Congress** seminar, comprised of people who shared a common political ethos, no doubt it would have been superfluous for Sachs to spell out the inevitable political role of art.

It is anyone's guess what Sachs would say to a completely converse group, one which denied that cultural activity, in transmitting ideas and values, plays a political role. What would he emphasise to artists who see art as a pursuit of private reflection with little place for the community-linked oral poet or protest theatre? Or to the literary critic whose university education has denied him/her an appreciation of the umbilical cord that links the artist to the community in Africa and Latin America? Would the message have been different?

Any critical assessment of an artist, white or black, liberal or radical, does not end with the aesthetic; it necessarily takes account of the specific milieu and how the artist engages with, relates to, is influenced by social circumstances and the issues of the times.

Sachs seems to argue with this: calling for broader parameters, he says "the criterion must be pro- or anti-apartheid". As co-architect of the **ANC**'s **Constitutional Guidelines**, he acknowledges that free speech is always circumscribed by other democractic interests of the community. Thus the **Guidelines** place a sanction on the propagation of racism, anti-semitism, and fascism.

It is impossible simply to throw overboard the age-old debate between those who accept the artist's social responsibility and those who opt for a narrower, more European conception of art. Many black artists become writers or artists because they seek to express political ideas.

The classrooms, the workplace, parliament, the broadcast media, daily newspapers and the courts, with their direct or structural

censorship, have no place for their aspirations. They are drawn to the cultural arena where they hope to create their own space for political articulation. The Emergency clamp down and vicious media gags have spurred artists to commandeer artistic space for voicing political ideals.

The direct approach in art, addressing topical political issues, cannot be summarily denounced as invalid. Bernold Brecht, Ngugi wa Thiong'o, the Soviet poster-makers and numerous Third World poets have proved beyond question that such work has an important place in the spectrum of cultural expression.

However, Sachs is charging that South Africa has had too much of a good thing - which is doing more harm than good if it is undercuttting other forms of art that could be more liberating and revitalising.

There is too little focus on how the ordinary person in an everyday situation is fighting back with laughter and wit and relationships and a refusal to succumb to despair. In addition, clenched fists and militant rhetoric alone do not denote important cultural work.

The best exponents of political art are those who strive for mastery of their craft, who exercise utmost artistic discipline and diligence, and who study different forms and techniques. It is these ingredients which demarcate the difference between effective art and works which count as important historical and cultural records or tools for mobilisation.

Far too many young progressive artists are anxious to follow role models but shirk discipline and hard work.

Art is born through experience, through grappling with issues, through working over perceptions and thoughts and feelings.

Sloganeering soon becomes a barrier to depth and genuine expression. It stifles creativity and reflection, replacing it with a mechanical incantatory approach which serves the organic link between the work and the artist and the community he is trying to serve. And when the drum-beating drowns out the needs and interests and doubts of

ordinary people, it becomes an obstacle to the building of a democratic ethos.

It would be wrong to condemn politically orientated work altogether. It would be a stultifying action, indulging in the same dictatorial prescriptiveness that Sachs labels "our own internal State of Emergency".

But it is an inadequate reponse merely to highlight the problem of poor quality and the dominance of overt political messages in art. Cultural organisations need to expose young artists to different forms of writing and painting and theatre, and to encourage greater attention to craft. Perhaps it is time to give space and recognition to the quieter, more reflective voices on our festival platforms, instead of only the more strident voices that usually come forward.

Sachs's paper has been hailed as a break-through. Perhaps what he says is unique because it is from the pen of a political leader, or because he addresses himself frankly to political organisations. However, much of what he says echoes what several leading cultural workers have been advocating for some time.

Novelist Nadine Gordimer, Congress of South African Writers president Njabulo Ndebele and poet Chris van Wyk have all been crusading for art that goes beyond the knee-jerk responses to the hurt caused by apartheid.

Ndebele has deplored the "overt political nature and journalistic reportage of some black South African fiction" as far back as 1984.

Van Wyk, reflecting on the "inadequacy" of post-1976 poetry, has lamented that political writing has been weakened where "writing was not sustained by a rich human and cultural dimension".

Even the performer/poet Mzwakhe Mbuli, the king of agit-prop, has denounced the tendency among younger poets - many of whom unsuccessfully try to emulate his artistry - of thinking it's as easy as knocking out a few "instant" lines for every political occasion.

Mi Hlatswayo, cultural co-ordinator of the **Congress of South African Trade**

Unions, has appealed for an "upgrading" of the cultural output of workers: "It needs to be of such a quality that it can challenge commercial cultural productions on merit, not on the basis that it's coming from progressive cultural organisations and thus has to be popular".

On the theatre front, many voices have called for a break with clichés and the hackneyed approach found in so much protest drama. Last year actor/director John Kani complained that imposters " jumping on the bandwagon" had lowered the quality of protest theatre: "No one wants to sit back and be told that we are black and we are suffering. We know that".

Ari Sitas, director of worker-culture programmes, has slammed theatre practitioners who produce work according to a set "formula", work that is lacking in depth and abounding in stereotypes, aimed more at overseas audiences than at the community at home.

The New Nation's former arts editor, Tyrone August, has been one of the most consistent and outspoken voices in calling for new ideas in theatre. As far back as 1987 he told his politicised readership: "Stop the Revolution, I want to get off! That's what I feel like after seeing what passes for protest theatre at the National Arts Festival in Grahamstown."

Although his newspaper was explicitly the voice of the oppressed, August ensured that the arts pages covered cultural events more broadly. Coverage included reviews from the Alhambra, Alexander, Andre Huegenot and Windybrow, even though few black people patronised these palaces of mainstream theatre.

This approach endorses the position that the construction of a new culture cannot take root without absorbing certain elements of the old.

Why did all these voices urging a new direction not coalesce into a beacon to mark the way forward for progressive artists?

Perhaps the time was not right - the State's mailed fist hung over the townships and thousands were experiencing detention. Perhaps it required members of the political

leadership to give the cue.

Whichever way we look at it, now is the time to break with a culture in which, as Sachs puts it, "our rulers stalk every page and haunt every picture", in which "everything is obsessed with the oppressors and the trauma they have imposed".

Now is the time to take up Njabulo Ndebele's challenge [uttered by a character in **Fools and Other Stories**]: " every aspect of life, if creatively indulged in, is the weapon of life itself aganst the greatest tyranny."

Sachs's paper has generated excitement within the broad artists' community, raising the possiblity of new alignments. Cultural organisations should answer this perhaps by carving out a new profile, one that is more inclusive and more forward-looking, one that invites open debate and co-operation in broad ventures aimed at building "one nation one country".

Implementation of the Cultural Boycott - a vital strategy to isolate apartheid - has in the past put us at odds with many artists who, though not part of our organisation, were not a part of apartheid formations and structure.

These artists perceived us as "censors", while we disliked the idea of being used as a political rubber stamp for the cultural passports of artists who avoided our communities, our organisation and our activities.

Now that Sachs is calling on culture organisations to work with "broader parameters rather than narrow ones", this entails greater scope for dialogue and enagagement with such artists. I'm sure Sachs does not mean that critical debate should cease, but rather that we see all artists who reject apartheid as friends more than enemies, to encourage "all forces for change".

In this regard, we should be asserting our influence in the cultural sphere through "better poems, better films and better music", in the words of Sachs, and through stimulation, co-ordination and effective organisation which advances the rights of artists.

All dimensions in centimetres

Gavin Younge
Hot Pursuit II, 1984-9
enamel zinc-coated welded steel
156.5 x 50 x 164.5
Private Collection

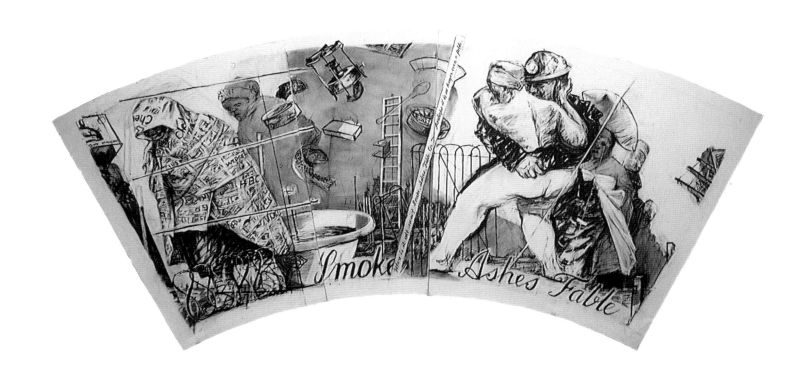

All dimensions in centimetres

William Kentridge
Smoke, Ashes, Fable, 1990
charcoal and pastel on paper [3 panels]
155 x 370

'culture **is** struggle's weapon - desk'[1]

Phil Molefe

The **Interim Cultural Desk** [2] this week said that as much as it agreed cultural organisations should only provide leadership and not control or prescribe to artists the way they should contribute to the struggle, the Desk maintained that culture must be used as a weapon for struggle.

Responding to the paper entitled **Preparing Ourselves for Freedom**, delivered at an **African National Congress** leadership seminar earlier this year by **ANC** constitutional advisor Albie Sachs, the **Cultural Desk** said it did not think seeing culture as a weapon of struggle is "wrong", "banal" or "devoid of real content". Sachs, in his paper, had called - tongue-in-cheek - for a five-year ban on **ANC** members "saying that culture is a weapon of the struggle".

The **Desk** said building an alternative, truly non-racial culture is one of the best ways to fight apartheid.

"Culture should give expression to the whole range of human emotions and experience, it should capture the fullness and contribute to the richness of the type of existence with which we wish to replace apartheid and enhance the quality of our life."

"Though we do not wish to prescribe how, it is our right and duty to challenge all cultural workers to contribute towards the struggle against apartheid in whatever way they may be best equipped".

Sachs, one of the **ANC**'s most influential intellectuals and co-author of the organisation's **Constitutional Guidelines**, argued in his paper that seeing culture as an instrument of the struggle is wrong and "potentially harmful."

"Instead of getting real criticism, we get solidarity criticism. Our artists are not pushed to improve the quality of their work; it is enough that it be politically correct," Sachs wrote.

The **Desk**, however, reiterated the view of the 1984 Gaborone arts conference and the **Culture for Another South Africa** [CASA] conference in Amsterdam in 1987 that "one is first part of the struggle and then a cultural worker."

"We challenge cultural workers to root themselves in the democratic movement so that their creative responses to life will be informed by an understanding and experience of the struggle."

"We also challenge cultural workers to contribute to the discussion and theory of culture that could help us understand what a non-racial culture could be, and how to address the imbalances to cultural expression brought about apartheid", said a statement from the **Desk**.

"We pose these challenges mindful of the fact that creativity does not follow rules, that each cultural worker must find a way of contributing that [which] is true to him/herself, and that different and varied creative reponses are to be valued as contributing to the richness of the culture that we wish to create."

The **Desk** said it does not demand that all art should be "poltical" in a very narrow sense of the word but should "express all aspects of humanity that will make up a non-racial way of life".

It re-affirmed its position that it is not only through art that cultural workers can contribute to the struggle.

1 First published in the **Weekly Mail**, March 9 - 15 1990

2 The Desk formulates artistic policy for the **United Democratic Front** [UDF]

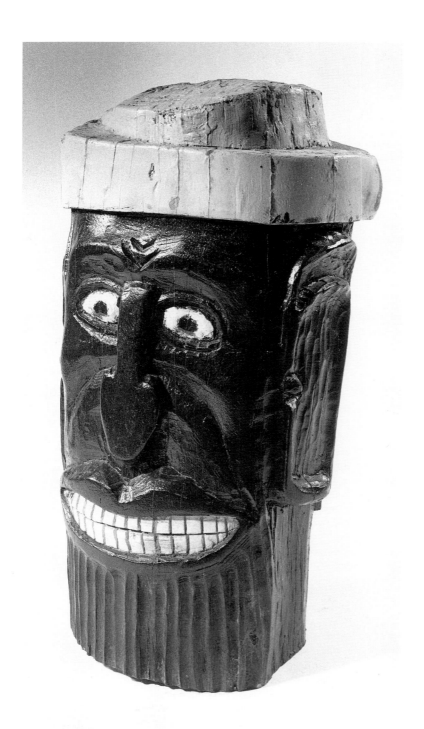

All dimensions in centimetres

Dr Phuthuma Seoka
Big Black Head, 1989
corkwood, enamel paint and nails
62.3 x 35 x 27.8
Museum of Modern Art, Oxford

'art as propaganda inevitably self-destructs'

Kendell Geers

Albie Sachs's paper "Preparing Ourselves for Freedom"- of which an extract was published in the **Weekly Mail** last month - has become the focus of much debate. In it he called for a five year ban from saying that "culture is a weapon of the struggle".

This has been hailed by those artists whose work has always remained unaffected by the events of the country, as justification now for their positions. Frank Meintjies reponded with an article in the **Weekly Mail** on March 2 saying that Nadine Gordimer, Njabulo Ndebele, Chris van Wyk and Tyrone August, among others, had been saying it all along.

Recently the **Interim Cultural Desk** all but rejected the paper, reasserting their original position that "one is first part of the struggle and then a cultural worker".

The focus of Sachs's paper was not to dismiss the fact that artists may be part of the struggle, but rather that art should now undermine apartheid through motivated criticism.

He writes "Instead of getting real criticism, we get solidarity criticism. Our artists are not pushed to improve the quality of their work, it is enough that it be politically correct".

Previously an artist was politically correct merely because s/he had selected the correct subject matter, namely fists, guns, spears or mouths screaming **Amandla**. It soon became nothing more than lip service. The alternative is now for art to remain critical of apartheid, but at the same time become critical of both itself as well as its own history. Historically, such art has been given the term avant-garde.

In the eighties, the term suffered numerous attacks under Post-Modernism, in the move away from the autonomy of the Modernist work of art. The concept of the avant-garde as "pioneers or innovators in any part in a particular period" is, however, as valid today as it was at the turn of the century.

Avant-garde art critically re-examines itself and continually re-adjusts its strategies, preventing it from degenerating into easy formulae. In that sense it is always dependent on history while at the same time, being a reaction against it.

It is diametrically opposed to propaganda, which sets out to present only that which serves its cause best, and in its particularism is unable to sustain any real criticism. The message must be absolutely clear. "Ambiguity and contradiciton are completely shut out".

Previously culture that perceived itself to be a weapon of the struggle, often degenerated into a state dangerously close to propaganda in its strict insistance on being politically correct.

Sachs points out, "In the case of a real instrument of struggle, there is no room for ambiguity: a gun is a gun is a gun, and if it were full of contradictors, it would fire in all sorts of directions and be useless for its purpose."

The avant-garde relies on ambiguity or contradiction, to question the values of both its maker and viewer. In an interview, Braam Kruger, a prominent South African artist, noted: "I only really feel secure when I distrust the art that I am making. When you don't really know what the work is worth, and you think its really bad, so you put it away, but when you next take it out and it still worries you, that's when it's subversive. I like that because the work is confronting me, undermining my values".

first published in March 1990

In its subversiveness avant-garde art will always be revolutionary. As soon as it is rendered impotent through inevitable repetition it ceases to be avant-garde.

In the search for new forms of expression, avant-garde art sets up a healthy state of competitiveness. Artists find themselves competing with history as well as each other to find a personal, unique solution to the question of representation. This raises the general standard of art.

Visual over-exposure often leads to immunity. Andy Warhol's **Disaster Series** or **Race Riots** illustrate the numbing effect that repetition has on any emotionally-laden subject matter. This is why avant-garde art always critically re-assesses both itself and its strategies. When artists in this country first began to paint fists, spears and guns, it was an effective form of resistance. In the same way that when you repeat a word over and over, it loses its meaning; fists, spears and guns have become clichés, and have lost any subversive potential they may have had.

When the peace parks first appeared late in 1985, they represented an art form whose optimisim threatened to undermine the misery and ugliness of the townships. This was contrary to what apartheid had set out to achieve and so the security forces had to systematically destroy them.

In Sachs's words "It by-passes, overwhelms, ignores apartheid, establishes its own space".

It is important not to forget Nietzsche's words when attempting to criticise an aberration like apartheid: "Whoever fights monsters should see to it that in the process he does not become a monster".

The move away from art in the service of the struggle does not mean that art claiming to be apolitical may now be justified. All good art is political in the sense that it challenges the ideological and cultural prejudices of both the viewer and the artist.

Political art must be perceived less as a set of predictable subjects and more as a critique of social representations. It is a critical examination of the ideologies of social structure like race, sex, culture, class etc.

An artist remains a member of society and in that sense is responsible to it. Rather than reinforcing the values of a particular society, s/he should critically re-examine them through his/her art, and in the process slightly change them.

In "Resistance Art in South Africa" Robert Hodgins quotes Robert Rauschenberg saying "If you see a picture and it doesn't somehow minutely alter your vision of life, then either it's a bad picture, or you're not looking properly".

Avant-gardism is by its nature not as accessible as propaganda. For this reason it has often been dismissed as elitist. The mistake in this country has been to lower the standards of art, in the hope of appealing to a wider audience. This art only resulted in creating culturally lazy people and reducing the span of possible cultural appreciation.

Increasingly we encounter clichés debasing Eurocentric traditions. "Swan Lake" is suddenly compared with and seen as inferior to Zulu dancing. It becomes fashionable to pay lip service to Afrocentricism and to denounce European values.

This is unnecessarily counter-productive... the range of possible modes of expression in South Africa is unique in its position of having the best and worst of the First and the Third Worlds. It is only through the critical examination and mutual acknowlegement of these traditions, that a uniquely African avant-garde may be born.

1

1. Helen Sebidi
Anguish, 1988

2. Johannes Chauke
Crocodile man, 1988
wood and paint
111.5 x 28 x 24

3. Mpumelelo Melane
Student, nd.
painted wood
121 x 25 x 20

inventing south african art

Gavin Younge

In an interview, Mi Hlatswayo of **COSATU** [1] said that the South African proletariat, being the producers of wealth, should lay the basis for a yet to be invented national culture. This call for one national culture has echoed, sometimes rather hollowly, around community halls for the past few years but not many have chosen to define the specific content of this unitary national culture. Hlatswayo believes that the traditions of the working classes should provide this content and when challenged to be specific, he has pointed to the poetry and drama which have arisen spontaneously out of funerals, marches and meetings. When it comes to the visual arts he admits candidly that union structures have not yet been able to penetrate this aspect.

The operative word here is "yet" it may sound chilling to some, but colour and ethnic conciousness is a threat to class awareness and thus prejudicial to the building of working-class solidarity; Hlatswayo's comments can therfore come as no surprise. What is at issue here, is their continuing relevance in the wake of events in Eastern Europe and the triumphant return of exiles to South Africa. Is the future well-being of South African art really assured by the dictum that there is to be one national art form?

Never mind its colonial past, South Africa's geographical isolation from the wellspring of the Modern Movement has gnawed at the soul of those artists, both black and white, who see in parochialism as much slackness as they see worth. These artists have tried to forge an art [and music, theatre and other art forms] which is both contemporary in its internationalism and yet characteristic of the South African experience. Their art, born of environmental and personal insecurities, forms, in many cases, an integral part of traditional social processes, albeit ones which are dislocated by art market interventions. Is it possible, and desirable, to forge national culture out of a single class faction in society?

After years of activism and union organising, Stanley Aronowitz answers this question

in his assessment of Marxism's contribution to sociological debates, in a document he called **The Crisis in Historical Materialism** [2] Here, according to Paul Bové [3] he offers a critique of all theories which postulate a trans-historical subject such as "the proletariat" as a privileged term in a totalising description of history. Instead he proposes a theory which pursues an alliance with practice, one which is specific and which advocates a self-managed society formed from an an alliance of autonomous and sometimes competing groups. For Bové the proletariat, or any other class, is constituted as the result of struggles about class. Thus class struggles are struggles against domination and for autonomy.

Wary of prescriptive practices and suspicious of the left's new-found interest in culture some artists, again both black and white, nonetheless tread carefully when it comes to participation in national art competitions like the Cape Town Triennial [sponsored by Rembrandt Tobacco Foundation] and the Grahamstown Arts Festival [sponsored by the Standard Bank].

But such hand wringing is not enough for Hlatswayo - he believes that art should be part of the struggle. Hlatswayo's is not an isolated viewpoint. Potose Lesoro, who was prominent in last year's controversy surround-

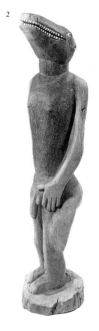

2

[1] Congress of South African Trade Unions.

[2] Stanley Aronowitz, "**The Crisis in Historical Materialism**," New York, Praeger, 1981.

[3] Paul Bové "The Ineluctablility of Difference" in Jonathan Arac [ed] **Postmodernism and Politics**, Manchester University Press, 1986. pp.8-9.

ing the **Desk's** [4] approval of the Grahamstown Festival prior to consultation with Grahamstown groups says matter-of-factly that traditional culture is reactionary. For him *national liberation is an act of culture - to have one nation means also to have one culture.* [5]

It is into this rhetorical barrage that Albie Sachs's paper **Preparing Ourselves for Freedom** so famously fell. This paper is a radical break with earlier pronouncements from **ANC** cadres and has been seized upon with relief by just about everyone to the left on the **SABC**'s Board of Control and to the right of **MK**. [6]

The **ANC** appears to have been rethinking its strategies since their conference in Arusha in December 1987. The moral superiority of those who had left, for whatever reason, began to lose ground at the same time that the **ANC** realised that they had better prepare for a membership drive once the international campaign for the organisation's unbanning took hold. At this conference the **ANC** undertook to initiate a process of consultation with democratic structures inside the country in order to identify appropriate guidelines in developing solidarity with democratic culture without, at the same time, undermining the Cultural Boycott. In the same year, the **ANC**'s Arts and Culture department participated in the **CASA** [7] conference in Amsterdam - this conference adopted a seven part preamble to thirteen resolutions. These, like most bureaucratic documents, do not make a rivetting reading but it is noteworthy that a selective approach to the boycott was advocated. Each one of these resolutions specifically affirmed the notion that *art should be part of the struggle.* It is surprising that Sachs waited two years before drafting his disclaimer.

His statement that this slogan should be banned for at least five years is intended ironically but I also think he meant it. As Brenda Cooper has said [8] his is a call for *better art and better politics.*

Before moving onto an aspect of his paper which has not been covered by others I would like to take up a point raised by

Rushdie Sears of **COSAW** [9]. He intimated that the **ANC** was out of touch with internal sentiment and that Sachs's examples of artists such as Hugh Masekela *et al* were not applicable. I think this is an important observation and it is worth noting that for many artists incarcerated in the townships, art **is** part of the struggle. Interviewed in his Aunt's Nyanga home, Sipho Hlati argued passionately that *here in this country, one has got to take sides, you either collaborate with the State or you are together with the people... What I mean by using "art as a weapon" is to actually reveal the conditions, day to day activities and just leave it to teach these conditions through art.* [10] For Sipho Hlati, and thousands like him, Sachs is out of touch with sentiments inside the country. Now that he is back in South Africa he is being asked to remember the small struggles fought by many people to persuade the government to unban the **ANC** and other organisations.

To his credit, Sachs advocates leadership and not control. He writes that it is apartheid which has closed our society. He does not say, but I think it is true anyway, that the notion of full artistic freedom is an anathema to many people associated with government ministries. Artistic freedom makes them foam at the mouth. This freedom is not simply the freedom to choose one's subject matter. Artistic freedom, if it is to remain artistic, is the freedom to act socially. In a situation of political repression the freedom to define oneself, to express oneself is taken away. In this situation, any act of self expression be it the wire wind pumps of Cradock or the clay 4x4s of Transkei is an act of emancipation. It was out of this realisation that the slogan *an act of culture is an act of struggle* was born. This formulation recognises cultured acts born of traditional social processes and other seemingly apolitical acts.

Sachs's contention, that the **Constitutional Guidelines** should not be applied to the field of culture, is an important one. It is this contention that makes the most positive advance against domination and for autonomy. After all, without autonomy, artists cannot relate to their tangled heritage, the revealed

and severed tradtions which convince us all of the cultural strength of a continent once thought dark.

So in the face of this, what is South African art and how is it to be invented? Tradition is the one quality that all revolutions have broken with. At the same time, tradition is the one quality most necessary for an understanding of art's affirmative social role. Thus as black South African artists have developed uniquely reflexive perspectives on their changing environment, so too, have white artists come to question the aesthetic traditions which are associated with colonialism.

There have been many false starts. Attempts to mobilise artists into one organisation dedicated to the building of one national South African art-style under the leadership of the proletariat have not gained much ground. Against this spirit of radicalism attempts have been made to construct genealogies out of the data of millenia rather than recent decades. If easel painting is synonymous with speculation some, like Michael Barry, have turned to mural painting. David Brown's sculptures recall the apparatus of pre - industrial society. Charlie Hallet affects alchemical alterations. Penny Siopis's rich surfaces deride rich practices. Stanley Hermans chronicles his street. Boetie Botha weaves his trace lines. Beezy Bailey danced with Nelson Mukhuba. Sculpture and painting is an historically bounded tradition. Whether or not any one tendency is chosen as "truly South African" and thus appropriate to the task of setting up a transformational model, is not something which can be decided solely in the realm of art. The necessary transformational model has to be sought elsewhere - in social processes and in the attitudes of commitment, modesty and courage of those artists who are prepared to re-enter the world which their myths have separated them from.

Billy Mandindi, represented in this exhibition by some powerful drawings, took leave of his comrades at a political meeting last November in order to undergo *ukwaluka*, a month long period of initiation. Given the urban sprawl attendant on one of South

[4] **UDF** Interim Cultural Desk, based in Johannesburg.

[5] Taped interview with the author, Grahamstown, July 1989.

[6] **SABC** [South African Broadcasting Corporation]; **MK** [Umkhonto we Sizwe], the military wing of the **ANC**.

[7] Culture in Another South Africa [**CASA**]. A Conference held in Amsterdam, December 1987.

[8] Debate at Centre for African Studies. University of Cape Town, 5 March 1990.

[9] Congress of South African Writers.

[10] Taped interview with the author, Nyanga, July 1989.

Africa's larger cities this meant camping on the narrow verge bounding the four-lane highway to Cape Town's airport. For anyone searching for cultural fault lines, the sight of ash-whitened youths sitting almost naked outside their rude shelters within divining distance of pantechnicons, pressages more than a hint of lost authenticity.

James Clifford wrote *intervening in an interconnected world, one is always to varying degrees "inauthentic," caught between cultures, implicated in others.*[11] In Mandindi's and other artists' cases, this statement can be turned around; it is the artists who have implicated themselves in the art market. Money not only talks loudest, it also talks for the longest. To take other examples; before any institutions brought his sculptures Nelson Mukhuba implicated himself in the Rand Show. Helen Sebidi exhibited at **Artists under the Sun**.[12] Against this character building apprenticeship of delayed rewards, Derrick Nxumalo found himself heir to the neglected tradition. Born into the expansive appetites of the late 1980s he could retire into professionalism before his first solo exhibition. People sought him out because in his work they found the echo of his presence untainted by the European aesthetic conventions so evidently in decline the world over. It is tempting to construct a transformational model out of this collapse. The whole thrust of the recent Hayward Gallery exhibition **The Other Story** was towards a modern synthesis, but one which preserved racial identities. Just as Picasso and Braque [and others] founded a European reformation on an assimilation of African aesthetic conventions, Araeen proposes a reversal.

Of an earlier exhibition he curated at the Chisenhale Gallery in London he wrote that, its purpose was *to put black art in its proper socio-historical context which is contemporary art which has nothing to do with Afro Asian tradition*s. [13] Consigned to the margins of an undisciplined and fickle contemporary art world, black art practioners in England must look upon South African artists with envy. With the unbanning of organisations [**ANC**, **PAC**, and **SACP**] cultural differences may no longer be stable. Always a matter of rhetoric, their status as essences are at last challengeable. With that realisation comes the freedom to retain, reject and invent continuities.

[11] James Clifford, **The Predicament of Culture**. Harvard University Press, Cambridge, 1988, p. 11.

[12] The Rand Show is an agricultural and trade fair. **Artists under the Sun** is an informal organisation promoting the sale of art on the pavements of Johannesburg.

[13] Rasheed Araeen, **The Essential Black Art**, London, Kala Press, 1988. p.5.

3

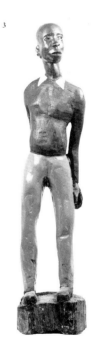

what are we supposed to be doing here - on earth?

Mongane Wally Serote

White domination in South Africa will soon come to an end. Ordinary women, men, and even children, in townships and villages, have worked and died for this to happen. They have now, in their hundreds and thousands, decided that while they are living on this earth, they will not be ruled by whites under the apartheid system. Through their numerous organisations, led by the **African National Congress** [ANC], they made the decision that South Africa must become a united, non-racial, non-sexist and democratic country. It is this decision which has given the South African struggle for liberation, massive international support.

The armed wing of the **ANC, Umkhonto We Sizwe** [MK], since its inception in 1961, has waged a humane armed struggle, an armed struggle of restraint against spilling blood because it comes from white skin. Yet the struggle is intense. Over three decades, it has escalated, and because it has defended the will and wish of the oppressed and exploited, who sought neither vengeance nor reprisal but peace and progress, its justness, has gained support from among the masses, who have willingly given their sons and daughters to it, at times at too early an age.

In November 1985, the black workers of South Africa, formed an organisation of their own, **The Congress of South African Trade Unions** [COSATU], it became the backbone of the South African struggle. It has engaged the capitalists who own 95% of the wealth of the country, who, over many decades, have evolved a ruthlessly exploitative economic system, which has been made to run smoothly by apartheid. In time, the workers organised and engaged in economic struggle against capitalism. Oppressed and exploited, yet also the majority, they will strip the economic system of South Africa of its exploitation.

The black workers, youth, women, the intelligentsia, and some white South Africans, through their democratic organisations, and

through international support for their just cause, have established a culture in South Africa, the objective of which is progress, justice and peace. They have brought sense to the apartheid regime, which in February of this year [1990], unbanned the **ANC**, the South African Communist party and other organisations. At last it has accepted that change is inevitable!

The process of mobilisation and organisation for liberation, has proliferated through every aspect of the life of the oppressed. A new South Africa has to emerge from this process. It is this activity within the masses which has inspired film-makers, writers, dancers, musicians, photographers, actors and artists consciously to search for their role not only in the struggle, but also in the life of the emerging new South Africa. South African cultural workers have, over the past eight years, held a number of festivals and conferences, in Botswana, Gaborone in 1982, **Culture and Resistance**, in Amsterdam 1982 **The Cultural Voice of Resistance**, in Amsterdam 1987 **Culture in Another South Africa**.

The conference element within these festivals, has searched consistently to establish a role for South African cultural workers in the non-racial, democratic struggle as a means of forging a society which will be part

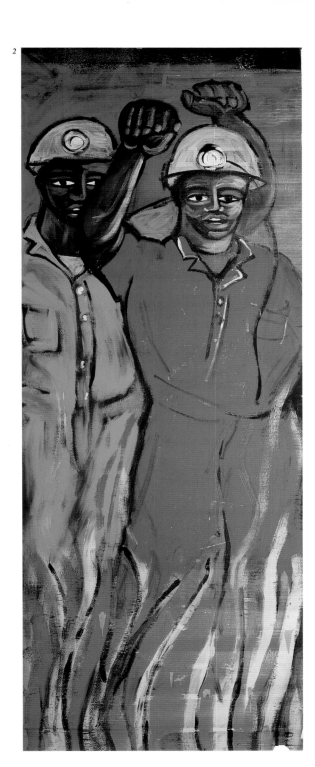

All dimensions in centimetres

1. Imvaba Artists' Group
Mural at National Union of Metal
Workers of South Africa Congress
held at Gosforth Park, Johannesburg,
May 1989

2. Workers 1989
PVA and acrylic on cardboard
430 x 150
Hung together with the June 16th and
Woman murals. Depicting: workers,
youth and women - as the backdrop
to a rally called by the **Congress of
South African Trade Unions**
[COSATU] to protest against the
implementation of the Labour
Relations Act

3. Dorothy Zihlangu
The People Shall Govern, 1989
Embroidery
51 x 54

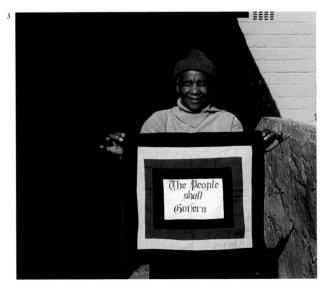

of a political and economic system which recognises the human value of the masses upon masses of people who are not white. It will involve these people, through their languages, traditions and customs, in celebration of the variety and wealth of the human experience. It will celebrate the fact that, although there are material barriers of seas, rivers, bridges, fences, walls and, at times, guns, people, whether black or white, are in essence human; because of this, they have no choice but to be part and parcel of each other. At the end of the day, the peoples of the so called "Third World", will interpret their own lives according to how *they* understand, live, experience and are forced by the "First World" to exist in it.

Yes, when this happens, the privilege, professionalism, civilisedness, wealth and opinionatedness of the First World will grind to an almost complete halt. And if we go by the way the South African struggle has unfolded, and by the many other countries where peoples eventually had to pick up arms to fight for space, life, and progress, the peoples of the First World must come to terms with the fact that the peoples of the Third world will one day come to a point in their lives when they will answer the question: *What are we supposed to be doing here on this earth?* by a simple : *to live.*

The Zabalaza Festival, workshops and talks of South African Arts, to be held in London in July 1990 is part of the process of establishing a base for non-racial and democratic cultural activity in South Africa. It has created another forum among South African cultural workers in which multi-artform explorative discussions can take place about their role in that society. The political role of cultural workers can be examined as they seek to establish how a viable society can provide the basis for their creativity. Black and white South African cultural workers, while organising cultural work and talking to each other, will, in a changed climate which promises a country which can actually be lived in, discover on a daily basis, and concretely, their differences and antagonisms.

Zabalaza seeks to arm the underprivileged through workshops in all artforms so that they will be able to participate in the creation of a non-racial, cultural milieu, which the masses of the South African people have created. But it also seeks to create a forum for this emerging culture within the international community.

The **ANC** has, over the years, spearheaded the isolation of the cultural institutions of apartheid through the Cultural Boycott. In 1987 in London at the Canon Collins Memorial Lecture, its President, Oliver Tambo called for the international community to support and nurture the emerging democratic culture of South Africa. **Zabalaza**, [which literally means *struggle* in Zulu] is the resource base to ensure that this happens. We struggled and are struggling to work out a common point of reference with some of the established professional cultural institutions in England, like the Museum of Modern Art in Oxford or The Institute of Contemporary Arts in London, where South African artists will exhibit their work and a series of discussions will take place during the first two weeks of July.

This project has raised a series of questions: Why is this Festival, workshops and talks taking place now in London and not South Africa?

Is it really possible for the cultural institutions of the First World to recognise and work with emerging mass-based cultural institutions in South Africa?

What criteria must First World cultural institutions use to judge the aesthetic value of the cultural work of the masses, who, over three centuries have been engaged in a battle for freedom?

If the experience of the First World cultural institutions has been tempered by their exchanges with the other Third World countries, such as Brazil, Argentina, Cuba, India, or Nicaragua, what then is the difference in their dealing with cultural workers from South Africa?

Lastly, now that Eastern Europe is going through such deep changes does the experience here of Western cultural institutions arm them to deal with cultural workers from other countries, such as South Africa, where art and other cultural manifestations are still informed by struggle?

I will not attempt here to provide any definitive answer to these questions, except to state that the answers will come from how we as a people wage the struggle for justice and peace in our country. That will be the answer and the judge. Of course I can see that our struggle is inspired and informed by other struggles but I feel that above all else, it is determined by how we as a people react to this, and know that we are part of the world; this locates us within a broader human experience.

A new culture therefore is emerging in South Africa. This culture will not leave civilisation as it found it. We from the Third World must ensure this - no - one else can do so - yet it is not the first Third World exhibition to be held in this Museum. For us in the Third World, when we note and experience this, many questions arise in our minds. At times they are questions about white people. Do they know that we love life? Do they know that we do not mind being black? Do they know that we have always said that it is not until more and more white people abandon and desert the exclusive worldwide white civilisation that we will believe that they mean the same thing when they talk about justice and peace. Do white people know that we do not, as black people, want to be told, spoken for and thought for by white arrogance? Do white people know that in our minds, consistently, because of institutionalised racism, subtle racism, and racism fuelled by economy, we have had to ask ourselves over and over again, how can whites be human, if they are able, for whatever reason, to turn a blind eye to injustice and a deaf ear to our reports.

Zabalaza as a cultural project, organised from London together with cultural organisations in South Africa, has raised these questions. If a project of this nature was to be organised with white South Africa, there would have been no such questions. Yes, white South Africans are professionals, they have the money, the resources, the skills, the means of communication and they have

over the years, interacted with England and the world at various levels formally and informally; they have always seen themselves as part of the "civilised culture" of Europe.

We agreed that a project of this nature must have deadlines; we agreed that we all live in the contemporary world; we agreed that efficient means for communication on this project must be established; we agreed about many things, and proceeded to work; we agreed also that we would take into consideration the concrete conditions we come from. Apartheid has not been abstract for us. It has impoverished every aspect of our lives. We are poor, we are uneducated, we are not "professional" in the sense that the First World means that word; we walk long distances to communicate with each other; we do not have phones and cars or faxes and messengers and money to "bike" information. We do the work of ten people, single handed - we still do and we regard this as efficient. We have never lived in a society which was organised to bring out the best in us. Even so, we consider it our right to interact with whomever we choose, and if anyone were to deny us this or to interfere with this right, we can only reply that we will always rely heavily on our experiences in the times of struggle.

This struggle is yet to produce many writers, film-makers, photographers, artists and other cultural workers, They will listen and watch carefully; they will feel and understand their own lives and world, and they will still give reports. We will develop an eye for who we are, and what we think we are supposed to be doing here on earth. The **Zabalaza Festival** has not even begun to tap that calibre of cultural worker among us but it is facilitating the process by which he or she may emerge.

The **art from south africa** exhibition at **MOMA** will illustrate this. Since it consists of works from the townships, villages and suburbs, it will proudly, although perhaps not in the aesthetic of the First World, declare that *culture is a weapon of struggle*. It will also declare that it has always known that *white is beautiful* but there is a difference in meaning

London April 1990

from that when blacks say *black is beautiful* for in that case, it meant a choice between death and life. When blacks said that, they were bound by steel and rusted chains. And saying it has resulted in the deaths of many. No white will die for saying *white is beautiful* in a new South Africa. The non-racial, non-sexist democratic culture of a United South Africa is emerging in a terribly hostile environment. It will battle against exploitation, and since racism and exploitation have many strong allies in the world - South African cultural workers must come to terms with this.

They must be objective and guided by reality, come to terms with the fact that, as they paint, make films, take photographs and as they write, projecting the new South Africa, they will be in battle.

They will be forging an image of the South African people, who have fought relentlessly for over three hundred and fifty years against cruel colonialism, racism, exploitation and oppression, while other peoples have progressed. They must also come to terms with the fact that at the point they are almost able to grasp freedom, through weapons they themselves have forged, the world may be impatient with the way they do it.

Toyi-toyi, the South African revolutionary dance which emerged from within the guerilla experience of **MK** as a weapon to mobilise, to organise, to inspire courage, determination and presence in life, may frighten some people, but there is no need to fear. Sport is part of culture, it too is political. I ask what did Mike Gatting think as he played cricket in South Africa, which he thought was apolitical, when suddenly it became political, and blacks did the *Toyi-toyi* as they demanded that he went back to Britain whence he came?

The painted and carved clenched fists, the AK47s, and the portraits of leaders of the Revolution, may not have meaning for other people, but they have been weapons for liberation for the South African people which brought about a difference between life and death. There have also been poetry performances and the struggle of making film

adapt to portraying the conditions of oppression.

All these elements are bringing into the world lives which civilisation had relegated to the dustbins of time. It is understandable that parts of the world, which are not repentant may not want to hear or see this. Also it is understandable that elsewhere there may be too much pain to witness this cruelty. But all this has very little to do with the victims of a cruel history.

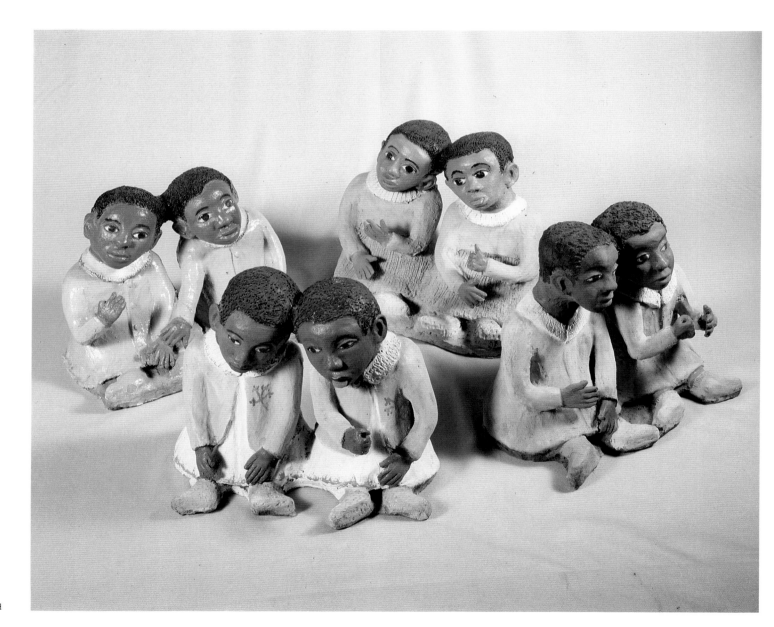

All dimensions in centimetres

Noria Mabasa
Mpho and Mphonyana, 1989
[Siamese Twins, heads joined]
clay and enamel paint [4 pairs]
34.5 x 46.5 x 26.5
Museum of Modern Art, Oxford

'moma show raises questions about people's culture and art museums'

Jacqui Nolte and Mario Pissara

This past year has seen the evolving fulfilment of resolutions passed by South African cultural workers at the **Culture in Another South Africa Conference** held in Amsterdam in 1987. One of these central resolutions pertained to the inseparability of art and politics, and the need for artists and cultural workers to organise themselves regionally, nationally and internationally so as to play an effective role in the liberation struggle.

In the Western Cape, the Visual Arts Group of the **Cultural Workers' Congress** [1] held a number of discussions in an attempt to understand in what way an exhibition such as that proposed by **MOMA**, might aid cultural organisation on the ground. At the same time political gains were counterbalanced by the identification of a number of problems.

It was recognised that historically art exhibitions tended to cater for an "art educated" public and that an international exhibition of South African art might superimpose criteria specific to such a viewing public but be insensitive to criteria which might be applied by cultural organisations within South Africa. This issue impacted upon the broader problem of the decontextualisation of cultural production. Being transposed into a foreign context and into an art museum posed the threat of cultural artefacts losing their particular significance. Removed from communities for which such work was made, the purpose of production might be unclear. An entirely different set of readings might accrue around the object, irrelevant to the original producer. Artificial values could then be substituted for the authentic values of the work. At worst, the item might simply function as a fashionable commodity. While this process of remodification is common to any form of cultural production, the specific issue raised for cultural workers in South Africa was how to ensure the maximum control of distribution so as to benefit the producers at a grassroots level. With regard to the interpretation of these cultural products the debate was also perceived as a struggle to defend those original intentions located within specific community and social concerns, over and above concerns with quality and connoisseurship. On both the financial and theoretical terrain the struggle persists, and both are contingent upon collective action.

The visual arts has long been seen as an individualistic realm. This has often been explained in the terms that the materials and character of artistic production [in particular painting and sculpture] are more suited to individual rather than collective vision. Proponents of this view often cite the worst examples of didactic art as irrefutable proof that collective vision is banal or kitsch. But if we recognise the need to build a non-racial, non-sexist and democratic South Africa, we have much to do to redress the imbalances of apartheid and we cannot do it alone. The task is to engage in the struggle with the dominant discourses and institutions of art in order to restore the democratic nature of artistic production and consumption.

The **MOMA** exhibition seemed to offer the cultural workers the opportunity to embark upon a high profile international event within the possibility of a certain degree of influence upon the nature of the show. In organisational terms the exhibition was seen as serving three prime purposes for organisations within: the possibility of contributing to the campaign to isolate

Jacqui Nolte and Mario Pissara are members of the Visual Arts Group of the Cultural Workers' Congress in Cape Town.

1 The birth of the **Cultural Workers' Congress** [CWC] was given impetus by the **CASA** resolutions. It sought to facilitate the development based organisations, from which the **Visual Arts Group** was born.

apartheid; the possiblity of giving voice to People's Culture in an international forum, and the possibility of building cultural organisation within our country by involving individual artists and organisations in the process of cultural organisation.

We were firmly committed to the idea of a show involving all media and manner of production, ranging from the individual professional practitioners, unacknowledged craftspeople and struggling collectives. We believe that only through a reflection of this range of production modes can we begin to reflect that "developing People's Culture" so freely referred to in recent cultural debate. A People's Culture is diametrically opposed to the idea of art as an elite activity for privileged viewers. It challenges the myth of the individual genius / artist by making evident visual expression from diverse forms of social organisation. It challenges the isolation of the art object and the perpetuation of pleasure in the rarified and decontextualised object. In doing so People's Culture embraces not only diversity but complexity and change - the meaning and resonance of each artefact being contingent upon the specific circumstances from which it was generated.

It is the underlying material conditions and ways of understanding and interacting with them that this should reflect. It is the hope of visual artists from the **CWC** in the Western Cape that the accompanying documentation will serve to provide some of the contextual information so necessary to fill out the story of the concerns and debates at home. People's Culture is not exclusive. It implies that the creative act of making meaning of this world is accessible to all. Given the South African history of a calculated exclusion of the majority from resources and facilities it is imperative that the "doors of culture" be opened - both retrospectively to give prominence to all types of visual production, and prospectively to stimulate a production which will finally erode the fading dominant fabric. The task at hand is not to appropriate a fortunate few onto the dominant institutions and discourse but to redress radically the imbalances created by the

entrenched cultural values of a protected class and race. To do so entails both short and long term initiatives, and the former will always be contingent upon the overriding principles of the latter. We hope that **MOMA** manages to convey this spectrum of cultural production and in so doing contributes our efforts to promote a People's Culture.

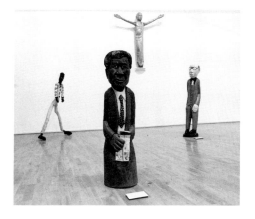

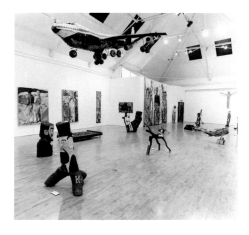

Two views of the installation of the **Art from South Africa** exhibition in the upper gallery of the Museum of Modern Art, Oxford, July 1990

desperately seeking 'africa'

Colin Richards

Terminologies in modern art in South Africa.
Many traditions, languages, cosmologies, and values are lost, some literally murdered: but much has simultaneously been invented and revived in complex oppositional context...[1]

"Transitional art" is a recent phenomenon in South African visual culture. While controversy surrounds the very notion of "transitional" art, we can at least agree on some features and artists associated with it.

"Transitional art" is often sculpture, though the term has also been applied to pictures. It is usually produced in rural or semi-rural contexts; its materials include indigenous wood, wire, tin, plastics, beads, urban debris, reflectors, animal skins, feathers... Surfaces may be left "raw" or coloured with enamel paint.

Subjects range from prominent political figures, news events, media celebrities, mythic beings of other kinds, sundry spirits - sublime and ridiculous - planes, cars, toys, telephones...

Noria Mabasa, Doctor Phutuma Seoka, Johannes Maswanganyi, the late Nelson Mukhuba, Johannes Chauke, Mzwakhe Mbatha, Billy Makhubele, Jackson Hlungwane, anonymous... are most often associated with the phenomenon. Some artists also produce traditional work for use in their own communities.[2] Artists from urban areas - black and white - have been referred to as "transitional" as well.[3]

Critics write of a "transitional" aesthetic. Some see it as a sort of ethno-pop with serious moments. Others think of it as serious art laced with sly fun. There are, doubtless, many views concerning this style. But is it even a style? That is a critical question.

I am interested here in examining what the term "transitional" means and how it is used within the dominant visual art world in South Africa.[4] The appropriation of culture has its own dynamic - one which has become particularly apparent during the past decade which has been characterised by States of Emergency and political crisis.[5]

Stating the obvious

Contact and exchange between cultures is a ubiquitous phenomenon. In South Africa a colonial heritage and the current politics of domination make "contact and exchange" a traumatic experience.

Cultural struggle takes many forms and occurs on many levels of discourse. Its effects register throughout social life.[6] To speak of "contact and exchange" is in a sense to misrepresent history. "Conflict and dispossession" are perhaps rather more accurate terms.

Forms of Oppression

Censorship, the destruction of cultural material, poverty, the mutilation of cultural traditions, the imprisonment, banishing and murder of cultural workers/artists are not the only forms of oppression.

While all of these stain South African cultural history, they have become less acceptable than they used to be. In "reformed," "multicultural" South Africa subtler persuasions are called for; these employ the mechanics of "co-option" and "appropriation".

Appropriation

Appropriation has many guises. Art historian Anitra Nettleton, for example, notes that

Colin Richards, art historian and critic, is a member of the 'Artists' Alliance

while Art History studies "the arts of Third World peoples" this involves these arts being "arbitrarily classified as such by virtue of their appropriation into Western art categories".[7] Critical writers have recognised the part Art History itself plays in structuring a cultural field.[8] This may involve a good deal of cultural violence. Hence "appropriation" extends beyond a simple [re]-presentation of cultural artefacts and practices.

Sites of "appropriation" are as numerous as sites of exchange: these pages, this catalogue, the gallery space, the popular press, the museum...[9] Whilst all "appropriation" might not be inappropriate, such sites are never neutral.

Representation

In order to be able to use cultural or social phenomena suitable "representations" for them need to be constructed. Calling something "craft", for instance, presumes the cultural destiny of both object and makers. Hence naming becomes labelling. A representation might best be seen as the way we label, speak for, or about, cultural and social phenomena. The field of "representation" is strongly contested territory.[10]

Here I intend to consider the "transitional" phenomenon as a form of representation. It appears to have played a significant role in "liberating" aspects of black visual cultural production for use by the cultural and economic institutions of the dominant art world. This has happened at the historical moment of a most profound crisis of confidence in that art world.

Transitional - the term

Some two decades ago anthropologist Nelson Graburn seems to have resuscitated the category "transitional" or "acculturation art".[11] The artefacts he was referring to [Eskimo "tourist" art] involved the *artistic production of those many peoples who have come into contact with civilisation* [sic].

In a later publication Graburn again refers to "the arts of acculturation": *Those forms that have elsewhere been labelled transitional, commercial, souvenir, or airport*

arts,... it also includes certain novel non-commercial art forms.[12]

Graburn explicitly refers to cultural producers in the so-called Fourth World, excluding those politically mobile producers of the increasingly powerful Third World.[13] He clearly distinguishes this group from what he calls the "assimilated group".[14]

Graburn's account raises particular political questions for us. We, in South Africa, are not dealing with a "conquered minority" which is anxious to assimilate. Rather we have an ascendant, increasingly powerful majority [excluded from his purview] which, admittedly, some South Africans might well wish to see as a collection of "conquered minorities".[15]

The term "transitional" seems to have been around for a long time. Perhaps its historical guises - ethnic, folk, curio - have made it difficult to filter through the fine mesh of cultural preconceptions upheld by the dominant art world.

A book innocently entitled **The Savage Hits Back or The White Man Through Native Eyes**, published over fifty years ago, includes material which is in some ways redolent of "transitional" imagery.[16]

A few items in it allegedly hail from our part of the world: a "Boer farmer" by the "Bechuanaland modeller", a clay tricycle, and a "Bushman" painting [Cape Province, c. 1913] of none other than Queen Victoria! In the manner of his time the author suggests that as *kindly sovereign, mighty ruler and crowned womanhood* the Queen was eminently congenial to *the primitive imaginations of her African subjects.*[17]

Her "crowned womanhood" seemed a dire attraction indeed: *the fullness of the Queen's bust made a deep impression upon the negro mind.* Against this the boer farmer was no match: *rather unintelligent face with small pig eyes, and... impertinently closed mouth.*[18]

Recent scholarship cites evidence that black carvers offered their wares for sale to whites in Southern Africa around the turn of the century.[19]

In South Africa the "transitional" first

appeared in the catalogue of the first exhibition of the African Tribal Art holdings[20] of the Standard Bank Foundation of African Tribal Art [est. 1979]. Amongst other things the intention of the Foundation was, according to the then curator to *include forms of art transitional between traditional or tribal art and the modern art forms found in current African societies.*[21]

The term was again used in a more recent catalogue [1986] of a similar but more extensive exhibition.[22] The author of the relevant entry, Anitra Nettleton, relates the phenomenon to changing socio-economic factors and shifting patronage/client relations: *Some artists relied for years on "tourist" patrons and the church or other charity organisations for the sale of their work and it is only recently that Western-style commercial galleries have become involved in this area.*[23] Nettleton might also have mentioned the white-dominated art world's ideological interest.

A place in the "official" story?

By the late seventies high art culture in South Africa was beginning to look severely unrepresentative. Questions of "relevance" and of a "national" cultural identity had pre-occupied artists and others for some time. Frustration, disaffection, and fragmentation in the art world seemed to come to a head towards the end of the decade. This owed much to the traumatic events of 1976.

The search for that chimaera - The Authentic "African" Image - amongst many white artists was often as intense as it was frustrating. So was the pursuit of a politically cogent way of addressing the socio-cultural calamity wrought in the name of apartheid.

The dual need for an "African" identity and political "relevance" found public expressions in the **State of Art in South Africa Conference**, held in Cape Town during July 1979.[24] The conference was itself subject to the effects of cultural struggle, being boycotted or ignored by many black cultural workers.[25]

At this historical moment the products of black artists and cultural workers were

effectively absent from the stage of the world of fine art. The art produced in the name of *Amadlozi* [26] and the Polly Street Art Centre [27] had constructed an *africanesque* aura which felt inauthentic. "Township art" [28] had already been trivialised, not least by the custodians of fine art culture. Other usable visual traditions - including what came to be called "transitional" - remained unnoticed in the rural areas or secreted away in ethnographic lockers.

A vision

The needs and visions of the beseiged white-dominated fine art world seemed to find clear expression in the statements of a major figure in that world. [29]

According to this account the pre-sixties "slavish" belief in the ideal of an "african" identity, mixed with a servitude to "European styles", resulted in superficiality. While "African Motifs" had been used by major artists [30] with some success *African symbols were mainly employed as visual devices functioning primarily as surface decoration for pictorial composition.* [Noteworthy here is not uncommon reduction of African culture to a simple resource of "motifs" and "symbols"].

A fallow period, of almost two decades, followed with local artists striving *tirelessly to absorb and emulate international art trends.* Absence of meaningful education in the arts, and *the world cultural boycott against this country* had lead to alienation and a crisis of credibility.

Then around *the mid-seventies art in South Africa began to change in a highly encouraging way. There was less reliance on European and American art styles. What in fact occurred was a focusing on local source material.*

Perceptions that local art was insular... inferior... shouldn't be tolerated any longer. A greater sense of freedom... a greater sense of confidence allowed artists to draw source material from the mythologies, icons and movements from past civilisations, as well as from the present.

[Past civilisations in the present?]

African Art, once seen as a mere curiosity by many artists is now of major importance, particularly for the student of art. Art of different and diverse cultures should be reprocessed and selectively used. Taking cognisance of the past can rekindle and regenerate ideas which, when filtered and distilled, are highly appropriate within the contemporary context.

Hence by *concentrating on our personal and immediate condition, with the knowledge of our largely untapped resources rooted in the past, South African artists are able to enter an innovatory phase unprecedented in this country.*

From this account we can gather that it was now quite legitimate for artists to root about in museums for source material, much as the museums themselves "rooted about" in "other" cultures not long ago.

An instance? *This university* [31] over the past years has *steadily built up a teaching collection of both African art and contemporary South African works.* This collection was then to become a resource. And it was here that the "transitional" first appeared. [32]

This might seem a benign if predictable story. Yet seen against the oppressive backdrop of pragmatic history certain phrases curdle. Whence this confidence to "use" the new-found resource? What does it mean to "reprocess and filter"? What of "the past in the present" being used to "rekindle" and "regenerate" ideas. [33] How does all this relate to the living members of supposedly "past cultures"?

A reawakening

The stage was now set for the entrance of the "transitional". Thus stimulated the fine art world duly announced a reawakening. [34] The advent of the National Art Competition and other major exhibitions became occasions for the ritual celebration of this rebirth. [35]

One commentary proclaiming the "reawakening" actually compared a VhaVenda exhibition [including sculpture by "transitional" Venda sculptors] with another exhibition of fine art wood sculpture. The writer observed that *the latter would have*

been enriched by the inspired Venda Sculptures, for it is inspiration of form and expression that these sculptures lack.[36]

The single, most dramatic coming out of the "transitional" was the 1985 BMW **Tributaries** exhibition.[37] Curator Ricky Burnett noted that *In compiling this exhibition we have not felt bound by the demands of anthropology. Our brief was to allow for images and items to come our way through a living traffic.*[38]

That "living traffic" delivered Noria Mabasa, Doctor Phutuma Seoka, the late Nelson Mukhuba, Jackson Hlungwane, Johannes Maswanganyi, others - named and anonymous -, assorted dolls, a windmill, satan... into the gallery and the public eye. The fine art world noticed.

The "Transitional" mobilised

The "transitional" concept is now part of the cultural lexicon,[39] though not without dissent. A number of directors of important cultural institutions have commented on the problem [40] and it has been the focus of some critical attention.[41]

Author of **Echoes of African Art** [1987] Matsemela Manaka argues that:

The use of this term is problematic in the sense that all artists are transitional because of the eclectic nature of art. We would not be in a position to talk about the stylistic development of artists if artists were not involved in some form of transition. If the term is applied to these sculptors, then it should be applied to all artists simply because art is always in motion. It is always in a state of transition.[42]

In **Art of the South African Townships** [1988] Gavin Younge comments: *When a few artists who lived in the rural areas first exhibited in Johannesburg in 1985, many believed that a new art form had been discovered. Quickly labelled "transitional", this work looked not only modern, but suitably African as well. In fact it was not new at all. It only appeared new in the context of an art market which insisted on its metropolitan primacy.*[43]

In **Images of Wood: Aspects of the History of Sculpture in 20th Century South**

Africa [1989], Elizabeth Rankin implicitly contextualises "transitional" material under the rubric "Efflorescence of Contemporary African Sculpture". She does not refer directly to the phenomenon but coins the interesting phrase "the Venda Renaissance".[44]

Marilyn Martin, current director of the South African National Gallery, attempted this definition: *"Transitional" art may be defined as one which results from new techniques and different economic and social conditions, the acknowledgement of the gap between the artist and the original spirit and/or function of the object, the adaptation answering to contemporary needs and aspirations.*[45]

When one asks "whose needs and aspirations?", the political questions begin.

Fine art culture and the "transitional"

Is not the "transitional" a construction fashioned to serve the economic and cultural interests of a constellation of high art institutions - the galleries, the public and private collectors, corporate patrons, the custodians of taste, the salon keepers?

If so, to be useful the "transitional" image and attendant rhetoric had to be distinguished from competing identities or "representations". Such phenomena might have been tagged differently in other places, at other times.

Other tags are available. Nettleton's catalogue entry above refers to tourist patronage. Graburn speaks of tourist art, airport art and souvenir culture in the same breath as the "transitional, art of acculturation".

Patronising labels such as "folk", "curio" - the quaint, the vernacular, the naive - speak of an art usually neither "expensive" nor "serious" enough for use in high culture. Under different circumstances fine art culture might have identified an ethno-kitsch aesthetic in the "transitional". But such an aesthetic would not be useful in enforcing relevance and identity within the dominant art world.

One point of view which expresses the need to distance objects from the above

argues that the work of Noria Mabasa, Nelson Mukhuba and Doctor Phutuma Seoka *cannot be equated with the producers of tin windmills and wire cars and bicycles.* But then this view is not consistent because *an artist like Billy Mukhubele elevates the "makorrakorra" wirecraft tradition to the state of art in some of his bird and animal figures.* [46]

The rhetoric of the "transitional"

What makes the "transitional" so appealing?

Certainly its vagueness is a value in itself. It calls forth "old" and "new" Africa, things naturally changing... It **authenticates** by pointing both backwards [Eden and essences] and forwards [historical present] simultaneously. The timeless ["theirs"] becomes historical ["ours"]. [47] It signals **development**: from margin [rural] to centre [cosmopolitan], from low [craft] to high [art], from simple ["natural"] to complex ["sophisticated"]...[48] It provides a form of **invisible mending**: rends in the cultural fabric wrought by any number of cultural catastrophes are magically made good. It innoculates: against charges of political indifference and cultural elitism, loss of identity, states of emergency. It provides fertile ground for growing **synthetic cultures**; of "identity", of "community", of cultural "wholeness". It provides the occasion for **"equal" exchanges**, easy give and take, "acculturation", "cross-pollination", "cross-fertilization"... It could be short-hand arm's length **identification** with the "oppressed". Consider these passages then with this rhetoric in mind; *The work, while owing allegiance to art historical references, is a synthesis of influences which are European and African, making for an art which could be considered a metaphor for South African art and its origins as well as for this exhibition. Artists like Andries Botha, Tommy Motswai and others project the time and place of South African art in distinguishing the influences which surround them. The fluidity created by the continual reassessment of stimuli and motivation of artists within South Africa have created an art which is challenging and in transition. It is therefore*

stimulating and identifiable as having the potential to present itself as a contemporary art from Africa and the product of a multi-cultural society rather than merely being experimentation with international models. [49] *and: [the artist's] drawings radiate a universality and maturity, which, on the surface, seem far removed from political or social tensions, or from immediate context. Yet his allusions to the history of South African Art [particularly Alexis Preller and Irma Stern] and the inclusion of patterned clay guinea fowl, indigenous beadwork and dolls in the most cerebral and mystical conceptions, point to a continued dialogue between tribal ritual and space-age techno-logy, between the "primitive" and "civilised". A ceramic vessel becomes a symbol of a society in transition, of the dissipation of tradition, of darkness in a land.*[50]

Two important notions in "transitional" rhetoric are "acculturation" and cultural "pluralism". These take on a particular political force in the South African context.

Acculturation

Certain writers mention "acculturated products" in relation to the work of Norman Catherine. [51] Another [52], uses the neologism "acculturisation". These are used interchangeably with a host of similarly passive terms describing "contact and exchange" - "cross-cultural interaction", "dialogue", "assimilation", "cross-fertilization".

A sculpture by Andries Botha calls forth this: here *the potential of "transitional" materials is fully and magically revealed.* Like Norman Catherine *he makes the assimilation seem unforced, unselfconscious, almost inevitable.*[53]

A major commission of inquiry into the arts, the Schutte Commission [1981-85] [54] also sought to [re]- present cultural relations in similiar ways. In an address at the State sponsored Arts Conference of 29 April, 1988, a speaker noted: *We all agree that there are unlimited prospects for creative interaction through the arts; the Schutte Report states emphatically that "spontaneous and natural cross-pollination between cultures and their art must remain unrestricted".* And much has

happened in this regard both in the so-called mainstream and alternative art forms. The meaning and applicability of words like "enculturation", "acculturation", "transitional" and "symbiotic" are being reconsidered and debated - mutual acceptance, appreciation and exploration of diverse cultural manifestations and democratisations are everywhere evident. And from the breaking down of barriers a distinctively South African vocabulary is emerging. [55]

Finally those attending the **Volkskas Atelier Awards** [Pretoria 1987] heard these words: To borrow from an other culture is naturally universal and is a process which takes place all the time.[56] European and American influences are readily absorbed and patterns of artistic direction followed by artists worldwide. In our own country the absorption of influences and experiences of Africa are far from new and neither is the exportation of this influence. The exhibition **Primitivism in 20th Century Art: Affinity of the Tribal and the Modern** held at the Museum of Modern Art [N.Y.] in 1984, well illustrated the absorption of other influences into the mainstream of 20th century art and the lasting effect this had. [57]

All this foregrounds the problematic of relations between the West and "other cultures".[58]

As far as the "transitional" goes there is little critique - either in the rhetoric or the work which uses it. To raise questions about rights, to query cultural exchanges is not to institute a new tabu. Yet if "use" is not to be mere appropriation - in discourse and in pictures - it should also in some way register critical rupture.

Noteworthy is one writer's insistence that in Andries Botha's work the concept of style no longer applies: one cannot label the sculpture as Post- or Late-Modern or Trans-avant-garde anything.[59] This seems in part an attempt to distance the work from the strategies of appropriation endemic to post-modernism.[60]

The notion of "acculturation" does not sufficiently register the tension characteristic of cultural "contact and exchange" in South Africa. Matsemela Manaka, like Steve Biko before him,[61] suggests that the term "acculturation" is misleading. It misrepresents the people's experience of cultural contact under colonisation. The notion fails to register the force involved in that contact. It minimises, or even ignores, the subject communities' resistance to genocide, racism and oppression. It emphasises the subjected communities' "adjustment" to the dominant culture - which in South Africa is a minority culture.

In the light of this it is difficult simply to accept statements such as "transitional art [is] contemporary artworks bridging a cultural gap." [62] Perhaps not expectedly this was said by an artist whose work is uncritically pluralist and paradigmatic of the problems of cultural "contact and exchange".

Pluralism - Unity in Diversity, Own Affairs, General Affairs...
Nettleton addresses the problem of pluralism by arguing [after Graburn] that ethnic arts can be used by dominant cultures in their exploitation of subject groups. Paradoxically, instead of appropriating such ethnic arts to the enhancement of an image of a united cultural heritage, in South Africa the ethnic images have been used to maintain separate ethnicities.[63]

Pluralism and the quest for a national cultural identity.
Pluralism is a peculiar manifestation in South Africa. The image of pluralism is often dragged into what is, in reality, a non-plural present, thereby obscuring that reality. Pluralism is also part of the vocabulary of State Power.

A telling example of this is the controversial **Republic Art Festival** of 1981.[64] The festival motto was **Unity in Diversity**. A report from the State's Department of National Education notes:[65] The presentation of countrywide Republic Festivals during May...was the most important cultural events in which the Department was involved this year. The Festival Director and other officers of the Department who undertook the organisational work in this regard played a leading role in making all the country's inhabitants thoroughly aware of the theme Unity in Diversity.[66]

The 1983 Constitution adopted a contradictory position on culture. Pluralism should see culture as a "general" affair. In the "new dispensation" it is an "own" affair. [67] The State however does need to present an image of cultural pluralism to the outside world [all the better to mask its segregationist policies within]. Hence State subsidised "international" exhibitions [68] include as diverse a representation of artworks as they can tolerate [69] and any political charge is tamed.

Recent official statements suggest that the ideology of pluralism - and the need to mediate the State/culture relationship - is still being promoted. [70]

Exporting pluralism and the "transitional"
The more benign image of "contact and exchange" is meant for local and international consumption.

While State-sponsored internationalism has been cut back by the Selective Cultural Boycott [71] the State has, with the help of important art world figures, been instrumental in sending a number of South African art exhibitions to the Valparaiso Biennial in Chile. Noteworthy here was the conspicuous "transitional" presence in the 1987 contribution. [72]

In this context the BMW **Tributaries** exhibition, which travelled to Europe,[73] also raised difficult questions. It was in some respects a courageous affair. Yet, perhaps, because of structural / institutional factors and the needs of fine art culture - a pluralist cultural melange [74] was, as autonomous "art", effectively detached from pragmatic history. Perhaps it is in the nature of such exhibitons that they become displays of culture " cut and dried". [75]

What is at risk?
If it is premature, however visionary it may be, pluralism threatens to mask the forces of domination. Furthermore, appeals to "indestructability of the human imagination, the

human spirit, to celebrate its manifold creations" [76] can hide the real material conditions in which imagination seeks to stay alive.

Such beliefs perhaps console the powerful more than the dispossessed.

Questions of "difference" are complex. On the one hand it seems consistent with the politics of domination, and colonial imperialism, to incorporate, "others" - to efface "difference" - in one realm [our common humanity?] only to reconstitute it elsewhere.

Erasing cultural difference is not unlike trying to erase class or gender difference. Who authorises the erasure? In whose name is it being made? The question of pluralism dogs post-modern debates. [77] For Hal Foster pluralism effaces history in its granting of all kinds of equivalence: ...art of many sorts is made to seem more or less equal... Art becomes an arena not of dialectical dialogue, but of vested interests, of licensed sects: in lieu of culture we have cults... that leads, in art and in politics, to a new conformity: pluralism as an institution. Posed as freedom to choose, the pluralist position plays right into the ideology of the "free market"; it also conceives of art as natural, when both art and freedom consist entirely of conventions. To disregard this conventionality is dangerous: art seen as natural will also be seen as free of "unnatural" constraints [history and politics in particular], in which case it will become truly autonomous -i.e. merely irrelevant... such innocence in the face of history implies a serious misconstrual of art and society. [78]

Other Questions

To call into question the routines of [Western] culture's "use" of "other" cultures is to raise the buried but not dead [repressed] questions of colonial history. These pose a special problem for many South Africans.

In the story of the "transitional", queries concerning cultural power and rights were never voiced. Whence the right to "lift" and use material from currently disenfranchised cultures? In terms of picture-making many [but not all] local artists' use of "African" material follows a dynamic not unlike Picasso's and an entire generation of European artists' use of the material culture of Africa and Oceania.

Dislocated, this material was considered a formal resource, a sign of the animated, the "primitive", the exotic and much else. Seldom was it seen as a collection of fragments torn from "other cultures" during the hey-day of colonial adventurism.

Hal Foster comments thus on the controversial **Primitivism in 20th Century Art** exhibition [MOMA, New York,..1984]: the recuperation of the primitive has its own history... from "formal quotations" [e.g. the appropriations of most fauves and cubists] to "synthetic metaphor" [the universal languages of several abstract expressionists] to "assimilated ideal" [the primitivism of most of the artists in the contemporary section] the primitive has become primitivist. [79]

The current political situation in South Africa gives these questions particular force. What elsewhere might be part of common wisdom is not so here.

Synthetic communities and synthesis

Quests for a national identity in the absence of enabling transformations in the socio-cultural base, seem strained and premature. Presumed cultural "synthesis" produces a synthetic african spirit more africanesque than african. Ricky Burnett noted this:

Artists and commentators alike often seduced by the notion of an authentic South African Art. This notion trivialises the awesome complexities of our situation. The cliché of "Africanness" and the romanticism of an "African Mystique" presuppose a solution where an investigation would be more appropriate. As programmes, such ideas tend to result in a hollow eclecticism or stylistic uniformity. [80]

However Burnett replaces this, and what he calls ideological prejudice, with fundamentally "apolitical" plurali n ["many worlds out there"] which is now a new form of orthodoxy.

Art can be visionary. That is its strength. But vision which denies history risks being mystification. The "transitional" provides a compelling emblem of "Africa" for a hegemonic but minority visual art world aspiring to an identity and scope it does not have. Its advent was opportune. All it required was that this world should hone its aquisitive strategies.

Almost wholly absorbed [or appropriated], the "transitional" wrought little in the way of structural or ideological adjustments in its institutional consumers. While it fattened and diversified institutional holdings and promised ideological replenishment, it did not require that the art world should address the cultural conditions in the urban or rural black communities.

Conclusion

The "transitional" marks the place where migrations of the [semi] rural workers and the cosmopolitan tourist intersect. It lies somewhere between the global and the local village. It is a crowded intersection. Perhaps for the art world the "transitional" is the "other" of "township art".

There often seems something forced, even desperate, about the way the South African art world latches onto the cultural expressions [recognisable to it] [81] of black communities. What returns beyond the economic empowerment of the few? Seldom are the complex questions of creative rights, creative possibilities, in the face of deprivation and exploitation, addressed with the same zeal as is the collecting of the art.

Apparently much of this material needs to be fumigated before it is allowed to travel. Does this also mean that it has to be fumigated ideologically? Is the result of such exhibitions really a sanitised pluralist vision? Does the "transitional" in fact express that tragic "need to co-opt difference into one's own dream of order, in which one reigns supreme"? [82]

1 James Clifford 1988, The **Predicament of Culture: Twentieth Century Ethnography, Literature, and Art,** Cambridge Mass. Harvard University Press, 1988, pp. 16-17.

2 See Anitra Nettleton, "The Myth of the Transitional: Black Art and White Markets in South Africa" **South African Journal of Cultural and Art History** Vol.2 No.4 [October 1988]; pp. 301-310. Matsemela Manaka mentions Johannes Maswanganyi, Noria Mabasa, Doctor Phutuma Seoka and the late Nelson Mukhuba in the context of the "transitional"; Matsemela Manaka, **Echoes of African Art,** Johannesburg, Skotaville, 1987, p.12. Gavin Younge mentions Nelson Mukhuba, Doctor Phutuma Seoka, Johannes Maswanganyi in **Art of the South African Townships,** London Thames and Hudson 1988, p.34.

3 Marilyn Martin made a somewhat irritable intervention concerning who might be called "transitional". Her argument for the "mutuality" of the concept is in support of a broader ideological position on acculturation [see below]. The relevant passage reads *The more frequently the term "transitional" is used to describe the work of some contemporary South African artists, the more unsatisfactory it becomes. It implies that a transition from one thing to another is taking place, that two traditions are being linked. But until now the word has only been applied to black art. Irma Stern included a funerary figure from Bakota in a painting. Walter Battiss arranged a number of identical carved birds from Swaziland across a canvas. Marion Arnold and Karel Nel used traditional and "transitional" objects in their work; no one would dream of describing their work "transitional". Martin wishes to see the relation as bidirectional, and later speaks of cross-cultural interaction, citing Norman Catherine, Joachim Schoenfeldt, Barend de Wet and Andries Botha. Marilyn Martin,*

"Straddling the Gap Between Was and Is", **Weekly Mail,** June 19 - 25, 1987, p.21. In the opening speech of the **A A. Mutual Life Vita Art Awards,** Karin Skawran noted, *representative of an art in transition is the work of Helen Sebidi, Jackson Hlungwani, Nelson Mukhuba, Lucas Sithole and Joachim Schoenfeldt.* This exhibition was held at the Johannesburg Art Gallery, 28 April 1987. See Karin Skawran "Vita Art Now", **South African Arts Calendar,** Vol. 12, No. 2 [Autumn, 1987], pp. 5-6.

4 Risking oversimplification, these words by the late Bill Ainslie are representative of a particular perception of the dominant visual artworld which in some degree I share: *Like everything in South Africa, the art world is split into two constituencies, one rooted in the "white" and the other in the "black". The first has government funding through the art that is taught in schools, universities and technikons. It is served by infrastructures involving major galleries, the South African Association of Arts, and various large corporations that make possible exhibitions, competitions, bursaries and grants which although modest compared to what is available in other parts of the Western world, are extremely generous compared to what is available within the larger constituency that is rooted in the "black" community; but [art] is not taught in black schools, and there are less than half a dozen places where it can be studied at a higher level.* Leaflet, c.1986, from the Johannesburg Art Foundation, Johannesburg.

5 Namely the troubled eighties. A State of Emergency was declared in mid-1985, see **Government Gazette,** Vol 241 [21 July, 1985] No 9876. There have been many proscriptions on the "publication" of visual material. For instance see Proclamation No R.95, 1987: "Declaration of a State of Emergency", **Government Gazette,** Vol 264 [11 June 1987]. Of particular significance are the various categories with a bearing

on visual material; "gathering", "periodical", "publication", "public place", "publish" [p. 2]; "restricted gathering", "security action", "security force" [p.3], "subversive statement" [p. 4]; and "unrest" [p.5]. A visually subversive statement could be a tattoo, a T-shirt, an emblem on a coffee cup, a painting, a photograph ... a picture of any sort; a text of any sort - even non-text blank spaces - could be considered subversive. Even now prohibitions on publication containing any photograph, drawing or other depiction" of "unrest" and its consequences are in force; see Government Gazette Vol 296 [3 February 1990] No 12287, pp. 3-4.

6 Perhaps the most obvious sites of struggle occur on the level of material conditions - resources, presence and state of available traditions and so on. Adequate social analyses of the conditions in which art is produced in South Africa has yet to be made.

7 Anitra Nettleton, " ... In what degree ... [They] Are Possessed of Ornamental Taste: A History of the Writing of Black Art in South Africa", in **African Art in Southern Africa,** edited by Anitra Nettleton and David Hammond-Tooke, Johannesburg, Ad Donker, 1989, p. 22.

8 In such structuring, discourses may reproduce and enforce subjection along any number of social axes - race, class, gender and so on. I am not suggesting intentional conspiracy with the ill-intentioned agents of oppression. Structural power relations make agents of us - we are always "positioned" in relation to, and by, political forces. On appropriation and complicity, Griselda Pollock comments: *On the one hand, art history takes as its object of study a form of cultural production and ideology - art. On the other hand, the discipline itself is a component of cultural hegemony maintaining and reproducing dominative social relations through what it studies and teaches and what it omits or marginalises, and through how it defines what*

history is, what art is, and who and what the artist is. Griselda Pollock, "Women, Art and Ideology: Questions for Feminist Art Historians", **Visibly Female. Feminism and Art Today: An Anthology,** London, Camden Press, 1987, p. 205.

9 In a sense "appropriation" is inevitable in any cultural exchange involving a contextual shift. As the opening quotation suggests, such shifts, and the meanings they carry in their wake, are not necessarily malignant or unproductive. See James Clifford, *op cit.*

10 For example, struggles around notions of ethnicity, tribe, culture, race and so on ramify and sustain the "discourse of domination" in contemporary South Africa. These notions are constructs. While not necessarily false [that would presuppose some essentially "true" or "natural" version] constructs exist by force of ideology. As such they are mutable, subject to the historical process in all its complexity. See the various discussions of notions of "tribe", "tradition", "culture", "race", and so on in **South African Keywords: The Uses and Abuses of Political Concepts,** edited by Emile Boonzaaier and John Sharp, [Cape Town, David Philip]. For the concept "discourse of domination", see p 6. To enter the terrain of terminology in South Africa is to enter a nightmare. What seems mere semantic nuance to others is of deep political significance to many South Africans. Certain words - "multicultural", "multiracial" may seem unproblematic elsewhere, whereas in South Africa they are deeply marked, not least by their privileged place within the language of State power. Questions of "representation" are complex; who authorises a given representation? Who does it speak for, who does it address? What system of interests and accountability motivates, articulates and disseminates a given representation, especially when made in the name of "others"? Whose language mediates - "represents" - a given cultural practice or phenomenon? Is it rea-

sonable to speak of mandate and sanction when speaking of the "representation" and exhibition of culture?

11 Nelson Graburn, "The Eskimos and Commercial Art", in **The Sociology of Art and Literature: A Reader,** edited by Milton C. Albrecht, James H. Barnett and Mason Griff, New York, Praeger, 1970, p. 340.

12 Nelson Graburn ed, **Ethnic and Tourist Arts; Cultural Expressions from the Fourth World,** Los Angeles, University of California Press, 1976, p. 5. The field is now a little more complex. The people of the so-called Fourth World are, according to Graburn: *all aboriginal or native peoples whose lands fall within the national boundaries and techno-bureaucratic administrations of the First, Second and Third Worlds.* p. 1.

13 Under "Popular Arts", Graburn writes: *The assimilation of previously colonised peoples to the arts and traditions of the dominant European powers can also take another turn. An artistic elite has arisen whose arts often take the forms of European traditions, but in content express feelings totally different [from "ethnic and tourist arts"], feelings appropriate to the new cultures that are emerging as the leaders of the Third World. Thus there are painters and poets in Mozambique, such as Malangatana ... who express in European terms African feelings about art and life, and in the former Belgian Congo, now Zaire, there is a genre called "arts populaire" ... that records for the modern Africans their feelings about their ancestral tribal past, their domination by harsh Belgian colonists, and their present developing and urbanising country. Such phenomena are not properly the subject of this book, for these people are moving from being powerless Fourth World minorities to being powerful leaders ... in their own Third World Countries.* p.8.
For further information concerning "arts populaire" in Zaire see Guy Brett, **Through Our Own Eyes:**

Popular Art and Modern History, London, GMP, 1986.

14 Graburn [1976]: *There are an increasing number of instances where conquered minority artists have taken up the established art forms of the conquerors, following and competing with the artists of the dominant society. These are characteristic of extreme cultural domination and hence the desire to assimilate.* p.7.

15 Of course this relates to the problematic of defining groups - the "black community" is a construct admitting [according to a purpose which, itself, must be examined] a good deal of differentiation. For a critical discussion of "community" and the "different" worlds model in a South African context, see: Robert Thornton and Mamphela Ramphela, "The Quest for Community", and John Sharp, "Two Worlds in One Country: First World and Third World in South Africa". In **South African Keywords: The Uses and Abuses of Political Concepts** edited by Emile Boonzaaier and John Sharp, Cape Town, David Philip, 1988.

16 Julius E. Lips: **The Savage Hits Back or The White Man Through Native Eyes,** London, Lovat Dickson, 1937.

17 *Ibid,* pp. 133, 158, 232.

18 *Ibid,* p. 133

19 Anitra Nettleton [1988], *op cit,* pp. 303, 310, note 18. See also Elizabeth Rankin, catalogue [1989], **Images of Wood: Aspects of the History of Sculpture in 20th Century South Africa,** Johannesburg, Johannesburg Art Gallery, p. 11. Illustrations of some early artefacts are included in this catalogue, see *inter alia,* figs p. 78; fig 18, p. 81; figs p. 85.

20 Housed at the University of the Witwatersrand Art Galleries.

21 The curator was Diana Newman. This exhibition was held at the University's Gertrude Posel

Gallery from 7 May to 27 June, 1980.

22 This exhibition involved the Foundation, the University Art Galleries Collection of African Art [est 1978] with selected works from the University Ethnological Museum Collection. It took place between 8 April and 15 May 1986, again at the Gertrude Posel Gallery.

23 The full **Transitional** Art entry reads: *The increase in migratory labour, changing labour patterns and the introduction of Western-style schooling in the rural areas of South Africa have caused tremendous change in the living patterns and cultural expression of both urban and rural dwellers in the black population. Responding to these changes artists working in both the rural and urban contexts have drawn on their historical traditions to adapt to a new patron-client relationship and to produce a "new" art for sale to a Western market. Some artists relied for years on "tourist" patrons and the church or other charity organisations for the sale of their work and it is only recently that Western-style commercial galleries have become involved in this area. It is often the combination of traditional elements such as the medium and style, with a modern subject, that gives these works their almost "quaint" quality.*

24 See especially Andrew Verster, "Is There A South African Art or Is It Still to Happen?", pp. 21-31 ... *we are a much more fragmented society than ever before, and the dream that some people once had, and which some still have, that somehow the bits and pieces will one day fuse together in a united whole, has all but vanished,* p. 21. See also Joyce Ozynski, "South African Painting and its Quest for an Identity", pp. 31-35. A paper suggestively titled "Transitions" by Pancho Guedes, was unfortunately not included in the published proceedings. For a brief, general overview of this period, including the conference, see Esmé Berman, **Art and Artists of South Africa**, Cape Town, A.A. Balkema, 1983,

pp. 23-26.

25 They seemed as indifferent to white cultural events as these had hitherto probably been to their needs. See Steven Sack's comments [catalogue] [1988], **the Neglected Tradition: Towards a New History of South African Art [1930 - 1988]**, p. 24. Sue Williamson's comments in her **Resistance Art in South Africa**, Cape Town, London; David Philip, Catholic Institute for International Relations, 1989, p. 9.

26 See Esmé Berman, *op cit*, pp. 31-33.

27 See Esmé Berman, *op cit*, pp. 338-339. See also, David Koloane, "The Polly Street Art Scene", in **African Art in Southern Africa: From Tradition to Township**, *op cit*, edited by Anitra Nettleton and David Hammond-Tooke, *op cit*, pp. 211-229; and Steven Sack, *op cit*, pp. 15-19.

28 Nicholaas Vergunst, in a paper "Cultural Debate on Township Art" cites a comment by art writer Frieda Harmsen, writing for the Department of Information in 1972, which is instructive:
An interesting art form has emerged from the Bantu Townships. Previously the South African Bantu have not expressed themselves through the medium of the visual arts to any great extent. The Zulus made beadwork. The Ndebele painted their huts. The rest of Bantu art was tourist art of little value. **South African Arts Calendar**, Vol 15, No 1, 1990, pp. 9-11. See also Gavin Younge, *op cit*, pp. 15-19; Frances Verstraete [1989], "Township Art: Context, Form and Meaning", pp. 152-171 in **African Art in Southern Africa... op cit**.

29 Excerpts from Professor Alan Crump's inaugural lecture as head of the Department of Fine Arts, University of the Witwatersrand, **Rand Daily Mail**, Friday, 14 October 1981.

30 Maurice Van Essche [1906-

1977], Alexis Preller [1911-1975], Cecil Skotnes [1926-] and Walter Battiss [1906-1982].

31 The University of the Witwatersrand, Johannesburg.

32 See notes 21 and 22 above.

33 It is a commonplace in the art world to hear that historical crisis and even tragedy have become an aesthetic resource: *A country which moves from one crisis to another in its historical development has the seeds of rich creativity. Art can, and often has, flourished in periods of painful social change and political upheaval.* This may be true, but in South Africa this seems both insensitive and self-serving. One finds this extending to particularly traumatic subject matter: for instance the use of a burning tyre as a symbol - sensational and aesthetic. The problem of aestheticising politics is seldom raised.

34 This area has not been well documented and publicly discussed. See Terry King, "The Competition for History"; Proceedings of the Third Conference of the South African Association of Art Historians, **Re-Writing the Art and Architectural History of Southern Africa**, held at Stellenbosch University, 10 - 12 September 1987, pp. 49-68. Some "national exhibitions": **The Cape Town Triennial** [b 1982, the Rembrandt Van Rijn Foundation]; **The Volkskas Atelier Award** [b 1986, annually, Volkskas Bank and The South African Association of Arts]; the **Standard Bank Young Artist Award** [b 1984, annually, The Standard Bank], **The Standard Bank Drawing Competition** [b 1987, every three years, The Standard Bank and The 1820 Foundation]; **The Vita Art Now Competition** [not national, only Johannesburg b 1987, annually, A.A. Mutual Life].

35 An entry entitled "Harvest of Diversity" in the catalogue for the 1985 Triennial exhibition, boasts that *the show will become a testi-*

mony to a new creative surge in the visual arts in South Africa ... Alan Crump, "Harvest of Diversity"; catalogue **Cape Town Triennial 1985**. A piece written on the Standard Bank National Drawing Competition two years later was headed "A stimulating re-awakening in the Visual Arts", Marilyn Martin, **Weekly Mail** [17 - 23 July, 1987], p. 21.

36 Marilyn Martin, *Ibid*, p. 21. There is a tendency to conflate the "transitional" and Venda sculptors. Not all of the "transitional" artists in this show were Venda speaking. This raises questions again of homogenising a group in conflict with marked differences, in this case language. Though of course, in raising such questions we risk reproducing a State-sanctioned ethnic construct.

37 See Ivor Powell, "Bad Faith Makes Bad Art", **Weekly Mail** [10 - 16 January 1986], p. 19. Powell remarks on the *sudden realisation that there was an indigenous, independent and vital art in South Africa and that it had been flourishing for years, unheeded by and regardless of the machinations of the art world in general.*

38 Ricky Burnett, catalogue [1985], **Tributaries - a view of South African Art.**

39 For example, Rhoda Levinsohn's **Art and Craft of Southern Africa**, published in 1984, bears the subtitle "Treasures in Transition". Kenneth Grundy notes in the foreword: *The Fourth World consists of societies in transition, and since culture is bound up with a people's situation and environment, art and crafts are changing too, and rapidly Strickly speaking, I suppose, there is no such thing as traditional art. All art is transitional. Some may be more dynamic than others. After centuries of relative quiescence the Fourth World is being exposed to new forces and its cultural expressions are proving to be vulnerable.* Rhoda Levinson, **Art and Craft of Southern Africa. Treasures in Transition**, Craighall,

Delta Books, 1984, p. 11. This text seems to be an example of what James Clifford calls "the salvage paradigm", which rests on particular notions of authenticity and history. This paradigm is suggestive in accounting for some of the allure of the "transitional".
Clifford speaks of the salvage paradigm as *reflecting a desire to rescue "authenticity" out of destructive historical change ... It is found not only in ethnographic writing but also in the connoisseur-ships and collections of the art world and in a range of familiar nostalgias.* James Clifford, "Of Other Peoples: Beyond the Salvage Paradigm", in **Discussions in Contemporary Culture**, DIA Art Foundation, Number One, edited by Hal Foster, Seattle, Bay Press, 1987, p.121.

40 Jill Addleson, Director of Durban Art Museum, mentions [but does not engage with] the "transitional" in the context of a whole gamut of classificatory problems: *Storms of controversy currently rage round nomenclature: should such lively objects be referred to as "art" or "craft"? Should a distinction be drawn between "urban" crafts and "rural" crafts? Is the term "transitional art" a sufficiently adequate description of contemporary Zulu art since all art may be seen in a state of continual transition? Finally, given the present highly emotional poitical climate, there is even debate about whether or not to use the name "Zulu" as descriptive of the very artists who created all these spirited works of art. In order to side-step such academic wrangling, I believe that the term "Zulu Art" conveniently embraces all manner of artistic expression and every nicety of description.* Preface, catalogue **The Zulu Vision in Art**. This exhibition took place at the Standard Bank National Arts Festival in Grahamstown [1-9 July, 1988]. These are not simply "academic wranglings" but deeply political issues. Director of the Pretoria Art Museum, Albert Werth, contributes a piece entitled "Looking at 'Non-Western' Art in

Africa", in which he engages in polemic about the "transitional" and acculturation; **Bulletin**, Vol. 22, No 1, January, 1988, pp. 17-23.

41 See for example, **The Neglected Tradition**, *op cit*. This exhibition, curated by Stephen Sack, was held at the Johannesburg Art Gallery from 23 November, 1988 until 8 January, 1989, pp.27-29. Catalogue, **Ten Years of Collecting** [1979-1989], edited by David Hammond-Tooke and Anitra Nettleton. This exhibition took place for 3-26th May, 1989, at the Gertrude Posel Gallery and Studio Gallery, Senate House, University of the Witwatersrand, Johannesburg, pp.45-52. "Transitional Sculpture" by Elizabeth Dell. See also: Anitra Nettleton [1988], "The Myth of the Transitional" *op cit*; Ivor Powell [1986], "Bad Faith makes Bad Art," *op cit*; Marilyn Martin, Straddling the Gap between Was and Is, **Weekly Mail**, June 19-25, 1987; Colin Richards, "That Authentic African Look Fades into Glib Cliché", **Weekly Mail**, August 28 - September 3; Hazel Friedman, "Failing to Blur the Boundaries", **Business Day**, 16 November, 1987.

42 Matsemela Manaka, **Echoes of African Art**, Johannesburg, Skotaville, 1987, p.12.

43 He observes that *One would have to be extremely cynical to hold the artists responsible for the fact that the art market had quickly moderated its practical concerns about the presence of wood-borer and had opened its vaults to this work.* Gavin Younge *op cit*, p.34. In spite of its title this book discusses much work which comes from rural rather than township areas.

44 Elizabeth Rankin, **Images of Wood...**op cit, pp..44-47. Rankin's note 159 refers to Nettleton's "The Myth of the Transitional: Black Art and White Markets". **Images of wood** was an exhibition organised by the Johannesburg Art Gallery in association wit the Hans Merensky Foundation. Professor Rankin

curated the show.

45 Marilyn Martin, 1987, "Straddling the Gap..."*op cit*, p.21.

46 *Ibid*, p.21. Martin's earlier words echo those of Anitra Nettleton, where the latter suggests it "implies something that is passing from one state to another, and thus denies the objects which it describes any real identity of their own" Anitra Nettleton [1988], *op cit*, p.302. The questions of value that underpin such issues are admittedly complex. Perhaps one thing we can be sure of is that aesthetic and social criteria are at the centre of this complexity. What is mere "craft"? What elevates it to "arthood"? Ndebele beadwork is a case in point. In 1985 [16 May to 30 June] the South African National Gallery hosted an exhibition **Women Artists in South Africa**. The cover image of the catalogue shows three photographs of individual women artists in working contexts. Two are identifiable in the manner of the discourse, as named artists - Jo Smail and Katrine Harries. In the centre, the third, an Ndebele woman in "traditional" regalia seated in front of a decorated wall, shall remain nameless. Or rather she is named "Ndebele Woman". The construction of artists remains incomplete. The entry referring to eight items on display is headed "Ndebele Women". The "works" are titled descriptively, with a short description of customary function [e.g: *Isiphephetu*. Unmarried girl's apron], and medium. In an article in the catalogue, a form of institutional theory of art seems to have conferred art status on this material: *There is ...a growing recognition of Ndebele beadwork as "art". This is attested by its being exhibited in art galleries, sold by art dealers and brought by collectors both locally and abroad. Once labelled as "art" by the connoisseurs, this categorisation is reinforced and perpetuated, resulting in a more general de facto acceptance that Ndebele beadwork is indeed "art". Furthermore in the process it has become a saleable commodity, a fact which clearly indicates that it*

has undergone a transformation from one cultural context to another*, Patricia Davison [1985], "Art Unframed: Aesthetic Expression Among Black Women," pp. 18-20.

47 Or from the "primitive" to the "civilised". Nettleton observes that *In a sense, the term "transitional" is merely a thinly disguised substitute for the term "primitive", except that, instead of implying something that stands at the beginning of a development, such as palaeolithic art, it implies something that is passing from one state into another, and thus denies the object any real identity of its own*. She also notes, *in adhering to the notion of the "transitional", we are adhering to a notion of development which itself carried the connotations of a movement from less to more sophisticated, from non-art to art, or more accurately, from unconscious to conscious art. Also adherence to this idea bestowed on the objects classified as "transitional" a value and legitimacy that inhered in their supposed traditional base..."* Anitra Nettleton [1988], *op cit*, p. 302. The "developmental" connotation becomes "evolutionary" inevitably in the following account. In its shadow come all the senses of "progress" - from lower to higher, simple to sophisticated, and so on - so characteristic of colonial discourse. Given the evolutionary tinge of many Western art historical narratives - "the story of art" - gliding from one inevitability to the next, the following comment is not as bizarre as it might first appear; "transition" fits the gap: *Traditional art and the cultural heritage of the Black people have largely been overlooked in art historical research. **The missing link** between traditional and contemporary art of the Black people has not been established and placed within the perspective of general art historical research.* Ute Scholz ed. **Phafa Nyika: Contemporary Black Art In South Africa with Special Reference to the Transvaal**, Pretoria, University of Pretoria, 1980, p.3. This particular art histor-

ical publication is shot through with many questionable assumptions about the "art of the black man".

48 Raymund van Niekerk's mention of "western virtuosity" being tempered by "acculturated products," [Catalogue for **Norman Catherine 1986/87: Recent Paintings, Sculpture and Assemblages**, Goodman Gallery, Johannesburg] suggests an opposition common in perceptions of "otherness": natural simplicity as against sophisticated virtuosity. This language is very common in talk around the "transitional". Referring to an international exhibition of work by Norman Catherine and Doctor Phutuma Seoka [At the Goodman Gallery, Johannesburg, May 1987.] Marilyn Martin echoed opposition in saying that the combination "was a significant and telling one, reflecting an extraordinary congruence between rural instinct and Western virtuosity." Steven Sack suggests that "rural culture was essentially tied to nature [while] people living in the slumyards, ghettoes and townships of the urban areas were exposed to cosmopolitan culture..." in "The Pioneers", in his catalogue **The Neglected Tradition**, *op cit*, p. 9. The association with the "transitional" and the natural may account for its allure, it fits certain western preconceptions of "otherness" more readily than township culture.

49 Christopher Till, Speech for the **Volkskas Atelier Awards**, given on 18 May, 1987, at the South African Association of Arts Gallery in Pretoria.

50 Marilyn Martin, catalogue [1986], **Vita Art Now** exhibition, held at the Johannesburg Art Gallery, 29 April-31 May 1986.

51 Raymund van Niekerk, former director of the South African National Gallery, in **Norman Catherine 1986/87**, *op cit*: "This painter has deliberately taken into his work the acculturated art products of his black fellow country-

men- they temper his own virtuousity...".

52 Marilyn Martin "Straddling the Gap..." *op cit*, p.21.

53 The sculpture titled **Dwase Drome van Boesmans en Ministers**. The writer argues that *here the potential of "transitional" materials is fully and magically revealed. Botha is completely at home with the materials and process of his black compatriots, but he has interpreted according to his own terms and vision. Like... Catherine, he makes the assimilation seem unforced, unselfconsciounes, almost inevitable.* Marilyn Martin, *Ibid*.

54 The report of the Commission, named after chairman Dr Jan Schutte, was published in February 1985. Its terms of reference were broadly... *to enquire into and report on the the promotion among all population groups of the creative arts in the field of literary arts, music and plastic arts, and financial aid to creative artists...* See Albert Werth, "The Report of the Commission of Inquiry into the promotion of the Creative Arts," **South African Arts Calendar**, Vol 10, No.1. June 1985; pp. 7-10.

55 Marilyn Martin "Report", in The Department of National Education's published proceedings of **Arts Conference of 24 April, 1988**. Speeches and Discussions [Pretoria, The Government Printer]; p.24. This celebrated exchange has its limits, and seems not to embrace anything like what Ms Martin terms "people's culture". See Colin Richards and Ivor Powell, "Storm over Springbok Artists", **Weekly Mail** October 6 to October 12, 1989, pp. 27-28.

56 My own translation: *Om van 'n ander kultuur te leen is natuurlik universeel en 'n proses wat gedurig plaasvind.*

57 Christopher Till, 1987 Speech for the **Volkskas Atelier Awards**, given on 18 May, 1987 at the South African Association of Arts Gallery

in Pretoria.

58 Perhaps not unsurprisingly, Mr Till failed to acknowledge the controversy this exhibition aroused. The issues raised in the aftermath of that exhibition are pertinent here. See James Clifford, "Histories of Tribal and the Modern" in his **The Predicament of Cultural Politics: Twentieth-Century Ethnography, Literature and Art**, Cambridge Mass., Harvard University Press, 1988, pp.189-214; Hal Foster, "The 'Primitive' Unconscious of Modern Art or White Skin Black Masks" in **Recodings - Art, Spectacle, Cultural Politics**, Port Townsend, Bay Press; Thomas McEvilley, "Doctor Lawyer Indian Chief: 'Primitivism' in 20th Century Art", **Artforum**, Vol 23, No.3, November 1984, pp.54-61; Yves-Alain Bois "La Pensée Sauvage", **Art in America**, Vol.73, No.4, April 1985, pp.178-188. See also chapter 6, "Identity Culture and Power" in Sandy Nairne's **The State of the Art: Ideas and Images in the 1980s**, London, Chatto and Windus/Channel Four Television, pp. 205-246; this also raises many issues relevant to this discussion.

59 Marilyn Martin, "Straddling the Gap...", *op cit*, p.21.

60 A great deal has been written on post-modern strategies of appropriation - pastiche, parody, quotation... These are double edged. Douglas Crimp, in a piece aptly titled "Appropriating Appropriation" for an exhibition even more aptly titled **The Image Scavengers**, notes ... *appropriation, pastiche, quotation - these methods can now be seen to extend to virtually every aspect of our culture, from the most cynically calculated products of fashion and entertainment industries to the most committed critical activities of artists, from the most clearly retrograde works... to the most seemingly progressive practices...* In **Theories of Contemporary Art** edited by Richard Hertz, London, Prentice Hall, 1985, pp.157-162. Of course the relevance of post-mod-

ern cultural debates for South Africa is in itself a question. Victor Burgin asserts that *the post-modern is a "first world" problematic - thus for example, the moral certainty and the political necessity that the black South Africans should democratically participate in the government of their own society, will not be swept away by any amount of fashionable gush about post-modernism...* Victor Burgin, "The End of Art Theory" in his **The End of Art Theory: Criticism and Postmodernity**, London, Macmillan, 1986, p. 198. While discrimination is called for many of the internal critiques developed in post-modernist discourse can prove useful here. In my view most of the work "appropriating" the "transitional" image is resolutely uncritical pluralism.

61 Matsemela Manaka: *I interpret acculturation to be the voluntary fusion of two cultures without any force or any form of domination determining the fusion. Any cultural fusion determined by domination leads merely to an imposition of foreign cultural values which amounts to cultural imperialism; op cit*, p.11.
Steve Biko: *Since that unfortunate date - 1652 - we have been experiencing a process of acculturation. It is perhaps presumptuous to call it "acculturation" because this term implies a fusion of different cultures. In our case this fusion has been extremely one-sided.* From "Some African Cultural Concepts" in **I Write What I Like**, London, The Bowerdean Press, 1978, pp. 40-41. See Steve Talbot: "The Meaning of Wounded Knee, 1973", in **The Politics of Anthropology** edited by Gerrit Huizer and Bruce Mannheim, the Hague, Mouton, 1979, pp. 232-233.

62 Elizabeth Dell [1989], quoting Karel Nel in "Transitional Sculpture", in catalogue **Ten Years of collecting**, p.51 and note 25.

63 Nettleton, October, 1988, *op cit*, p.309.

64 See *inter alia*; G. Muller Ballot,

"Nuus en Kommentaari; Eerste NUK-Vergadering van die Jaar". **South African Arts Calendar** Vol.6, No 3 and 4, April/May 1981, p.2.; G. Muller Ballot, Supplement "Crisis in South African Visual Arts: Top Level Reaction", **South African Arts Calendar** Vol. 6, No 3 and 4, April/May 1981; Andrew Verster "Art and Society Conference Organised by the NSA", **South African Arts Calendar** Vol 6, No 9 and 10, October and November, 1981. This journal is the official publication of the South African Association of the Arts, which in many ways has been the primary agent mediating the State/culture relationship in South africa.

65 Until the so-called new dispensation [1983] the Department's National Cultural Council concerned itself with the "preservation, promotion and advancement of the culture of the Whites in the Republic of South Africa," **Department of National Education Annual Report**, 1981 [Pretoria, The Government Printer], p.42. The National Cultural Council was dissolved in 1983, in accordance with the **Cultural Promotion Act**, 1983 [Act 35 of 1983]. **Department of National Education Annual Report**, 1983 [Pretoria, The Government Printer], pp.6, 55. After the changed constitution the Department's brief was, and remains "to deal with matters regarding national education policy, sport and culture as general affairs". [**State Department of South Africa**, 1986, p.67]. The Directorate of Culture in the Department, is, significantly, "responsible for the promotion of educational and cultural ties with other countries, while with regard to general affairs it is also responsible for the preservation, development and advancement of culture in South Africa," **Department of National Education Annual Report**, 1986 [Pretoria, The Government Printer], p.46. The Department is also responsible for the appointment of Cultural Attachés, as part of its "external

culture campaign". **Department of National Education Annual Report**, 1983 [Pretoria, The Government Printer] p.7. Interesting in this context are the chief aims of the Department's foreign educational and cultural programme: *[a] promote awareness of South African Culture in all its facets abroad; [b] utilise every opportunity to cause cultural life within South Africa to be enriched from abroad: and [c] maintain and strengthen cultural ties of South Africans overseas with their native land.* The Directorate of **Culture in the Department acts in terms of the Culture Promotion Act** No.35 of 1983. This act empowers the Minister to, *inter alia* [as he may deem necessary or expedient] "arrange for exhibition of art, books and other objects of culture from the Republic abroad...: [ss 2.[1] [b] [iii]. See also ss 2.[3] [a,b] and ss 3. [5] [a.d].

66 **Department of National Education Annual Report** [1981] [Pretoria, The Government Printer], pp.41-42. Rodney Harber, National Vice-President of the South African Association of Arts, against the wishes of some of his constituency, supported this exhibition: *This national event is a rare opportunity and has been organised in the belief that it will further the course of art in our country - open as it is to all artists irrespective of their affiliations or views.* Rodney Harber, "Republic Festival Art Exhibition," **South African Arts Calendar**, Vol 6, No.3 and 4, April/May, 1981, pp.6-7.

67 **The Republic of South Africa Constitution Act**, 1983 [Act No. 11], states that *Art, culture and recreation [with the exception of competitive sport] which affect mainly the population group in question"* [schedule 1, note 3,p.70] *are designated Own Affairs* [part 1V, ss 14, notes 1 and 2, p.12]. This designation is subject to the provisions of ss. 16 p.14, namely, the discretion of the State President.

68 The South Africa partial to "internationalism" has been that of

the dominant culture. Many international exhibitions of "our art", administered by the South African Association of Arts, are rooted firmly in State policy. In 1978 the then National President of the South African Association of Arts, Justice J. F. Marais, congratulated Ms Jenny Basson "and her special division in the Department who continue to achieve in this field." J. F. Marais [1978], President's report, 1977, Presidentsverslag, South African Arts Calendar, Vol 3, No 8 September, 1978, p. 4. The department in question was the notorious Department of Information. In fact an earlier issue of the **South African Arts Calendar** [Vol 3, No 2, March 1978, p. 8] sported an image of the illustrious Eschel Rhoodie himself. He opened an exhibition from the then Rhodesia organised by his department. The Ms. Basson mentioned above, was heavily involved in organising overseas exhibitions, from the Saõ Paulo Biennale to child art in Paraguay. See *inter alia*; Jenny Basson [1978a], "Suid Afrikaanse Kuns Oorsee", **South African Arts Calendar**, Vol 3 No 1, [February], p. 10-11; Jenny Basson [1978b], "Wes-Duitsland Behou Kultuurverdrag met Suid-Afrika", **South African Arts Calendar**, Vol 3, No 2, [March] p. 3; Jenny Basson and Stefanie Potgieter [1978c], "Kinderkuns Behaael Sukses in die Buiteland", **South African Arts Calendar** Vol 3, No 4, [May], p. 3.

69 Tolerance was tested in 1981 [the year of the "successful" Republic Festival exhibition]. The South African entry to the Valparaiso Biennial, Chile, of that year was abandoned due to the political implications of some of the works submitted. Most conspicuous amongst these "protest works" were Paul Stopforth's contribution from his **Biko** series. According to Esmé Berman "the [Department of National Education] advised all [participating] artists that it *could not be expected to promote and finance officially the exhibiting of such work abroad* and was therefore

withdrawing South Africa's entry from the Bienal [sic]". Esmé Berman [1983], *op cit*, p.463.

70 See **Arts Conference of 29 April 1988: Speeches and Discussions**, published by the Directorate of Culture, Department of National Education [Pretoria, The Government Printer, NATED 05-002 [88/08]]. F. W. de Klerk [1989], "Address by the Minister of National Education, on the occasion of the establishment of the Foundation for the Creative Arts; Pretoria - 24 February 1989". **South African Arts Calendar**, vol 14, No 1, pp.4-5. See also Marilyn Martin's editorial in the same number.

71 See the publication issued by the convenors of the **Culture Against Apartheid** symposium held in Athens, 2-4 September, 1988, [United Nations, 1988] for background and other information.

72 See Kathy Berman, "The Rose and the Apple Fly Away", **Weekly Mail**, July 24 - 30, 1987, p. 21. Berman ends her piece thus: *Suddenly, whether intentional or not, a large part of the exhibition begins to hearken back to a former colonial era as the works land up harmoniously humming the exploitation and appropriation blues.* See also, Hazel Friedman and Colin Richards, "Portrait of the Artists Among the Generals", **Weekly Mail**, June 12 - 18, 1987, p. 23; and Colin Richards and Ivor Powell, *op cit*, pp.27-28.

73 From 30 April 1985 until 11 July 1986: **BMW Gallery**, Munich; City Hall, Steyr, Austria; **BMW** Dealer, Karlsruhe; **BMW** Regional Office, Darmstadt; **BMW** Regional Office, Saarbrucken; Sinclair House, Bad Homburg.

74 Burnett: *there are many different worlds out there and I am not sure that to simply exhibit work is quite enough.* Burnet chooses to use the trope of "alchemy": *The geographic, intellectual and political climates, the fauna and flora, our ideas and the way we live, all*

conspire through a complex alchemy, to profoundly influence the image produced in this country. Art images, both in their style and content, are mirrors of other forces. There can be no simple anticipation of an indeterminate future, and no one kind of answer to a complex living experience.

75 Burnett seemed sensitive to the difficulties the introduction of this material would present. In the catalogue, he writes: *This exhibition is not about traditional, aesthetic absolutes. It addresses itself to variety and it unashamedly acknowledges social and contextual references. To find some texture of truth, it is important to adopt a broad perspective - in South Africa this is not only highly desirable but it is also unavoidable. In a post-colonial third/first world conglomerate such as this, assumptions about the supremacy of the Western tradition and its value system are not appropriate. Neither are they entirely irrelevant. Yet however much catalogues include critique often this is contradicted by the actual exhibiting of works, where the conventions of fine art display hold sway. Given this, catalogues become marginal notes, to be invoked should the politics of display raise unruly questions. Critique is thus registered but not felt or seen; it is present but absent.*

76 Burnett's soft ideological sidestepping of the political dimension is characteristic of the liberal humanist tradition which holds sway amongst many art cognoscenti. He sets up twin poles of aesthetic prejudice and ideological prejudice and then takes the gap. In doing so he indulges in a metaphysical celebration of the imagination: *Those who allot to the power of the imagination a supreme position in the hierarchy of being, and those who insist on the freedom to pursue the imaginative life are vital elements in the crucible of change. Indeed, few are empowered to do this.*

77 The age of pluralism, argues Arthur Danto, is upon us: *It does*

not matter any longer what you do, which is what pluralism means. When one direction is as good as another direction, there is no concept of direction any longer to apply. Arthur Danto, "The End of Art", In his **The Disenfranchisement of Art**, New York, Columbia University Press, 1986, pp. 114-115.

78 Hal Foster "Against Pluralism", in **Recodings - Art, Spectacle, Cultural Politics**, Port Townsend, Bay Press, 1985, pp. 15-16.

79 Hal Foster "The 'Primitive' Unconscious of Modern Art, White Skins Black Masks", *Ibid*, pp. 191-192.

80 Catalogue [1985] **Tributaries: A View of South African Art** [BMW South Africa].

81 Much transitional material fits a category with a long tradition in western culture, namely free-standing wood sculpture. It was probably easily absorbed and authenticated because of this. Further it was made generally by identifiable individuals, not anonymous collectives. Being directed at the market gave it a commodity appeal which tended to minimise any but the most generalised sense of its origins.

82 Thomas McEvilly [1984] *op cit*, p. 59.

biographies

Michael Barry

Born 1954, Port Elizabeth, Eastern Cape; lives in Port Elizabeth

Schooled at Paterson, Eastern Cape. Worked at Ford Motor Company, Port Elizabeth [2 years]. Worked with SAFMARINE, in Cape Town [2 years]. Studied art at Michaelis, Cape Town University [4 years]. Worked as a Night Shelter supervisor, Cape Town. Worked as school teacher in Cape Town and now in Port Elizabeth. Participated in various group exhibitions in Cape Town. Belonged to the **Vakalisa** group. 1986 moved to Port Elizabeth, joined **Imvaba** Arts Association and participated in group exhibitions.

Deborah Bell

Born 1957, in Johannesburg; lives in Johannesburg

1983 University of the Witwatersrand Architecture Department.
1986 University of the Witwatersrand, completed M.A.F.A 1986 taught painting at Department of History and Fine Arts, University of South Africa, Pretoria; Cité Internationale des Arts, Paris
1988 taught at Centre for Continuing Education [Wits]
1989 taught painting at Witwatersrand Technikon.

Exhibitions
1982 Market Galley, Johannesburg [solo]
1983 Carriage House Gallery, Johannesburg
1984 Carriage House Gallery, Johannesburg
1985 MAFA exhibition, Rembrandt Gallery, Johannesburg
1988 **Hogarth in Johannesburg** exhibition and portfolio of etchings. Goodman Gallery, Johannesburg
1989 Solo show, Potchefstroom Museum. Also participated in numerous group shows in the following centres: Market Gallery, Johannesburg; South African Association of Arts, Pretoria; **Volkskas Atelier** Exhibition and in Washington [USA].

Awards
1986 Merit Prize-winner, **Volkskas Atelier Award**
1986 Spent two months at the Cité Internationale des Arts, Paris.

Publications
"Hogarth in Johannesburg", Witwatersrand University Press, Johannesburg, 1990 "Resistance Art in South Africa", Sue Williamson, David Philip, Cape Town and Johannesburg, 1989, Catholic Institute for International Relations, London, 1989

Collections
S.A. National Gallery, Cape Town; Johannesburg Art Gallery; Durban Art Gallery; University of South Africa, Pretoria; University of the Witwatersrand Collection, Johannesburg; University of Pietermaritzburg Collection; Tatham Art Gallery, Pietermaritzburg; Roodepoort Museum; Department of National Education; Sanlam Collection; Sasol Collection; Friends of the National Gallery.

John Berndt

Born 1950; lives in Cape Town

Studied five arts for BAFA degree. Started working in community programmes in 1976. Worked as a freelance designer / book illustrator for progressive organisations and trade unions and at present is co-ordinating a Media Training Course for them.

Willi Bester

Born 1956, Montague, Cape Town; lives in Mitchell's Plain, near Cape Town

Grew up in Montague, but was "removed" from there under the **Group Areas Act**. Had little formal training, painting old buildings in Montague. One year at the **Community Arts Projects**, Cape Town, under T. Gurgen. Bester uses material collected from the township streets to make collages and paints in oils and watercolours.

Exhibitions
1982 District Six, Cape Town
1989 Baxter Gallery, Cape Town
 Various group exhibitions in Stellenbosch and Schotse Kloof.

Andries Johannes Botha

Born 1952, Durban; lives in Durban

1970 graduated from the George Campbell Technical College
1971-6 studied sculpture at the University of Natal, Pietermaritzburg and awarded BA.[Fine Arts]
1978 obtained Higher Diploma in Education, and taught at Brentonwood High, Durban; became a lecturer at Technikon Natal, Durban
1983 established the Community Arts Workshop, Durban.

Exhibitions
1974 **Art South Africa Today**, Durban
1978 Shepstone Hall, University of Natal, Durban
1980 Group exhibition, Natal Society of Arts, Durban
1981 Group Exhibition, Neil Sack Gallery, Durban
1982 Group Exhibition, Natal Society of Arts Gallery, Durban The Market Gallery, Johannesburg
1983 Gertrude Posel Gallery, University of the Witwatersrand, Johannesburg
1984 Cafe Gallery, Durban
1985 Gallery International, Cape Town. **Cape Town Triennial**
1986 Natal Artists, Natal Society of Arts, Durban, Tatham Art Gallery, Pietermaritzburg **Volkskas National Exhibition**, Pretoria
1987 **Volkskas National Exhibition**, Pretoria Natal Society of Arts, Durban
1988 **Cape Town Triennial**.

Collections
Durban Art Museum; Johannesburg Art Gallery; Technikon Natal; Tatham Art Gallery, Pietermaritzburg.

David Brown

Born 1951, Johannesburg; lives in Cape Town

1968 Matriculated from Westford High School
1970 enrolled Michaelis Art School, Cape Town
1972 obtained Diploma in Graphic Design
1973 obtained Advanced Diploma in Fine Arts [Photography]
1973-82 worked for a year as a set painter for CAPAB, then taught at the Ruth Prowse Art Centre, Woodstock
1982 working full-time as an artist.

Exhibitions
1978, 80, 83, 85, 88 solo exhibitions, Goodman Gallery, Johannesburg
1979 Cape Town Biennial 1980 Group exhibition, Bloemfontein Museum
1982 **Sculpture in the Making Exhibition**, South African National Gallery, Cape Town
1985 **Artists from the Cape**, Rand Afrikaans University, Johannesburg
 Art 16 '85 Basel
 Tributaries
1987 **Vita Art Now**, Johannesburg Art Gallery
1988 **Sculpture in Wood**, National Gallery, Cape Town
1989 **Vita Art Now**, Johannesburg Art Gallery.

Awards
1985 Johannesburg Centenary Sculpture Competition, Johannesburg Art Gallery [one of four winners]
1986 **Vita Art Now**, Quarterly Award and Runner-up Award
1988 **Vita Art Now**, Quarterly Award and Annual Award Winner.

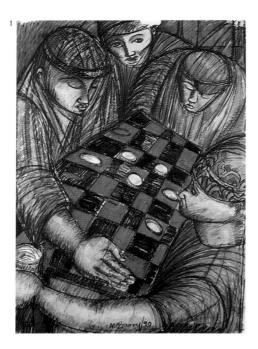

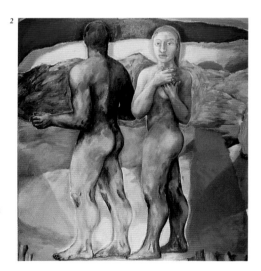

All dimensions in centimetres

1. Michael Barry
Chess Players, 1990
pastel on paper
84 x 60

2. Deborah Bell
World's Body, 1989
oil on canvas
180 x 160.5

3. Andries Johannes Botha
Genesis, Genesis Jesus..., 1990
iron, wood and woven thatch grass
158 x 160

4. David Brown
Procession [15], c.1985
bronze
41 x 66
S.A. National Gallery, Cape Town

5. Norman Catherine
Intensive Care, 1987
charcoal and pastel
91 x 100.2
The Goodman Gallery, Johannesburg

6. Last Rites, 1989
wood, metal, canvas and acrylic
102 x 60 x 60

7. Johannes Chauke
Pig Policeman, 1988
wood and paint
111.5 x 23 x 35
The Standard Bank Collection of
African Art, University of the
Witwatersrand, Johannesburg

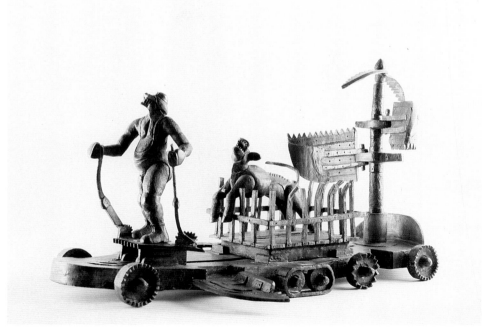

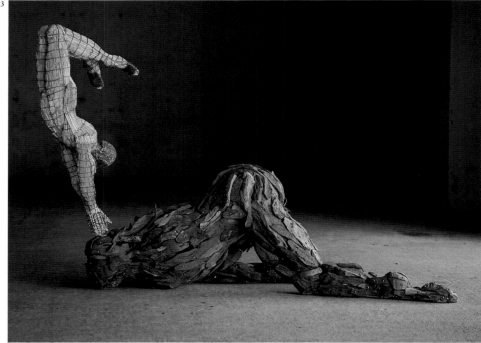

5

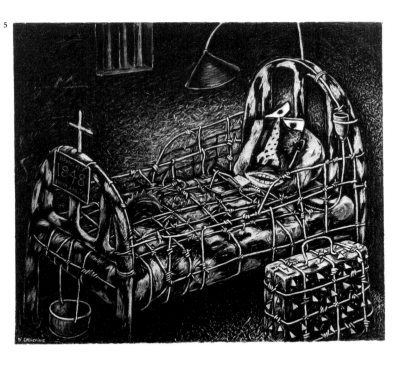

6

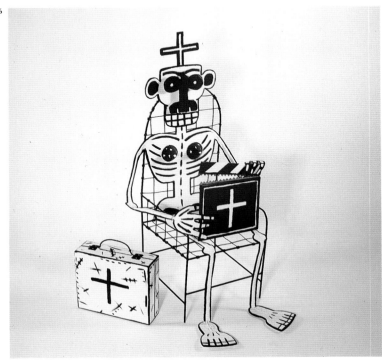

7

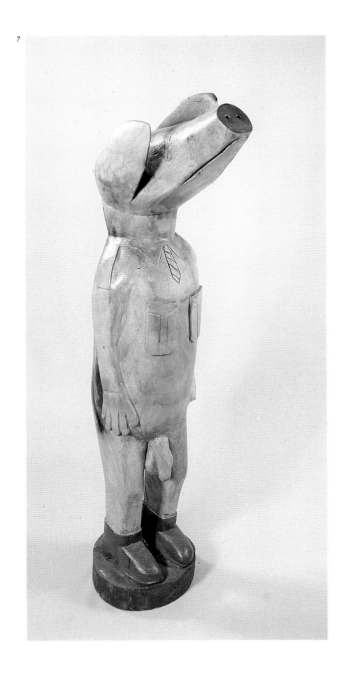

Commissions
1983 CT Revenue building, 3-piece life size, Figure, dog, structure
1985-6 Johannesburg Art Gallery, **Tightroping**

Collections
Durban Art Museum; Johannesburg Art Gallery; Pretoria Art Museum; S. A. National Gallery, Cape Town; SANLAM Collection; SASOL Collection Tatham Art Gallery, Pietermaritzburg; University of South Africa, Pretoria; University of the Witwatersrand Art Galleries, Johannesburg.

Norman Catherine

Born 1949, East London; lives in Hartebeespoort, Transvaal

1967-9 East London School of Art

Solo Exhibitions
1969 Herbert Evans Gallery, Johannesburg
1970 Motif Gallery, East London.
1971 Natal Society of Arts Gallery, Durban
1972 Goodman Gallery, Johannesburg
1973 Goodman Gallery, Johannesburg
1974 Goodman-Wolman Gallery, Cape Town
1976 Gallery 21, Johannesburg
1978 Kunsthandel Siau, Amsterdam Gallery 21, Johannesburg
1979 Rand Afrikaans University
1980 Goodman Gallery, Johannesburg
1982 Goodman Gallery, Cape Town Gowlett Gallery, Cape Town
1984 S.W.A. Association of Arts, Windhoek
1985 Goodman Gallery, Johannesburg
1986 Goodman Gallery, Johannesburg S.A. Association of Arts, Pretoria Area X Gallery, New York.
1987 Goodman Gallery, Johannesburg.

Collections
S. A. National Gallery, Cape Town; Johannesburg Art Gallery; Durban Art Gallery; Ann Bryant Art Gallery Sandton; Municipal Art Gallery Boksburg; Town Council Art Collection Pretoria Art Museum; Walter Batiss Museum, Somerset East; Pelmama Art Collection, Johannesburg; University of South Africa, Pretoria; University of the Witwatersrand, Johannesburg; University of Stellenbosch; University of Natal, Pietermaritzburg; Rand Afrikaans University, Johannesburg; Chase Manhattan Bank, New York; Volkskas Bank, Pretoria; Everite Art Collection, Johannesburg; Premier Milling Corp, Johannesburg; Mobil Court Art Collection.

Johannes Chauke

Born c.1930, Mojadji; lives in Blinkwater

Chauke learnt to speak Afrikaans whilst working as a labourer on nearby farms 1969: he and his family and other Tsonga speakers, grouped under the leadership of Chief Msengi, were removed from Mojadji and resettled in Blinkwater as part of the attempts to consolidate the Lebowa "homeland". He was married to Sophie, who died in 1975. They had four sons who are all sculptors [although the second eldest Tom died in 1983]. His work is sometimes attributed to "Albert Chauke."

Collections
Standard Bank Foundation of African Art at the University of the Witwatersrand, Johannesburg.

Chicken Man

Fanlo Mkize, also documented as Fanozi
Born c.1959, Richmond, Natal; living Willowfontein, Imbali township near Pietermaritzburg

Worked for Clover Dairies dealing in live chickens. Now sells his sculptures outside the Old Supreme Court, Pietermaritzburg and at the flea markets in Pietermaritzburg and Durban, often dressed in a chicken outfit. Also sells through Helen de Leeuw and Goodman Galleries in Sandton and Lizard in Cape Town.

Exhibitions
1985 Standard Bank National Festival of the Arts, Grahamstown
1986 Tatham Art Gallery, Pietermaritzburg, **Transitional Art**.

Collections
Tatham Art Gallery, Pietermaritzburg.

Caroline Cullinan

Lives in Brixton, Johannesburg

1976-80 studied Fine Arts at the Michaelis School of Fine art, University of Cape Town. Involved in setting up first Fine Arts Students' Council and magazine, SPOEG, as well as poster workshops during the 1976 riots
1980-1 lived in London
1981-7 returned to South Africa became a partner in **The Graphic Equaliser S.A.**, the first progressive design studio serving community organisations, unions and democratic movements. Conducted various silkscreen workshops in conjunction with community organisations
1986 first Caroline Cullinan Full Colour Calendar released since then it has been an annual publication in conjunction with the **Weekly Mail**
1988 the **Graphic Equaliser** closed down in a security Police swoop on resistance organisations
1988-90 worked as freelance illustrator, designer and poster maker for numerous progressive organisations; designed anti-apartheid t-shirts which resulted in protracted prosecution under the Internal Security Act.

Lionel Davis

Born 1936; lives in Cape Town

1968 attained Senior Certificate in Robben Island
1978 first art lesson at **CAP**
1980-1 art course at **Evangelical Lutheran Art and Craft Centre**, Natal
1986-8 attended **Thupelo** art workshops

1987 was invited to **Triangle Artists' Workshop**, Pine Plains, New York
1989 was invited to **Thapong International Artists Workshop**
Since 1978 has shown in many group exhibitions.

Collections
Botswana Museum, Gaborone.

Dumile

Full name Zwelidumile Geelboi Mgxaji Mslaba Feni
Born 1939, Worcester, Cape Province; lives in New York

After his mother died when he was five or six he went to live with relatives in Cape Town When he was eleven he worked for his father, a trader and preacher and started carving and drawing.
1950s he was an apprentice at the Block and Leo Wald Sculpture, Pottery and Plastics Foundary in Jeppe.
1963-4 began drawing career in earnest while a patient at the Charles Hurwitz S.A. National Tuberculosis Association Hospital in Johannesburg. Together with Ezrom Legae he decorated numerous walls at the hospital. Received support as an artist from Lionel Abrams, Bill Ainslie and Barney Simon.
1968 went into exile and en route to London visited Nigeria and China.
1979-80 Artist in Residence at African Humanities Institute at the University of California, Los Angeles, also, visiting lecturer at the Massachusetts College of Art, Boston.

Exhibitions
1963 Gallery 101 [solo]
1965 Johannesburg [Transvaal Academy]
1966 Gallery 101 [solo] SA - tour **SA Breweries Art Prize Exhibition** Pretoria **Republic Festival Exhibition** Durban Art Museum [solo]
 Adler Fielding Galleries, Johannesburg **Artists of Fame and Promise**
1967 Johannesburg [Transvaal Academy-solo]
 São Paolo, Brazil [Biennale]
 Adler Fielding Galleries, Johannesburg
1968 Goodman Gallery, **Sketches from a private collection**, [solo]
1969 Grosvenor Gallery, London, UK [solo]
1970 Goodman Gallery [The 51 Club Winter Art Exhibition]
1971 Gallery 101 [Group 51]
1972 Gallery 101 [Group]
1975 Goodman Gallery [SA Sculpture]
 Gallery 21 London
1977 Gallery 21, S.A. National Gallery, Cape Town [Cape Town Festival-Drawing by SA Artists]
1979 Rand Afrikaans University, Johannesburg; Pretoria Art Museum; University of the Orange Free State, Bloemfontein; William Humphreys Art Gallery, Kimberley
1981 Jabulani Standard Bank, Soweto, **Black Art Today**
1982 National Museum and Art Gallery, Gaborone, Botswana

1988 La Galleria, New York, USA
 Statements City without Walls Gallery, Newark,
 New Jersey, USA
 USA - tour, **Voices from exile - seven S.A. artists**

Awards
1966 **South African Breweries Art Competition**, [Merit
 Award]
1971 African Studies Centre, University College, Los
 Angeles, Art Competiton [first prize].

Commissions
1978-80 Mural for University of California, Los Angeles;
 Triptych of drawings for the American Committee
 on Africa's **Unlock Apartheid Jails** campaign.

Collections
Ann Bryant Gallery, East London; Durban Art Museum;
Pelmama Art Collection, Johannesburg; Pretoria Art Museum
S.A. National Gallery, Cape Town; University of Fort Hare,
Alice, Ciskei.

Ricky Dyalouyi
Born Guguletu, Cape Town 1974; lives in Cape Town

Trained at the **Community Arts Project** and is at present a
student at the CAP, Woodstock, Cape Town. He has exhibit-
ed in a group show there.

Gertrude Fester
Born 1952; lives in Cape Town

One of 14 people who stood trial for treason in what
became known as the **Yengeni Trial** [called Yengeni because
of Tony Yengeni who allegedly led the an **MK** cell]

1987 Arrested and held in solitary confinement under
 section 29 in prison in Wynberg, Cape Town.
 Charged along with other trialists and confined for
 a further 8 months in Cape Town's Pullsmoor Prison,
 where she was allowed access to drawing and writ-
 ing materials. Paintings done at this time she kept
 hidden in her cell. Feb.'89 trial started; March '90
 she and seven others were aquitted. The trial still
 continues for the other six. Returned to work as an
 English teacher at Hewett College, Cape Town. She
 is an active member of the **United Women's
 Congress** [UWC].

Fikile Magadeledla [Fikile]
Born 1952, Johannesburg; lives in Johannesburg

As a child trained as a boxer. Left school in 1969 and studied
with Bill Ainslie.1973 became a full time artist and co-
founder of the **Soweto Art Association**.

Exhibitions
1973 Lidchi Art Gallery, Johannesburg [group]
1978 Sharp Festival, Grahamstown [Festival Art
 Exhibition]
1979 Goodman Gallery [Exhibition of Drawings]

1981 Gallery 21 [Haenggi Foundation National Art
 Competition]
1982 National Museum and Art Gallery, Gaborone,
 Botswana
1985 **FUBA** [Creative Workshop, A selection of Work by
 Distinguished Black Artists].

Collections
Pelmama Art Collection, Johannesburg; University of Fort
Hare, Alice, Ciskei.

Lovell Friedman
Born 1963, Cape Town; lives in Cape Town

1982 B.A. Fine Arts, Michaelis School of Art, Cape Town
1989 M.F.A.,Michaelis School of Art, Cape Town

Exhibitions
1989 Centre for African Studies M.F.A, University of Cape
 Town
1990 Baxter Gallery, Cape Town

Collections
S. A. National Gallery, Cape Town

Louis Michael Goldberg [Mike]
Born 1952, Johannesburg; lives in Australia

After matriculating from Greenside High School,
Johannesburg he enrolled for an architecture degree at the
University of Witwatersrand, Johannesburg. After two years
he registered for a B.A. [Fine Arts] degree at Michaelis Art
School. Graduating in 1976, he returned to Johannesburg
where he became a founder member of the Market Gallery
in 1977. At the end of 1978 he was awarded a Higher
Diploma in Education from the University of Witwatersrand,
Johannesburg in 1980. In 1980 he began a two year period
as Manager of the Market Gallery, followed by a teaching
post at Damelin College, Johannesburg. Since then he has
emigrated to Australia.

Exhibitions
1977 Market Gallery, Johannesburg
1978 Market Gallery, Johannesburg [solo]
1981 Market Gallery, Johannesburg [with Paul Stopforth]
1985 **Cape Town Triennial**
1986 Market Gallery, Johannesburg [solo].

Collections
Johannesburg Art Gallery; S.A. National Gallery. Cape Town;
University of the Witwatersrand, Johannesburg.

Jackson Mbhazima Hlungwane
Born 1923, Nkanyani, Northern Transvaal; lives in Mbokote,
near Elim, N.W. Gazankulu

The son of a Shangaan migrant worker, Hlungwane worked
for a tea and coffee merchant and then a mattress manufac-
turer before being laid off for losing a finger in an industrial
accident.

1946 Ordained into the African Zionist Church and

created his own religious group, making his followers'
adornments.
Spent last 30 years building a stone palace to the glory of
God where he preaches and sculpts.

Exhibitions
1985 Africana Museum in Progess, Johannesburg
 Tributaries
1985-6 National Society of Arts, Durban; Irma Stern
 Museum, Cape Town
 Market Gallery, Johannesburg, **Out of Africa**
1986 Market Gallery [2 person exhibition with Nelson
 Mukhuba]. Africana Museum in Progress,
 Johannesburg [Jubilee exhibition of the Institute of
 the Study of Man in Africa. Documentation of
 Jackson Hlungwane's Acropolis. Site - "The New
 Jerusalem"]
1987 University of the Witwatersrand, Johannesburg
 [Collection of Peter Rich] **Standard Bank National
 Arts Festival**, Grahamstown [VhaVenda Sculpture]
 Johannesburg Art Gallery, **Vita Art Now**
1988 South African Association of Arts, Pretoria,
 VhaVenda/Shangaan Wood Sculpture
 Johannesburg Art Gallery [Vita Art Now]
 S.A. National Gallery, Cape Town.

Commissions
1983 Woodcarvings for cover illustration of **Swivuriso**
 [new translations of old testment book of proverbs
 in Tsonga]. Annual report of the United Bible
 Society, Stuttgart, FRG
1983 Commissioned by Tiakeni Textiles Co-operative to
 create woodblocks for cloth.
1988 University of Cape Town, large whale for African
 Studies building foyer.

Collections
Irma Stern Museum, Cape Town; S.A. National Gallery, Cape
Town; University of Cape Town, Department of African
Studies; University of South Africa, Pretoria; University of the
Witwatersrand, Johannesburg; Tatham Art Gallery,
Pietermaritzburg.

Pieter Jensma Wopko
Born Middelburg, 1939; lives in Johannesburg

Jensma is a poet and a printmaker
Late 1960s he worked in Botswana for the Department of
Information as a graphic artist
He has taught in various parts of South Africa.

Poetry Publications
Sing for our Execution, 1973
Where white is the colour where black is the number, 1974
[banned]
I must show you my clippings, 1977.

1

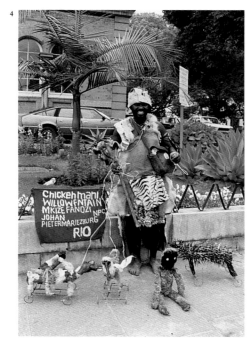

4

All dimensions in centimetres

1. Chickenman
[Johannes Fanozi Mkize]
Porcupine, c.1988
wood, porcupine quills, wire, hide,
bitumen and drawing pins
72 x 52 x 75
Tatham Art Gallery, Pietermaritzburg

2. Road sign:
Farmersin Hot Coun Tries, 1988
wire, wood, masonite and paint
57.5 x 58 x 17.5

3. Road sign:
*GONEF
ISHING*, nd.
wire, wood, masonite and paint
50 x 29 x 18
Museum of Modern Art, Oxford

4. Chickenman in Pietermaritzburg

5. Caroline Cullinan
Namibia, 1988
gouache on paper
40.5 x 43.6
Mr & Mrs Simon Stanford,
Johannesburg

6. Shebeen Dreams, 1988
gouache on paper
40.4 x 43.6
Mr & Mrs Nicolas Haysom,
Johannesburg

7. Lionel Davis
Fruits of our Labour, 1989
linocut
36.5 x 31

8. Dumile Feni
Till Death us do part, 1967
pen and ink on paper
55 x 65

2

3

4

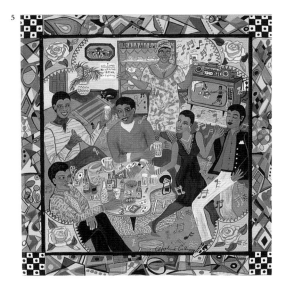

5

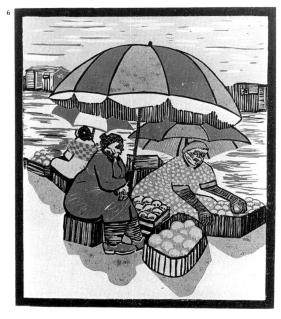

6

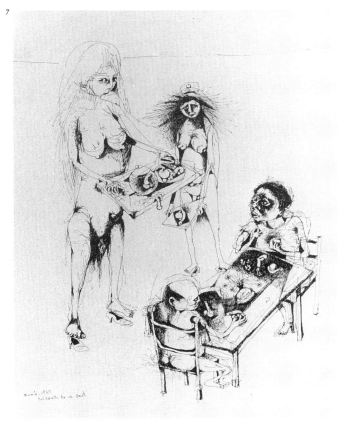

7

William Kentridge

Born 1955, Johannesburg; lives in Johannesburg

1976 BA in Politics and African Studies at the University of the Witwatersrand, Johannesburg. Founder member of Junction Avenue Theatre Company

1977-8 studied at the Johannesburg Art Foundation under Bill Ainslie

1979-81 taught etching at Johannesburg Art Foundation

1982 studied theatre at Ecole Jacques Lecoq, Paris.

Exhibitions

1979 Market Gallery, Johannesburg 1981 Market Gallery, Johannesburg Association of Arts Gallery, Cape Town

1985 Tributaries [tour]; Cassirer Fine Art, Johannesburg Association of Art Gallery, Pretoria

1987 Hogarth in January show with D. Bell and R. Hodgins, Vanessa Devereux Gallery, London

1989 Vanessa Devereux Gallery, London

Awards

1981 First prize for National Graphics Competition, Bellville Red Ribbon award at the American Film Festival, New York

1985 Merit Award winner on **Cape Town Triennial**

1987 winner of quarterly **A.A. Mutual Vita Award**

Since the age of four, houses I have lived in, my school, university and current studio have all been within three kilometres of each other

In the end all the work I do is about Johannesburg, a rather desperate provincial city. All attempts to escape it [including a year at theatre school in Paris] have failed. I have to recognise, that while Oxford may be foreign, London certainly is a suburb of Johannesburg. Far more familiar and accessible than most of my own country.

I have never tried to make illustrations of apartheid, but the drawings are certainly spawned by and feed off the brutalised society left in its wake. I am interested in a political art, that is to say an art of ambiguity, contradiction, uncompleted gestures and uncertain endings. An art [and a politics] in which my optimism is kept in check and my nihilism at bay.

Vetkoek/Fete Galante and Johannesburg - 2nd Greatest City after Paris
Drawings for projection by William Kentridge
Vetkoek/Fete galante mute 2 minute animated drawing 1985

This film was made for an exhibition at the Market Gallery in Johannesburg shortly after the declaration of the State of Emergency. A stringent press censorship had been imposed and the newspapers were filled with blank spaces where stories had been prohibited. The film was made in my studio on one sheet of paper. It chronicles a history of images, events, people, and interactions, all of which are subsequently erased leaving a blank, but bruised sheet of paper. The sheet of drawing paper was exhibited on the exhibition with the file projected alongside.

The film was made over two days. Everyone who came into the studio was included in the film; my daughter, wife, friends, a tramp asking for money [this disease of urbanity].

Subsequently, even blank spaces in newspapers were

deemed to be subversive and prohibited.

Johannesburg - 2nd Greatest City after Paris
8 minute animated drawing, 1989

The film chronicles the battle between Soho Eckstein [property developer extraordinaire] and Felix Teitlebaum [whose anxiety flooded half the house] for the hearts and mines of Johannesburg. Not to mention the affections of Mrs Eckstein.

The film was made in my studio; a drawing on the wall at one end and a wind up bolex camera at the other. I would draw, walk across the room, shoot off two frames of film, walk back to the drawing, so at the end of the film I was left with about twenty rather beaten drawings.

The characters and some of the interactions came directly from two dreams. What there is of a narrative was evolved backwards and forwards from the first key images, [the procession through the wasteland, the fish in the hand].

William Kentridge

David Koloane

Born 1938, Alexandra, Johannesburg; lives in Johannesburg

Educated St Michael's Primary School in Alexandra, St Peter's Secondary School in Rosettenville and Orlando High School in Soweto.

1974-7 art training, Bill Ainslie Studios

1977 co-founder of **FUBA** art gallery in Johannesburg

1982-3 head of Fine Arts at **FUBA**
participated in **Thupelo Workshops**, Johannesburg and **Triangle Artists' Workshops**, New York

1985 awarded Diploma in Museums' Studies, University of London.

1986-7 curator of the **FUBA** Gallery

1988 one of the judges for the 1988 **Cape Triennial**.

Exhibitions

1975 Nedbank Gallery, Johannesburg [2 person exhibition with Michael Zondi]

1978 Johannesburg, **Black Expo** Exhibition

1979 Bill Ainslie Studios, Johannesburg [group] Gallery 21 [solo]

1982 National Museum and Art Gallery, Gaborone, Botswana. University of Zululand [African Arts Festival]

1983 New York, USA, **Triangle Artists'**, **Workshop**

1984 London, UK, **Stockwell Open Studios** New York USA, **Triangle Artists' Workshop**

1985 **FUBA** [United States/South Africa Leadership Exchange Programme-**FUBA** Workshop Exhibition] **FUBA** [2 person exhibition with Ben Nsusha] London, UK. **Stockwell Open Studios** Africana Museum in Progress, Johannesburg **Tributaries**

1986 University of the Witwatersrand, Johannesburg, Thupelo Workshop Exhibition Academy Art Gallery, Paris, France [group] University of South Africa, Pretoria [Portraits-group] Alliance Française, Pretoria, **Historical Perspective of Black Art in S.A.** London U.K., **Triangle Artists;**

FUBA

1987 Johannesburg Art Gallery, **Vita Art Now** S.A. tour, **Standard Bank National Drawing Competion** Johannesburg Art Foundation, Natal Society of Arts, Durban; National Museum and Gallery, Gaborone, Botswana

1988 National Gallery, Harare, Zimbabwe.

Awards

1983 British Council Scholarship.

Collections

BMW, Germany; Johannesburg Art Foundation; MOBIL [SA Cape Town]; National Museum and Art Gallery, Gaborone, Botswana; Sached Trust, Johannesburg; Triangle Workshop Collection; University of Zululand.

Thirza Kotzen

Born 1953, Johannesburg; lives in UK

1974 received B.F.A. University of the Witwatersrand, Johannesburg

1976 Advanced Study Diploma in Printmaking, Central School of Art and Design, London

1979 M.F.A., University of Oregon, Eugene, USA

1979 Graduate Teaching Fellow, Printmaking, University of Oregon, Eugene

1980-1 visiting Lecturer, Printmaking, University of Oregon, Eugene.

Exhibitions

1979 M.F.A. Thesis Exhibition University of Oregon, Eugene [group] Gallery 141 [solo]

1981 Museum of Art, University of Oregon, Eugene [solo]

1982 The Market Gallery, Johannesburg [solo]

1983 The Carriage-House Gallery, Johannesburg

1984 Exhibition for Lloyds bank Award, Royal Academy, London [group]

1985 Curwen Gallery, London [solo] Camden Annual Juried Exhibition, London [group]

1986 Yehudi Menuhin School of Music, Surrey [group] Christmas Exhibition, Curwen Gallery, London [group]

1987 M.M. Arts Group Exhibition, Butler's Wharf, London [group] Summer Exhibition, Curwen Gallery, London [group] Camden Annual Juried Exhibition, London [group]

1988 Galeria Internacional de Arte, Algarve, Portugal Christmas Exhibition, Curwen Gallery, London [group]

1989 Offcentre Gallery, Bristol [group] Curwen Gallery, London [solo]

1989-90 **Art London**, Olympia, Curwen Gallery, London.

Commissions and Collections

1984 P. & O. Group for the **Royal Princess** Liner, Southampton I.B.M., Paris

1987 Keynes Hospital, University of Canterbury, Kent

1988 St Thomas's Hospital, London.

Sandra Kriel

Born 1952; lives in Stellenbosch

Schooling and University training in Stellenbosch. M.A. at Stellenbosch University. One year painting studies at the Nationaal Hoger Instituut voor Schone Kunste, Antwerp, Belgium.
Taught art at Stellenbosch for eight years. Completed three year course in Psychology through the University of S.A. Currently teaching art at Bellville Teachers Training College. Did documentation on Farm Workers [Vir 'n Stukkie Brood] which was published by Taurus.
Works in mixed media, using embroidery cotton, photocopy and velvet.

I believe art should communicate its own reality; the private and personal within the public and social. The artist should be involved with what is happening in and around her/himself and through the creative process deal with the joy and pain; not in a self-indulgent manner, but in order to interpret and communicate, to empower and mobilise through the creative process...

Sandra Kriel

Henry de Leeuw

Born 1953, Bellville South; lives in Cape Town

1987-9 studied at the Community Arts Project, Cape Town. Teaches art in the Bellville Art Project and is involved in community based projects.
Has participated in numerous group shows and had a one-man show in 1989.

Thomas Molatodi Lehupela

Born 1962, Paradys Location, Thaba 'Nchu, Orange Free State; lives in Paradys Location, Thaba 'Nchu, Orange Free State.

Attended Penyang Primary School until Standard IV, but left owing to financial difficulties. First made clay sculptures when he was seven.
1984 began working in wood after meeting Father Frans Claerhout. Primarily self-taught, but acknowledges influence of the Thaba 'Nchu group, including George Ramagaga.

Exhibitions
1989 Group Exhibition, Bloemfontein.

Commissions
Catholic Church, Thaba 'Nchu.

Collections
BNM

Suzanne Louw

Born 1964, Cape Town; lives in Cape Town

She attended Primary school at Wynberg Primary School and then Hershel High School in Cape Town
1986 received B.A. Fine Arts at Michaelis School of Art, University of Cape Town.

Noria Mabasa [Mabaso]

Born 1938, Tshigalo, Ramukhumba, Venda; lives in Vuwani district, Venda

Early 1950s Mabasa moved to White City, Soweto
1955 married and returned to Venda
1970s although she had no formal art training she began making clay figures which represented such traditional themes as domba initiation
1983 began working in wood after seeing sculpture by Nelson Mukhuba and Meshack Rapahalalani
1985 began working with "Ditike - The Craft House of Venda", a project of of the Venda Development Corporation, which began promoting her work.

Exhibitions
1984 Venda Sun Hotel, Thoyouandou, **VhaVenda Art Exhibition**
1985 Africana Museum in Progress, Johannesburg, **Tributaries**
1986 Goodman Gallery, **Parade**
University of the Witwatersrand, Johannesburg [Standard Bank Foundation Collection of African Art]
1987 Johannesburg Art Gallery, **Vita Art Now**, National Gallery, Cape Town, **Figurative Ceramics and Decorated Textiles**
Standard Bank National Arts Festival, Grahamstown, **VhaVenda Sculpture Exhibition**
1988 South African Association of the Arts, Pretoria **VhaVenda/Shangaan Wood Sculpture Exhibition** University of South Africa, Pretoria, **Clay+**.

Collections
Johannesburg Art Gallery; Pretoria Art Museum; S.A. National Gallery, Cape Town; Standard Bank; University of Fort Hare, Alice, Ciskei; University of the Western Cape, Bellville; University of the Witwatersrand, Johannesburg.

The clay figures which are typical of Noria's work generally depict images of the world around her. She has modelled armies of soldiers, policemen, nurses, doctors and occasionally she makes portraits of people she meets or hears about.
The twin figures included in this selection of work depict Mpho and Mphonyana, two Siamese Twins who captured the hearts of South africa. They were born joined at the head and were later separated in a well-publicised operation conducted at Baragwananth Hospital in Soweto. Noria watches television and is strongly influenced by the imagery found in this medium.
The clay figures are understandable. Soldiers, policemen, twins. The two exceptions are the "flower pots". **The Female Flower Figure** and the **Boy Killed by the Crocodile**; the vase pot represents the spirit. These two works are more "spiritual" than the more obviously realistic portraits. These works were made in **1988** and because of their strangeness have been left relatively unnoticed although they were included in the exhibition held at UNISA called **CLAY+**.
These two works represent something beyond reality. Noria often talks of the influence of her dreams on the work she makes. The flower spirit was directly from a dream. Her early dreams were of a figure - an ancestor - teaching her how to make clay figures. These dreams came at a time when Noria was sick and she was "cured" by actually following the dreams.

The scene of the crocodile is based more on actual experience. Noria lives next to the Levubu River *[Eng: Hippopotamus River]* which is infested with crocodiles. Noria has seen three people being eaten by these reptiles.
An interesting aside is Noria on technology. She has benefitted materially from her art and has managed to buy many mod cons. A fridge, T.V., coal stove and much Western furniture. But she is afraid of electricity. She says of an electric iron that when she uses one that the electrical current travels up her arm and affects her head.

David Rossouw.

Vuyisane Maijima

Born 1966, Guguletu, Cape Town; lives in Nyanga East, Cape Town.

Part-time student at the Community Arts Project, Cape Town.

Billy Mandindi

Born in 1967, Guguletu Township, Cape Town; lives Guguletu Township, Cape Town

He finished the first year of High School at Ntaba-Kandoda High School in Ciskei
1985-6 full-time at **CAP**
1987 enrolled for degree in Fine arts, Michaelis School of Art, University of Cape Town.

Chabani Cyril Manganyi

Born 1959, Mofolo, Soweto, Lives in Mofolo, Soweto

1963 started pre-school [non-European creche]
1965 Grade A, Orlando, Hlanganani Primary School attended at Morris Isaacson during High School the Soweto riots
1969-78 attended part-time art lessons at the Mofolo Art Centre [informal lessons with Dan Ragoathe and Cyril Khumalo]
1979-81 studied Fine art diploma, Drift
1981 established a three year Fine Art Course in Soweto for full-time and part-time students

Exhibitions
1978 EXPO
1979 Oppenheimer Tower
1979 King Williamstown Arts Festival
1980 University of Zululand
1981 African Museum, Durban
University of Zululand
Mofolo Art Centre
1982 Mofolo Art Centre
Soweto Home-Makers Festival
1983 Mofolo Art Centre
1984 Mofolo Art Centre
1985 Mofolo Art Centre
1986 Johannesburg Sun
1987 Johannesburg Art Foundation
1988 African Museum - Johannesburg Market Theatre Gallery
1989 Gordsforth race Course [Thupelo]

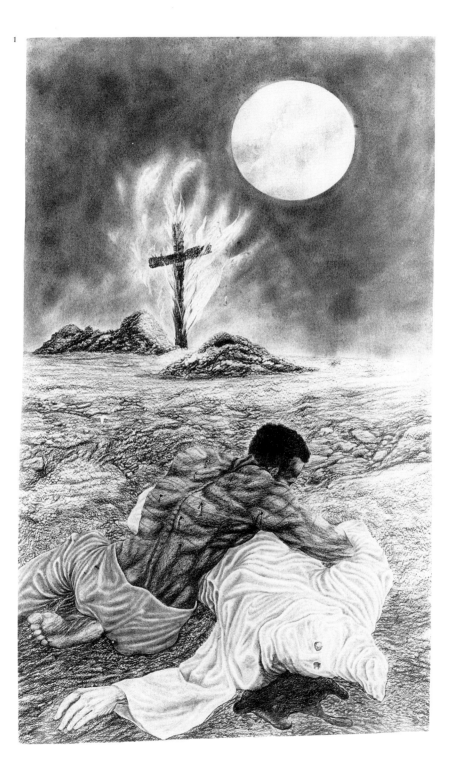

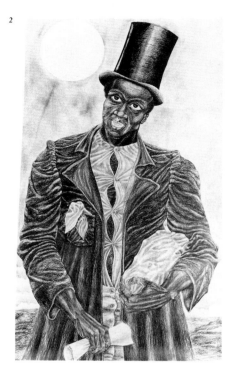

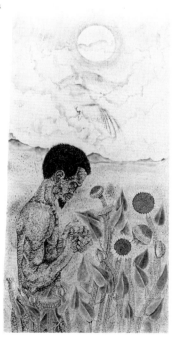

All dimensions in centimetres

1. Fikile Magadlela
From Roots series, nd.
drawing
129.5 x 76.5
The Goodman Gallery, Johannesburg

2. From Roots series, nd.
drawing
134 x 76.3
The Goodman Gallery, Johannesburg

3. Nature in a poets Song,
Drawing No 15, nd.
157 x 76
The Goodman Gallery, Johannesburg

4. Michael Goldberg
Hostel Monument for Migrant
Worker, 1978
steel, wood, horns, fibre and clock
138 x 195 x 78
University of the Witwatersrand,
Johannesburg

5. Jackson Hlungwane
Throne, 1989
Munzere wood
2,560 x 1,600 x 1130
Private Collection

6. Fish, 1990
wood
70 x 126 x 25
Private Collection

7. Son of Adam, 1990
wood
66 x 26 x 26
Private Collection

5

7

African Arts Institute, Durban
Former Rorke's Drift Students
Market theatre Gallery, Johannesburg

Awards

1988 **New Vision Art Award** [for Burial of a Hero I]
 Nominee, **Triangle Workshop**

Latest Exhibitions

1989 Thupelo, Broederstroom
 Market Gallery, Johannesburg
 Thupelo Gallery
 White City, Soweto

Collections

University of Zululand; Kwa-Zulu Investment Corporation;
Natal Akos Construction, Johannesburg; Rorke's Drift, Natal
Rev. Jay Hohnson, Idaho; Rev Bloom, Germany; Chris
Mageza, Soweto; Kits Mageza, Soweto; Barney Nkotsi,
Soweto; Tony Nkotsi, Soweto; Dr Gordon Sibiya,
Johannesburg; Mrs Mophiring, Pimville; Thupelo Art Project,
Johannesburg; Prof. Nick Marits, University of South Africa;
Mr Riddleheimer; Mrs S. Makhene, Pimville; Mrs V. Sithole,
American Life Insurance; Rederick Macraw, Paris; Martina
Arroyo, New York.

Burial of a Hero deals with after effects that the community
experienced after Steve Biko's death.

The writing above his head is a commitment that was
adopted by the oppressed masses of South Africa, that everyone
of their lives, a virus of apartheid life span, will be cut short
until it completely dies and is replaced by a democratic South
Africa.

South Africa is a very tense at the moment. It experiences
all sorts of killings, necklace, stoning, shootings and also
killings caused by the police force and soldiers. Steve Biko was
one of these victims who died in police hands. **Burial of a Hero**
was inspired by the death and burial of Steve Biko. I saw masses
at his funeral singing, chanting, mourning and also crying for
the loss of a leader. It happened in 1977, but since then I can not
afford to isolate myself from the present political surroundings
of everyday life.

**The People Never Lost Hope, but went back home in respect
and dignity.**
Burial of a Hero IV

Title: Slaughtering For A Hero
Medium: Wood, Oil, Acrylics

In our culture when death arises or a member of our family gets
married, the slaughtering of an animal takes place. **On Burial of
a Hero IV**, we talk about slaughtering because a life of a hero
has been lost.

This is common in South Africa, we slaughter more ani-
mals for death than birth or celebrations.

Chabani Cyril Manganyi

Bhekisani Manyoni

Born 1945, Greytown, Natal; lives in Germiston,
Johannesburg

1960-3 studied at Rorke's Drift Art School
1963-5 taught at Rorke's Drift Art School
1965-73 taught art at a school for the physically disabled in
 Newcastle, Natal
1973 taught printmaking at SATCO Training Centre,
 Mbabane, Swaziland
 Curator of the Pandora Gallery, Mbabane
1979 artist-in-residence at Katlehong Art Centre,
 Germiston.

Exhibitions

1970 Durban Art Museum [group]
1973 Manzini Showgrounds, Swaziland [solo]
 Nairobi, Kenya [group]
1982 Rand Afrikaans University, Johannesburg
1984 Constantia Shopping Centre, Johannesburg [group]
1985 Africana Museum in Progress, Johannesburg,
 Tributaries
 FUBA [group]
 South African Association of Arts, Pretoria
 American Embassy, Pretoria [group]
1986 Sandton Sun Hotel
 Rand Afrikaans University, Johannesburg
 Carriagehouse Gallery, Johannesburg [group]
 South African Association of Arts, Pretoria
 Waterloof House Preparatory school, Pretoria
 Waldorf School, Sandton
 FUBA
 Sotheby's, Johannesburg
 Market Gallery,
1987 South African Association of Arts, Pretoria
 South African National Gallery, Cape Town
 Waterloof House Preparatory school, Pretoria
1988 Helen de Leeuw Gallery [group]
 South African National Gallery
 Market Gallery [solo]
 Cavendish Square [solo]
 Gallery International, Cape Town [group]
 South African Association of Arts, Pretoria [group].

Awards

Award for Mesana tapestry design
Hans Merensky Trust, Grahamstown [special award].

Collections

Botshabelo Sun Hotel; Durban Art Museum; Putco;
Sached Trust, Johannesburg; Tatham Art Gallery,
Pietermaritzburg; University of Zululand; Vista University,
Soweto; University of the Witwatersrand, Johannesburg.

Louis Khela Maqhubela

Born 1939, Durban, Natal; lives in London

1951 moved to Johannesburg
1957 while still at school, studied at Polly Street Art
 Centre
1958 left Orlando High School in Soweto
1959 studied under Cecil Skotnes and Sydney Kumalo at
 the Jubilee Arts Centre and received guidance from
 Giuseppe Cattaneo
1960 Design Center, Johannesburg
1960s Designed mosaics for schools in Soweto and
 SANTA [South African National Tuberculosis
 Association].
1966 toured Europe; worked with Douglas Portway and
 met Gerard Sekoto
1973 moved to Spain
1978 moved to London.
1984-5 Goldsmiths College
1985-8 Slade School of Art [Printmaking]

Exhibitions

1961 Lawrence Adler Galleries, Johannesburg, **Artists of
 Fame and Promise**
1962 Adler Fielding Galleries, Johannesburg, **Artists of
 Fame and Promise**
1963 Lidchi Art Gallery, Cape Town, **Polly Street Artists**
1965 Alder Fielding Galleries, Johannesburg, **Township
 Life**
 Piccadilly Gallery, London, **African Artists**
1966 Adler Fielding Galleries, Johannesburg, **Artists of
 Fame and Promise**
1967 Adler Fielding Galleries, Johannesburg [Solo]
 Piccadilly Gallery, London, UK [African Art]
 Durban Art Museum, **Art S.A.Today**
1968 Lidchi Art Gallery, Johannesburg [Solo]
1969 Camden Arts Centre, London, UK, **Contemporary
 African Art**
 Helen de Leeuw Gallery, **Polly Street Artists**
 Durban Art Museum, **Art S.A. Today**
1974 Goodman Gallery, [Festival of Graphics and
 Multiples] Gallery International, Cape Town.
1976 Gallery International [Group].
1981 Jabulani Standard Bank, Soweto **Black Art Today**
1983 Witwatersrand University **Art and Artists of South
 Africa**
1986-7 Johannesburg Art Gallery **Johannesburg Art and
 Artists: Sections from a Century**
1987 South African National Gallery, **Contempery S.A.
 Prints and Drawings**

Commissions

Late 50s: mosaic for the Township Halls in Jabavu "White
 City", Soweto
 Six murals at Jubilee Social Centre
 Mosaics at Molfo Park Recreation Centre, Soweto
 Mosaics at Oppenheimer Park, Soweto

Awards

1959 Rembrandt Company Schools Exhibition [prize]
1961 Artists of Fame and Promise [second prize]
1966 Artists of Fame and Promise [second prize]

1969 Art South Africa Today [Cambridge Shirt Award]

Collections

Anglo American; Johannesburg Art Gallery; Johannesburg Art Gallery; South African Art Gallery; Standard Bank, Johannesburg; University of the Witwatersrand, Johannesburg.

Johannes Maswanganyi

Born 1948, Msengi Village near Giyani, Gazankulu; lives in Msengi Village near Giyani, Gazankulu

No formal art education. Taught by father, who carved fuctional objects, such as spoons, bowls and jsuri for crushing maize

1965 started making nyamisoro [figure shaped medicine containers], spoons, bowls and musical instruments
1969 worked in a brick factory;
 returned to Msengi.

Exhibitions

1985 Africana Museum in Progress, Johannesburg
1986 University of the Witwatersrand, Johannesburg
1987 Market Gallery [solo]
 Rand Afrikaans University, Johannesburg
 Waldorf School, Sandton
1988 Johannesburg Art Gallery, **FUBA**
His work has been sold in Giyani, Tzaneen and Duiwelskloof. He also exhibits with the Goodman and Helen De Leeuw Galleries in Sandton, African Magic and Melville Place in Johannesburg and Lizard in Cape Town.

Collections

Durban Art Museum; S.A. National Gallery; University of the Witwatersrand, Johannesburg.

Johannes is a successful artist and trader in artefacts. The work included in this exhibition - **The Politician [Malan]** either **Dr Malan** or **Magnus Malan** - is done in the hardest indigenous wood, **leadwood**, and was originally unpainted in 1986 but was never sold from the Goodman Gallery, and was painted two years later.

Johannes has a keen eye for detail and combined with a simple bold linear approach to his work, creates unique, cynical images that often have a humorous overtone.

Another work [1989/1990], carved from Maroela wood is called **Family Tree**. This work is quite traditional in a sense that it represents Johannnes's ancestors in the skulls and skeleton. Recently he has depicted this image a lot. His subject matter which was originally very much based on the external world, making depictions of white politicians, has changed to more personal, fantastical and religious themes.

Johannes started carving under the guidance of his father who is a fine traditional craftsman, making headrests, spoons, bowls, beer scoops and other utilitarian items. Integral to traditional Tsonga carving is "burning", thus the early *Nyamisoro* [witch doctor dolls] were carved and decorated with burning [poker work].

Johannes is both a traditional and western man and has been able successfully to span the gap between the two worlds. He has two wives, ten children, a modern [i.e. square] house, a motor vehicle [Peugeot bakkie], attends regular church services and supplies traditional herbalists with *Nyamisoro*.

David Rossouw.

Menzi Mcunu

Born 1964; lives in Durban

Studied at **The Community Arts Workshop**

1986 won a bursary to study at Technikon Natal. Later began part-time teaching with Thami Jali and Sfiso Mkame [teaching art classes for free to underprivileged black students]
1987 taught at **Community Arts Workshop**
 Held mural painting classes for children.

Exhibitions

1985-6 Natal Society of Arts
1987 **Community Arts Workshop**
1988 **Thupelo** artists' workshop exhibition in Johannesburg, as one of the Natal representatives.

Mpumelelo Melane

Born 1964, Port Elizabeth, East Cape; lives in Port Elizabeth

Went to school at Stutterheim, Eastern Cape, where he first started making small clay animals. Worked as an assistant driver for a transport company for two years; started wood carving [first using a pen knife until a friend gave him a set of chisels as a gift].

Now, working as a full-time artist making necklaces, figures and large sculptures.

1988 joined **Imvaba Arts Association**, active in mural group and has been in group **exhibitions**.
 Influenced by Nelson Mukhuba, Gumede and Noria Mabasa.

Harold Mettler

Born 1954, Carnarvon, Cape; lives in Cape Town.

A self-taught linocut artist and sculptor in marble and wood. Exhibited at the 1990 Namibian Independence Celebrations as a guest of **SWAPO**.

Collections

Private collections in South Africa; Ohio, USA; San Francisco, California; Sweden.

Justice Sfiso Mkame [Sfiso]

Born 1963, Durban; lives in Clermont, Durban.

1979 left Mtwalume High School, where he had studied handicrafts and drawing in Standard I [although there was no art teacher]
1982 art training; Open School, Durban
1983 art training; Little E. Theatre, Durban
1986 worked as student teacher at the Community Arts Workshop.

Exhibition

1986 Café Généva, Durban [Community Arts Workshop-

group]
 Theatre, Durban, **Artists Against Conscription**
1987 Clermont Hall, Clermont [Clermont Art Society-group]
 Paul Mikula and Associates, Durban [group]
 University of Zululand [African Arts Festival - group]
1988 Grassroots Gallery, Westville, Natal [three person].

Awards

1987 University of Zululand African Arts Festival [First prize for drawing].

Collections

The Campbell Collections of the University of Natal, Durban; Tatham Art Gallery, Pietermaritzburg; University of Zululand.

Michael Mosala

Born 1939, Thaba Nchu; lives in Botshabelo Township, Orange Free State.

Looked after his father's cattle herd as a young boy. Received art instruction and encouragement from Father Claerhout at the Tweespruit Mission.

After 1966 began exhibiting work, together with Michael Thladi, Martin Kwadipo and George Ramagaga in Bloemfontein and Welkom.

Established a studio at STK Centre at Botshabelo and currently sells his work through Tweespruit and the Volksblad art market at Bloemfontein.

Titus Moteyane

Born 1963, Atteridge, Pretoria; lives in Atteridge, Pretoria

Left school in Standard VIII. He creates objects such as motor cars and aeroplanes out of tin and wire which he collects from a dump near his home. He does not sell these works but keeps them in his garden and repaints them annually; he does sell paintings on slates. He is an acrobat and presents a one-man show where he uses his body and voice to produce a sound like a five piece orchestra.

Exhibitions

1984 Pretoria Art Museum [Makorakora]
1985 Africana Museum in Progress, Johannesburg
 Tributaries
1986 S.A. National Gallery [Tin and Wire: Toys and sculpture from South Africa]
 University of the Witwatersrand, Johannesburg [Standard Bank Foundation Collection of African Art].

Collections

S. A. National Gallery; University of the Witwatersrand, Johannesburg.

All dimensions in centimetres

1. Wopko Jensma
Wail for the beast 2, nd.
linocut
27.3 x 30.7
Private Collection

2. David Koloane
Untitled, 1989
oil on canvas
150 x 80

3. Thirza Kotzen
Olifants II, 1988
oil on canvas
63 x 198

4. Henry de Leeuw
1990-1994, 1990
colour linocut
29.5 x 52

5. Untitled, 1989
colour linocut
59 x 42

6. Suzanne Louw
Washington Street, Langa, 1986
wood block relief print
60.5 x 83
Gavin & Glenda Younge, Cape Town

7. Noria Mabasa
Ten Soldiers, 1989
clay and enamel paint
80.5 x 24.5 x 16
Museum of Modern Art, Oxford

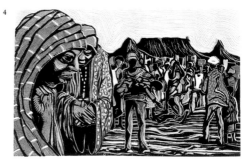

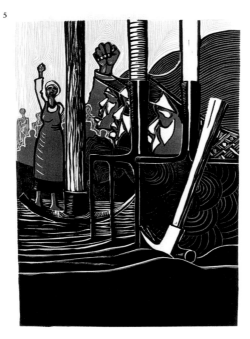

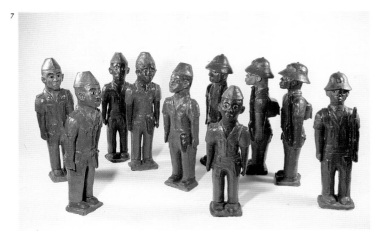

Thomas Tommy Trevor Motswai

Born 1963, Johannesburg; lives near Johannesburg.

Motswai is a deaf-mute who studied for eleven years [1968-79] at the Kutlwanong School for the Deaf, where he also taught art. He is mainly a self-taught artist and has worked at the Wynberg Pottery, Johannesburg. He is a member of the Artists' Market.

1980 studied irregularly at **FUBA**, Johannesburg and at Bill Ainslie's studio
1982-3 worked as an assistant to Kurt Lossgott.

Exhibitions
Motswai has participated in several group exhibitions from 1979 in South Africa
1986 group show Monte Carlo
1988 Goodman Gallery, Johannesburg, [solo].

Awards
1985 **Santam Bursary**
1987 **Volkskas Atelier Merit Prize**
1987 **Sol Plaatjies Graphic Art Award**
1987 **Excelsior Award**

Collections
Johannesburg Art Gallery; S.A. National Gallery, Cape Town; Tatham Art Gallery, Pietermaritzburg; University of South Africa, Pretoria; University of the Witwatersrand, Johannesburg

James Serole Mphahlele

Born 1954, Pietermaritzburg; lives in Pietermaritzburg Area

1970 Mamaolo Primary School, Standard VI.
1975 Junior Certificate, Kgoadia Moleke
1976-7 teacher training, Sekhukhune College of Education
1980 art training, Ndaleni Training College
1982 Rorke's Drift Art School, Natal
1984-5 tutor, Alexandra Township
1986-7 part-time tutor, Art and Craft Centre, Makanspoort Mission Station.

Exhibitions
1986 **FUBA** Gallery, Johannesburg [with Ranko Pudi]
1989 Gallery 21, Johannesburg [solo].

Collections
Durban Art Museum; Pelmama Collection, Johannesburg; Ann Bryant Gallery, East London; University of South Africa, Pretoria; University of the Witwatersrand, Johannesburg; Department of National Education, Pretoria; Kauffman Museum, Kansas, USA.

Since we are on the brink of loosing all that was best in African Art and African Tradition, who will take the initiative to retrieve that which has been lost to the West? Traditions have to be passed on to future generations.

James Mphahlele
1.2.1989

The **Dialoga** series of 25 linocuts by James Serole Mphahlele is about the Closing Ceremony of the Initiation. The Name given to this ceremony is *goAlogsa/goAloga*.

The Chief and Indunas of the Pedi tribes in the Northern Transvaal [Lebowa] are the controlling heads of circumcision lodges. They are qualified to conduct traditional initiation schools, but require permission from the local Magistrate or Government office.

The Chief and the men of the kraal, *bakgomana ba Mosate*, gather in secret and elect the following:

a] Master of the Lodge, *Rabadia*, and Deputy Manager
They are the men who know the details of initiation and who are related to the Chief's Kraal or Capital. They will spend days and nights with the initiation until the Closing Ceremony;
b] The Surgeon or Village Doctor
c] Their elders who have taken part in and witnessed other initiations. They act as instructors and shepherds.

Closing Ceremony
The Head of each kraal carries a stick with red dyed sheep skins, *Hlaba*, from the Chief's Kraal to the initiation lodge.

The body of each initiate is smeared with red-ochre, called *letsoku*. The young men are now called Dialoga. They put on the *Hlaba* and their elders give them each a stick called *Lekgai*.

As soon as the intiation lodge starts burning, set on fire by the medicine man, the young men start running to the village, not being allowed to look back [*Mphatho/Moroto*].

Upon arriving at the village, the Chief's son leads the procession, holding the rod of honour [sefoka], all singing songs of victory.

All fathers and the Elders carry wood to make a fire in the Chief's Kraal.

Owen and Goldwin Ndou

Goldwin, born 1954, Gwamasenga, Venda; lives in Hamutsha, Venda. Owen, born 1964, Gwamasenga, Venda; lives in Hamutsha, Venda.

Owen and Goldwin often work together on the same piece of sculpture [together they won first and second prizes in the 1989 University of Zululand African Arts Festival]. Their father was a wood carver and produced stamping blocks, bowls and walking sticks. Owen attended Tshipetane Junior Secondary School until the ninth year of schooling.

These two artists came to my attention in 1986. Owen, the younger brother is also the chief spokesman for the team; he also brought the work to DITIKE [the Craft House Of Venda] to sell. Their early work was craft-orientated and as with many of the other artists their craft was bad. Innovation being important to the brothers, they would carve spoons and bowls with heads and arms attached. They were roughly finished and were not acceptable as craft items.

They slowly developed into producing fine art [and at present are the most productive artists in this region, producing a major work every month].

For the brothers the need to create an image is of greater importance than making work with a good finish. thus their work is rather unacceptable in the Venda context, falling more into a kind of "Expressionist" style.

Biography
Owen and Goldwin grew up in Venda. Goldwin working for many years on the railways. Owen finished school and immediately started carving and once the work was selling he encouraged Goldwin to return to Venda and help him carve. They work very closely together, sometimes making work individually but often working in close conjunction with each other.

The themes that they deal with have nostalgic reference to past times - and beast contesting territories - of animals fighting and killing for survival. Other themes are biblical. They keep a book where many of their ideas are written. They are at present busy with a work on AIDS as well as biblical themes - Judas and the Crucifixion. They love extremes - drama - blood - life - survival. These two young artists have literally taken the bull by the horns and are committed to succeeding as artists.

Describing the working process of these two artists helps shed light on the working process of most of the woodcarving artists in Venda, Lebowa and Gazankulu. This area has large area of woodland usually far from the settlements because of the demand for firewood. The artists usually go out into the bush and start carving the work there to make it lighter. Once the work is nearly finished it is carried out of the bush to the artist's home. Some of the Venda artists have trucks, others like Owen and Goldwin have physically to lug the work out of the bush.

The wood is controlled in certain areas by the Department of Nature Conservation and permits need to be bought to chop living trees.

Green wood is preferred by most of the craftsmen as it is the traditional method. Most of the artists prefer dry wood [Jackson Hlungwani, Albert Mnyai, Noria Mabasa]. Owen and Goldwin prefer softwoods, Fig and Quinine tree. This is because these trees are easier to carve, larger and lighter than most of the hard woods.

The tools the artists use vary vastly. Many artists use adzes made from car springs, old files or chisels. Others use chainsaws, mallet and chisel and other western saws and axes.

David Rossouw.

Charles Sokhaya Nkosi

Born 1949, Durban; lives in Soweto

1974-6 studied painting, graphics, sculpture, weaving and ceramics at Rorke's Drift Art School
1977-80 worked as full-time artist at Mariannhill
1980-1 taught art at the Open School, Durban
1982-6 worked as graphic artist at the **SABC**
1986 to present day, senior tutor at the AIA, **FUNDA**, Soweto

Exhibitions
1974 Sweden, **Rorke's Drift**, organised by Otto Lundbohm]
1975 Durban Art Museum, **Art South Africa Today** Durban Black Expo, organised by Don Joseph
1977 Natal Society of Arts, Durban [three persons exhibition with Duke Ketye and Michael Ntuli]
1979 University of Natal, Pietermaritzburg [part of centenary celebrations group]

1974-80 University of Fort Hare [annual group exhibition]
1977-84 University of Zululand [annual group exhibition]
1980 Mariannhill Art Gallery [two person exhibition with Bongani Shange]
1979-80 Natal Society of Arts, Durban - tour [group] Durban, **Black Expo**
1981 Gaborone, Botswana, **Culture and Resistance Conference**
1982 Medical University of South Africa [Medunsa] [group]
National Museum and Art Gallery, Gaborone, Botswana, **Art Toward Social Development: An Exhibition of South African Art**
1984 University of Zululand [group]
1987 Shell Gallery **Explorations** joint exhibition with Vincent Baloyi and AIA students
Tatham Art Gallery, Pietermaritzburg, **Rorke's Drift Fine Art School in Retrospect**
1988 Johannesburg Art Gallery, **Vita Art Now.**

Commissions
1978 Three life-size murals at the Glebe Tavern, Durban [Durban Municipality].

Awards
1984 University of Zululand Art Exhibition [second prize for painting].

Collections
The Campbell Collections of the University of Natal; Museum of African Art, Munich, FRG; University of Fort Hare, Alice, Ciskei; University of Zululand.

Anthony Nkotsi [Tony]
Born 1955, Johannesburg; lives in Johannesburg

1978-9 studied at Mfolo Arts Centre, Soweto
1980-2 Rorke's Drift Art School, Natal
1983 co-founded **Skuzo**, a printmaking studio in Johannesburg, with Dumisani Mabaso; also at the Hammanskraal Art Project
1984 taught at Open School, Johannesburg
1985 taught at **FUBA**, Johannesburg
1986 teaches Johannesburg Art Foundation; now, head of the Printmaking Dept.
1988 studied lithography at the Peacock Printmakers' Studio in Aberdeen and the Printmakers' Workshop in Edinburgh [British Council Scholarship].

Exhibitions
1979 Soweto Oppenheimer Towers [Mofolo students group show]
1980 University of Zululand [Rorke's Drift Art students]
1982 University of the Witwatersrand, Johannesburg [group]
Sandton Sun [group]
1983 Milner Park, Johannesburg [SA Contemporary Art]
Skuzo Printmaking studio, Johannesburg [Skuzo, group]
Market Gallery [Skuzo, group]
1984 Market Gallery [group]
Botswana, **Culture and Resistance Conference**

1985 Shell gallery, Johannesburg [Phumalnga Tapestries - two were developed from Nkotsi's paintings]
1986 Academy Art Gallery, Paris, France, **Eleven Contemporary Black S.A. Artists**
L'Espace Belleville, Paris, France [Art, Witness or Actor in Society]
1987 Johannesburg Art Foundation [group]
Natal Society of Arts, Durban; National Museum and Art Gallery, Gaborone, Botswana [group]
1988 Goodman Gallery [solo]
Market Gallery, **Detainees' Parents' Support Committee Exhibition**
FUBA, **Tenth Anniversary Exhibition.**

Awards
1988 British Council Scholarship
Won **Thupelo/Triangle Workshop Award** simultaneously, but was unable to take this up.

Commissions
1986 Woodcut for hotel in Swaziland

Derrick Vusimusi Nxumalo
Born 1962, Dumisa, Natal; lives in Durban

Passed Standard VIII at Phindavela, but had no formal art training
1985 worked at African Art Centre, Durban
1986-8 worked as miner at the Vaal Reef Gold Mines
1988 returned to Dumisa where he works on various commissions.

Exhibitions
1987 University of Zululand [African Arts Festival]
Natal Society of Arts, Durban [selected works form University of Zululand Festival of African Art]
1988 S.A. - tour [**Cape Town Triennial**].

Awards
1987 University of Zululand African Arts Festival [first prize].

Commissions
1988 Anglovaal.

Collections
Durban Art Museum; The Campbell Collections of the University of Natal, Durban; Tatham Art Gallery, Pietermaritzburg; University of the Witwatersrand, Johannesburg.

Deanna Petherbridge
Born 1939, Pretoria; lives in London

1956-60 studied Fine Arts at University of Witwatersand and tutored in history of art
1961-6 lived in London, teaching art and working on large canvases and sculptured reliefs
1967-72 lived in Greece, working on pen and ink drawings
1971-2 two interior commissions, London
1973-5 Arts Council Awards
1980 Prizes: Art into Landscape III and Holborn Station

competition
1981 Greater London Arts Association Award
1982 helped to organise conference on Art and Architecture at the ICA, London; Artist-in-residence, City Art Gallery, Manchester
1984 designed sets for ballet "A Broken Set of Rules" for The Royal Ballet, Covent Garden
1985-6 British Council sponsored visit to India
1986-7 designed sets for ballet "One by Nine" for The Royal Ballet, Covent Garden
1987 publication of Art and Architecture, HMSO
British council sponsored lecture tour of India, in association with touring exhibition "Temples and Tenements"
1989 commission from the Artistic Records Committee of the Imperial War Museum
Award, Edwin Austin Abbey Memorial Scholarships.

Articles published in **Architectural Design, Art Monthly, Architectural Review, The Financial Times.**
Part-time teaching: Architectural Association, Reading University, Middlesex Polytechnic.

Major Exhibitions
1973 Angela Flowers Gallery, London
1975 **The Iron Siege of Pavia and Other Drawings**, Whitechapel Art Gallery, London
1977 Gallery K, Washington DC
1978 Hayward Annual'78, Hayward Gallery, London
1979 Midlands Art Centre, Birmingham, Yehudi Menuhin School, Cobham
1980 **India: Tombs and Temples**, Angela Flowers Gallery, London
1982 **Deanna Petherbridge: Drawings 1968-82**, Gallery of Modern Art, City Art Galleries, Manchester
1983 **Deanna Petherbridge: Drawings 1968-82**, Warwick Arts Trust, London
1984 **Line and Interline**, Quay Arts Centre, Isle of Wight
Geometry of Rage, Arnolfini, Bristol and Third Eye Centre, Glasgow
1987 **Temples and Tenements**, Fischer Fine Art, London
Drawing on a Wider World, Harris Museum and Art Gallery, Preston
1987-8 **Temples and Tenements**, British Council Tour: Bangalore, Madras, Delhi, Calcutta, Santiniketan, Bombay
1990 **Themata**, Fischer Fine Art, London.

Collections
Arnolfini Collection Trust; Arts Council of Great Britain; Bankers Trust, London; Basildon Arts Trust; Bell Telephone, USA; Cleveland Gallery, Middlesbrough; Government Art Collection; Imperial War Museum; Harris Museum and Art Gallery, Preston; Manchester City Art Galleries; National Westminister Bank; Robert McLaughlin Gallery, Ottawa, Canada; San Francisco Museum of Modern Art; Sheffield City Art Galleries; The British Council; The Contemporary Art Society; The Victoria and Albert Museum; The Whitworth Art Gallery, University of Manchester; Trafalgar House, plc; Unilever plc; University of Glasgow Art Collection.

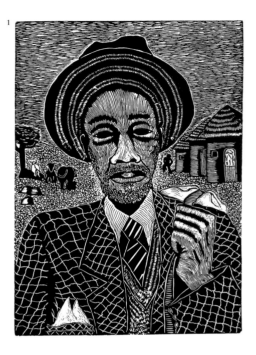

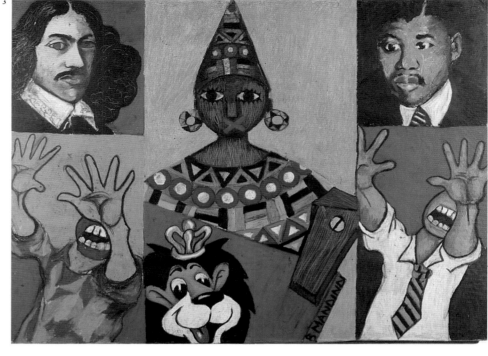

All dimensions in centimetres

1. Vuyisane Maijima
From home to Emgodini, 1990
linocut
42.2 x 29.5

2. Billy Mandindi
Homage to Township Art, 1989
oil pastel on paper, mounted on
masonite
126 x 95
Bruce Campbell-Smith, Cape Town

3. Untitled, 1989
oil pastel on paper, mounted on
masonite
Bruce Campbell-Smith, Cape Town

4. Chabani Cyril Manganyi
African Feast, 1990
oil on incised wood panel
173 x 244.2

5. Slaughtering for a hero
[Burial of a Hero IV], 1990
oil and acrylic on incised wood panel
81.2 x 121.9

6. Bhekisani Manyoni
Chalabash, nd.
wood cut
64 x 63

7. Family in Love, nd.
wood cut on tissue paper
71 x 63

8. Louis Khela Maqhubela
Untitled, 1989
oil on canvas
160 x 114
Private collection

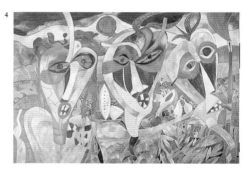

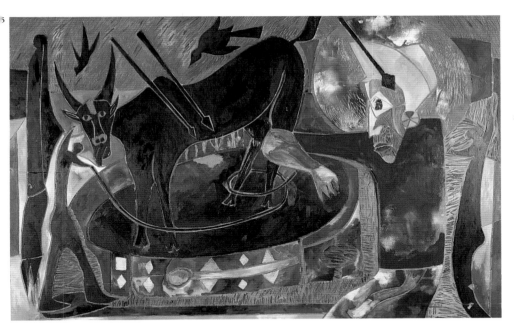

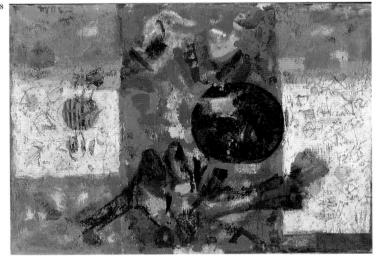

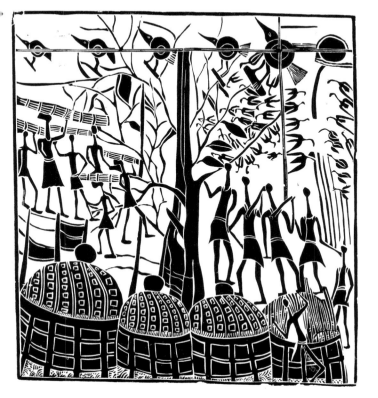

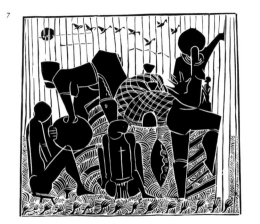

Dubani Tiki Phunguala

Born 1960, lives in Kwa Mashu

1980-2 B.A. Fine Art, University of Fort Hare, Alice, Ciskei
1983-6 taught at Mzuvale High School
1985 taught children on Kwa Mashu Community Project
 Founder member of the Natal Visual Arts
 Organisation [NAVAO].

Exhibitions
1982 University of Fort Hare Gallery, Alice Ciskei
1983 Festival of African Art, University of Zululand
1984 Festival of African Art, University of Zululand
1988 Cosath, A Culture Festival
 Currently working as a part-time artist and
 employed by the **Congress of South African
 Writers** [COSAW].

George Ramagaga

Born 1953, Pimville, Soweto; lives in Botshabelo Township,
Orange Free State.

Completed primary schooling in the East Rand. Attended
high school in Pietersburg.
1974 took Primary Teacher's Certificate in Groblersdal
 and Teacher's Diploma in Art at Ndaleni, Natal.
 Taught in black schools until 1983 when he took a
 studio at the STK centre where he works as a full-
 time artist.

Freddy Ramabulana

Born 1930 ? Venda, N. Transvaal; lives in Nzhelele, Venda

Freddie is an extremely traditional man. Like many of the older
artists he has a background training in traditional woodcarving
and wire weaving techniques. Like many of the artists he was
not really a good craftsman but a far better artist [this value
judgement is not consistent with the Venda point of view. There
is no name for *art* in Venda - only *beauty*. Thus things that are
well carved and especially well-finished are regarded by them as
beautiful; this is their concept of art].

Anyway Freddie's work is ugly - he carves roughly and
his images are ugly. In my opinion his work is the most "mod-
ern" of all the Venda artists. The strange holocaust figures,
always looking brave but lost and weak, express the unhappy
relationships that exist between most of the traditional people
[many dressed in Westernised clothing] and the new colonist
consumerism; most people live at the bottom of the scale and
can only afford the cheapest goods that the consumer society
offers.

The figure of a woman by Freddie Ramabulana included
in this exhibition was made over the past few months. Freddie
regards this piece as one of his best.

Freddie is no purist; he will carve whatever wood he
finds whether hard or soft and he treats both in a similar way,
resulting in rough, scarecrow figures with glass eyes, wigs and
tattered clothing.

Freddie is extremely poor and is treated very much as an
outcast in his society. He is tall, suffers from a rare skin disease,
very bad corns, and bad treatment from his fellows. He lives
with his mother in his kraal in Nzhelele Venda, doing odd jobs,

and carving to make ends meet.

David Rossouw.

Phillip Rikhotso

Born 1945, Mamedwa, Tzaneen district; lives in Dzumeri,
Gazankulu

Rikhotso had no formal schooling. He worked mining on the
Main Reef for one year then joined the Josephine mine at
Gravelotte
1977 began carving in earnest
1980 he and his family were relocated in Dzumeri [40km
 south of Giyani, the seat of the Legislative
 Committee of Gazankulu]. Here he continued to
 carve representations of animals and interpretive
 studies based on Tsonga folk tales. Sold his work
 on the roadside in Tzaneen, but presently sold his
 work through dealers making rounds in a light truck
1981 won first prize at the Giyani Agricultural Show.

Phillip is a sickly man, living in a very dry area of Gazankulu.
 Phillip's work varies greatly in quality. He is extremely
good at carving animals, some of which are superbly naturalistic
and in contrast he makes images like the **Spook Family** in this
exhibition which are roughly carved and painted. These figures
have a certain reference to traditional dolls in their poses. They
are carved in Quinine wood with the exception of the small ani-
mal which is carved in hardwood. Quinine trees [*Minadze*] is
the wood traditionally used to carve bowls, spoons, headrests
etc. This wood is easy to carve, wet or dry and if carved wet
does not crack very much while it dries.

David Rossouw.

Shelley Sachs and Graham van Wyk

Graham van Wyk
Born 1953, Cape Town; lives in Johannesburg

Currently working as National Education Coordinator, **S.A.
Commercial Catering and Allied Workers' Union** [SAC-
CAWU]
1971 matriculated Trafalgar High School, District Six,
 Cape Town
1972 registered for BA degree, University of Cape Town
1972-8 involvement in various cultural/educational organi-
 sations
1976 school librarian, Alexander Sinton High School,
 Athlone Cape Town
1977 graduated with BA degree in Sociology, University
 of Cape Town
 member: Super 8 Film Group; worked on a film
 depicting the destruction of Distict Six
1978 completed Higher Diploma in Librarianship,
 University of Cape Town
1981-3 committee member: Woodstock, Salt River, Walmer
 Estate Civic Association
 member: **WOSAWA** Youth Organisation
 member: **Azanian Students' Organisation**,
 University of Cape Town

member: W/Cape Coordinating Committee for the
Culture and Resistance Festival in Gaborone,
Botswana
Editor, **Forward Worker**, newspaper of the
Domestic Workers' Association
1983-5 research assistant, Southern Africa Labour and
 Development Research Unit, University of Cape
 Town. Researched socio-economic conditions of
 rural workers in the Little Karoo towns of Calitzdorp
 and Oudtshoorn
1984-6 assisted with the establishment of the Cape Town
 Trade Union Library;
 librarian, Cape Town Trade Union Library prepared
 cultural programmes for the Readers' Club of the
 library;
 participated in 2nd Carnegie Inquiry into Poverty
 and Development in Sothern Africa; conference
 paper, jointly with Dudley Horner: "Quiet
 Desperation - the poverty of Calitzdorp."
1985 organiser, **Commercial Catering and Allied
 Workers' Union** [CCAWUSA] Western Cape Branch
1986 elected Branch Secretary, **CCAWUSA** W/Cape
1987-9 National Education Officer, **CCAWUSA**
1989 National Education Coordinator, South African
 SACCAWU.

Shelley Sachs

Born 1950, Bloemfontein; lives in Johannesburg

1964-70 studied art under various artists: Ainslie; Skotness;
 Atkinson; Wake [drawing, etching, painting, sculp-
 ture]
1968-70 teaching art/creative expression / interdisciplinary
 art in Community Arts Centres
1970 worked on Peoples' Playground and with communi-
 ty/Rondevlei Cape
1970-3 Diploma in Fine Art and Post Grad. Dip Fine Art
 [distinction], Michaelis School of Art, University of
 Cape Town
1972-6 workshops for Johannesburg Art Foundation inter-
 mittently [1976, "Easel Painting"; Beuys;
 Performance Art; S.A. Association of Arts on "Art
 and Capitalism". 1977, Stellenbosch University on
 Beuys's Conception of Art; 1975, Cooper Union,
 New York; Beuys's Conception of Art; 1986,
 Zimbabwe - **What is Relevant Art?** at Art Centres
 in Harare and Bulawayo].
1974 studied and tutored at Hamburg University partici-
 pant in Post. Grad. seminar groups: Alternatives to
 the Avant-garde;
 Picture Analysis; Languages of Art; and "sculpture"
 under Franz Erhardt Walter
1974-5 Studied under Joseph Beuys - **Free International
 University**
1975 taught at Tertiary Institutions - Michaelis
1976 taught at Cape Town Arts Centre; High Schools-
 Trafalgar; Camps Bay
1977 participant at **Documenta 6** in the FIU/Joseph
 Beuys Group for 100 days
1977-9 taught at Langa Cultural Centre
1979 translated and disseminated **Alternatives to the**

Existing System of the East and West, for the
Beuys/Green/Third Road Alternative

1981-7 did private tutition for adults
1984-7 taught at Foundation School of Art
1986 worked on **Towards a People's Culture Festival**
1987 involved in Community Arts Programme
wrote Concept of Aesthetic Value, Honours compo-
nent for Cultural Sudies Course, African Studies
Centre, University of Cape Town
1988 Federated Union of Black Artists
1989 taught at Phuthing
1977-90 involved in various alternative education for various
community organisations and worker groups, in the
fields of cooperatives; early childhood education;
democratic processes and collective action and cul-
ture.
Currently a member of the **Artists' Alliance**
1990 accepted for M.Phil Thesis "Realism - and the
struggle for Liberation" at Warwick University, UK.

Exhibitions
1968 Breweries Biennial
1975 Responses to Detentions, Space Gallery
International Women's Year Exhibition, Natal
1985 **Art for Peace**, Cape Town
1988-90 exhibits at the African Art Centre, Cape Town.

Performances and Installations
1971-6 various in South Africa and Germany
1972 **Vigil over Time**, performance and installation
1972 Taming Power of the Great, Space Gallery, Cape
Town
1973 Allegory of the Mind, Space Gallery, Cape Town
1974 Fire Ceremony 1, Work Gallery, Hamburg
Fire Ceremony 2, Hamburg University
1975 Crying Earth, Cape Town [with eighty participants in
the city].

Book Illustrations
1988 **Children of Africa**, Vumani/Bucha Books

Commissions
1984 mural to celebrate worker's victories, Cape Town
Trade Union Library
1985 poster to commemorate **COSATU** launch
1976 media banners and logos for Trade Unions and
community oragnisations.

Monument to the Disposessed

We intend this installation as both a monument to the dispos-
sessed and a salutation to the workers in South Africa and all
over the world who rise up against their conditions.

Our work is not intended just for reception by an art
gallery public but aims to be accessible to, and find resonance
among working people not schooled in the values of "high art".
Speaking to this expanded audience does not necessarily mean
sacrificing complexity and glossing over contradictions.
However, it does sometimes mean making use of forms of direct
statement that appear to be offensive to the "discreet charm" of
the bourgeois art world.

This relates therefore, to yet another side of struggle -
this time for an alternative art practice.

Shelley Sachs and Graham van Wyk.

Joachim Paulus Schönfeldt
Born 1958, Pretoria; lives in Transvaal

Family moved to South West Africa [Namibia] soon after he
was born.
1975 matriculated Windhoek
Two years at Pretoria University
1978 enrolled at University of the Witwatersrand,
Johannesburg, begins as a sculptor
1981 graduated with BA [Fine Arts] degree, followed by
Higher Diploma in Education
1984-8 Employed by Meneghelli Holdings as
Curator/Manager/Researcher
1988 worked full-time as an artist
1989 worked in Italy.

Exhibitions
2 Group exhibitions, Market Gallery, Johannesburg
1985 New Visions, Market Gallery, Johannesburg
1986 Gallant House, Johannesburg [solo]
1988 Langerman gallery, Johannesburg [solo]
1989 Johannesburg Art Gallery [Vita Art Now].

Collections
Johannesburg Art Gallery; Market Theatre Foundation
Collection; University of South Africa, Pretoria; University of
the Witwatersrand, Johannesburg.

I recently sent a letter to an overseas friend with whom I have
not spoken since before February - a month which represented
a watershed in our country. In the letter I wanted to explain life
in South Africa, but it had to be South Africa behind the inter-
national headlines in the short three months of February, March
and April [This is written on Labour day, May 1st, 1990] I got
stuck. I rejected the nominal narrative option because I am not a
correspondent of note and English is not my mother tongue. I
came close to repealing this option after a dry spell of three
days where the letter did not progress beyond the exchanging of
pleasantries.
Gradually I was drawn to political cartoons that appear
in the local press. The cut-out cartoons were arranged in a
comic-strip fashion with comments of my own to contextualise
them. It was a clear way to solve my problem and to relate my
experience. My "loss for words" and solution to this while try-
ing to complete the letter, came to mind with this exhibition.
The recent political developments do not prepare one for its real
presence. Maybe that is why people call it "political climate" or
"political atmosphere".
It is because one feels it like the weather. To explain this
feeling is difficult. To communicate it in art is also difficult - a
kind of loss for words. It may be easier in times like these to
follow art with a word and image combination like the political
cartoon. Maybe better art is produced in the attempt to over-
come the loss for words. Inevitably there are artists who have
the ability to carry on making art unperturbed by the weather.
I find these three directions highlighted at the moment:

overt political art, art that overcame the loss for words and just
art. No doubt the exhibition takes cognisance of all of these
aspects. But I cannot help but feel that the real [art] struggle is
the middle one of the three.

Joachim Schönfeldt

Lucas Thuso Seage
Born 1956, Newclare, Johannesburg; lives in Soweto

1973 Barolong High School, Gaborone, Botswana [Form II]
1975 returned to Soweto
1976 Daelin College, Johannesburg
Mofolo Art Centre, Soweto [Cyril Kumalo]
1977 Open School, Johannesburg [Nats Mokgosi]
1978-80 **Johannesburg Art Foundation** [Bill Ainslie]
1981 First prize for sculpture [Konrad Adenauer
Foundation Bursary] at the The Haenggi
Foundation National Art National Art Competition
for black artists
1981-2 won first prize from **Pelmama Art Foundation**
which enabled him to take up 3 years scholarship.
Studied Heidiger University, Berlin, then went to
the Düsseldorf Academy, Düsseldorf [Joseph Beuys,
Klaus Rinke]
1987 Set design and building for local and national film
companies
1988 established Soweto interior and design consulting
agency to promote and educate local artists.

Solo Exhibitions
1980 Market Theatre Gallery, Johannesburg
1983 Market Theatre Gallery, Johannesburg
1989 Passe Par Tout Gallery, Johannesburg
[**Metamorphosis**].

Group Exhibitions
1981 The Haenggi Foundation National Art Competition,
Johannesburg
1983 The Haenggi Foundation National Art Competition,
Johannesburg [Pelmama Permanent Art Collection]
1988 Johannesburg Art Gallery [**The Neglected Tradition**].

Collections
S.A. National Gallery, Cape Town; Johannesburg Art Gallery,
Johannesburg; Pelmama Permanent Art Collection,
Johannesburg; University of Fort Hare, Alice, Ciskei.

Mmakgoba Mmapula Helen Sebidi
Born 1943 in Marapyane [Skilpadfontein] Hammanskraal
area, Northern Transvaal: lives in Johannesburg.

Her first teacher was her grandmother, a traditional painter
of walls and floors
Attended Khutsong Middle School
1959 left Khamane High School to work as a domestic
worker for a woman artist in Johannesburg.
1960s worked as a dressmaker
1970-3 studied with John Mohl
1975 returned to Marypyane, continued painting
1977 began selling work at **Artists Under the Sun**, in

All dimensions in centimetres

1. Johannes Maswanganyi
Dr. Malan, 1986-8
leadwood and enamel paint
139 x 27.5 x 27
Private collection

2. Verwoerd, 1987
wood and enamel paint
75 x 23 x 25
University of the Witwatersrand Art
Gallery, Johannesburg

3. Ancestor Tree, 1990
marula wood and enamel paint
127 x 116.5 x 59
Museum of Modern Art, Oxford

4. Menzi Mcunu
Postcard to the State President, 1990
photo-etching and aquatint
33.5 x 24.6

5. Mpumelelo Melane
Siamese Twins, 1989
wood
120 x 27 x 26

6. Harold Mettler
Dr. Mandela released from Victor
Verster Prison, 1990
linocut
44.7 x 32.1

7. Justice Sfiso Mkame
Love, 1987-8
craypas and wax crayon on paper
64 x 86
University of the Witwatersrand Art
Gallery, Johannesburg

8. Michael Mosala
Stations of the Cross III, c.1987
jarrah wood
The Catholic Mission, Botshabelo

9. Titus Moteyane
British Airways, c.1981
varnished enamel roof paint on slate
28 x 40.5
Gavin & Glenda Younge, Cape Town

10. Saulsville, Philadelphia,
Atteridgeville, c.1987
watercolour on paper
35.5 x 122.2
Gavin & Glenda Younge, Cape Town

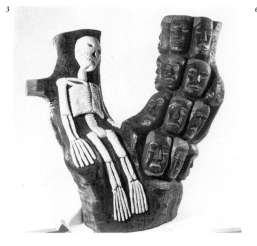

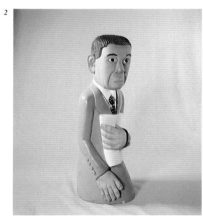

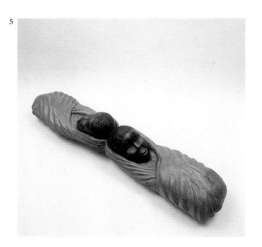

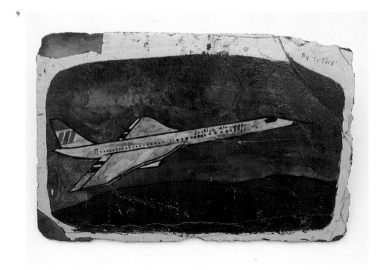

9

10

	Joubert Park, after showing it to Mohl
1985	studied pottery /clay sculpture at **Katlehong Art Centre** in Germiston: also taught pottery to children there
1986-8	taught in Alexandra
1986-7	worked at the **Johannesburg Art Foundation**
1987-8	participated the **Khula Udweba** art teachers project, organised by AIA at **FUNDA**

Exhibitions

1977	Johannesburg [**Artists under the Sun**]
1980	Johannesburg [Brush and Chisel Club].
1980-1	Washington, USA
1985	SA Pottery Exhibition]
1986	FUBA [solo]
	Sothebys Johannesburg [**Art for Alexandra**]
	Johannesburg Art Foundation [group]
	University of the Witwatersrand, Johannesburg [**Thupelo Workshop Exhibition**]
1987	Johannesburg Art Gallery [**Vita Art Now**]
	FUBA [Delfin/FUBA Creative Quest Exhibition]
	FUBA [Seven women artists]
	Johannesburg Art Foundation; Natal Society of Arts, Durban; National Museum and Art Gallery, Gaborone, Botswana [**Thupelo Workshop Exhibition**].
	SA - tour [**Standard Bank National Drawing Competition**]
1988	Market Gallery [**Detainees' Parents' Support Committee - 100 artists protest against detention without trial**]
	SA - tour [**Cape Town Triennial**]

Awards

1988	**Fullbright Scholarship**
	The Star Woman of the Year Candidate.

Collections

Africana Museum Johannesburg; Art Workshop, London, UK, Sasol Collection; University of Bophuthatswana, Mafikeng; University of South Africa, Pretoria.

Sydney Malefo Selepe

Born 1964, Alberton; lives in Soweto

1983	Matriculated Katlehong High School
1985-8	children's art tutor at the Progress Youth Club [a voluntary orgaisation in Soweto]
1987-9	Course on Child Art Education African Institute of Art
	worked at **FUNDA** Arts Centre as part-time Project Co-ordinator for the Creative Youth Organisation
1989	worked on the Joint Enrichment Project, as a children's art tutor for Leratong Arts group freelance illustrator for Frontline magazine
1990	appointed as Khulu Udweba Field Worker Studying for B.A. Fine Arts, with the University of South Africa and the African Institute of Art based at **FUNDA** Arts Centre, Soweto.

Exhibitions

1986	University of Zululand [group]
	student exhibition a **FUNDA** Centre
1987	Shell Gallery, Johannesburg [group]
	Wits Theatre Gallery, Johannesburg [group]
1988	Works [prints] selected by Matsemela Manaka for Europe tour with a play [SIZA]
	FUBA [3 artists]
1989	Johannesburg Art Gallery [**Vita Award** - A.A. Life]
	Works [prints], selected by Theo Gerber for Paris Horizonte Arte Difusâo, Mozambique [group]
	University of Zululand [group]
	Sol Plaatjie Exhibition, Unibo [group].

Commissions

Mural for Sego, The African Calabash, Market Theatre [with Nhlanhla Xaba]

1988	Mural for **Sounds of Africa**; for example, Bayete and Sakhile, Market Theatre
1989	Mural for **Siyazazi Modelling School**, 7th Floor Medical Centre, Johannesburg.

Awards

1985	SANCA
1986	Solly Weiner Study Bursary.

Collections

FUNDA Arts Centre;
Private collectors, South Africa; Mozambique; Germany; Spain.

Book Illustrations

Poetry book for children [NEAC]
English book for primary school children [Skotaville].

Dr Phuthuma Seoka [Phatuma]

Born 1922, Modjadji, near Duiwelskloof, Lebowa; lives in Modjadji, Northern Transvaal

Left school in Standard IV and went to Johannesburg for sixteen years

1953	established "Seoka's Twin Products" and a herbalist trade in patent medecines and remedies
1966	returned to Molototsi, near Duiwelskloof and opened a barber's shop. Began carving cow horns and later soapstone
1976	began to carve animal figures from indigenous wood and then human figures and heads.

Exhibitions

1983	Milner Park, Johannesburg [**S.A. Contemporary Art**]
1985	Africana Museum in Progress, Johannesburg [**Tributaries**]
	Market Theatre Gallery [**Out of Africa**] Johannesburg
1986	University of the Witwatersrand, Johannesburg [2 person exhibition with Dr Jim Magumu]
	South African Association of Arts, Western Cape University of the Witwatersrand, Johannesburg [Standard Bank Foundation Collection of African

	Art]
1987	Goodman Gallery [solo]
	Basel, Switzerland [Art Fair]
	Standard Bank National Arts Festival, Grahamstown [**VhaVenda Exhibition**]
	Passe par Tout Gallery, Johannesburg [group]
1988	South African Association of Arts, Pretoria [**VhaVenda/Shangaan Wood sculpture**]
	Johannesburg Art Gallery [**Vita Art Now**].

Collections

Durban Art Museum; Johannesburg Art Gallery; Tathum Art Gallery, Pietermaritzburg; University of the Witwatersrand, Johannesburg.

Dr Phuthuma is of the Pedi [Northern Sotho] people. Johannes Maswanganyi is a Shangaan. Phuthuma is older. They live very close to each other - they were friends, until Johannes started painting his sculpture, which Doc says was directly copying him. Now they are not friends.

There is a distinct difference between the two artist's work. Doc prolific, paying less attention to detail, produces many works where the untouched forms of the trees are merely painted to incorporate them into the sculpture. His themes vary vastly. He is extremely eclectic, copying the work of the late Nelson Mukhuba whom Doc revered, and doing many generalised images of race types, dancers, politicians etc. Thus Doc's oeuvre is indefinable. He produces drums, headrests, stools, wire cars [almost anything that he thinks will sell]. He carves wet wood. Corkwood trees are his favourite in that they are soft and light. The form of the living trees often conjurs up formal relationships which resemble figures - perhaps it is after seeing Doc's work that I look at Corkwoods with this kind of eye. Corkwood is almost impossible to carve when it is dry as it becomes cork, and doesn't so much carve as squash. Typical of Doc is his use of paint. His colours are vivid, often the paint covers up his lack of finished detail.

Doc has been a salesman, a wrestler, a producer of curios for many years - he is an entrepreneur involved in selling vegetables and art. His two sons have helped produce a vast number of his works; thus Doc's works could be classified as studio works. Both his sons are extremely creative: Zak, the older, is now in Johannesburg, and Lazarus, is still at home completing his schooling. Both of them hope to get a formal education in art.

David Rossouw

Paul Sibisi

Born 1948, Umkhumbane, Durban; lives in Kwa Mashu, Natal

1954-61	Primary education, Ekujabuleni B.C. School and Chris Nxumalo Higher Primary School
1962-5	Chesterville Secondary School, Durban [Std IX]
1966-7	teachers training programme at Amanzimtoti Teachers Training College
1968	awarded a Department of Bantu Education bursary studied art at Ndaleni Art School
1969-71	taught art at Appelbosch Training School
1973-4	funded by a bursary awarded by the South African Institute of Race Relations in Durban, studied at Rorke's Drift

1975-7 taught at Kwathambo Combined School near Amanzimtoti

1984 received an **Operation Crossroads** Africa grant

1987 studied art education and graphic techniques at Fircraft College in Birmingham, UK
Present teaches art, English and guidance at Mzuvele High School in KwaMashu.

Exhibitions

1968 Metropolitan Church Hall, Pietermaritzburg [group]

1970 University of Fort Hare [Annual Exhibition]

1973 [Black Expo]
Durban Art Museum [**Art S.A. Today**]
Bojoj Gallery, Durban [solo]

1974 Natal Society of Arts, Durban [two-person exhibition with Vuminkosi Zulu]

1976 Norman Dunn Gallery, Hilton College, Natal [Urban African Art]

1980 Natal Society of Arts, Durban [Members Exhibition]
University of Zululand [African Arts Festival]

1981 Gallery 21 [Haenggi Foundation National Art Competition Exhibition]
African Art Centre, Durban [solo]
University of Zululand [African Arts Festival]
[Exhibition of Black Art as Represented in the Campbell Collections of the University of Natal]
National Society of Arts, Durban [members exhibition]
African Art Centre, Durban [solo]

1982 National Museum and Art Gallery, Gaborone, Botswana [**Art Toward Social Development. An Exhibition of S.A. Art**]
Bradford, U.K. [International Print Biennale]
National Society of Arts, Durban [My environment - members exhibition]
University of Zululand [African Arts Festival]

1983 University of Zululand [African Arts Festival]

1984 University of Zululand [African Arts Festival]
Bradford [International Print Biennale]
National Society of Arts, Durban [Weddings - members exhibition]

1985 Africana Museum in Progress, Johannesburg [**Tributaries**]

1986 Gallery 21 [Contemporary African Art. Selected works from the Pelmama Permanent Art Collection]

1987 Anderson O'Day Gallery, London, U.K. [**My people are our people** - solo]
Paul Mikula and Associates, Durban [group].

Awards

1970 University of Fort Hare Art Exhibition [award]

1973 Black Expo 1973 Graphic art award

1980 Art on the Mole 1980 [third prize]

1981 Art on the Mole 1981 Competition [first prize]
Haenggi Foundation National Art Competition [fourth prize]

1984 **Operation Crossroads Africa Grant**.

Durant Sihlali

Born 1935, Germiston; lives in Soweto

Early interest in art encouraged by his father, who practiced drawing and modelling

1947 family moved to Moroka, Soweto

1950s began painting murals for business premises and homes

1950-3 studied at Chiawelo Art Centre, Moroka, under Alphius Kubeka

1953-8 studied at Polly Street Art Centre under Cecil Skotnes. Studied briefly under Carlo Sdoya, then with Sidney Goldblatt

1965-6 Sihlali and Ulrich Schwanecke travel on landscape painting trips

1965-70 continued own work whilst designing jewellery and curios for Atlanta

1970 began painting full-time

1978 began teaching on **FUBA** outreach programmes

1983 appointed Head of Fine Arts, at **FUBA**

1985-6 attended Arson Art School, Nice for six months [French Goverment Scholarship].

Exhibitions

1966 Lidchi Art Gallery, Johannesburg [monotypes - solo]

1967 Adler fielding Galleries, Johannesburg [solo]

1968 Lloys Ellis Gallery, Johannesburg [solo]

1969 Gallery Michaelangelo, Johannesburg [solo]

1970 Group Elysia, Johannesburg [group]

1972 Gallery 101 [group]
Triad Gallery, Johannesburg [solo, group]

1974 National Arts Society, Johannesburg [African Art]
Triad Gallery, Johannesburg [solo]

1975 Elizabeth Art Gallery, Johannesburg [solo]
Johannesburg [Group 51 Winter Exhibition]

1976 Elizabeth Art Gallery, Johannesburg [solo]

1977 Pieter Wenning Gallery, Johannesburg [solo]

1978 Everard Read Gallery, Johannesburg [solo]

1979 Gallery 21 [group]
Nuremburg, West Germany [group]

1979-80 South African Association of Arts, Johannesburg [Renaissance II '79]

1981 Athens, Greece; Palermo, Italy; USA; Canada - tour [group]

1982 Gallery 21 [solo; group]
National Museum and Art Gallery, Gaborone, Botswana
Rand Afrikaans University, Johannesburg [Living Arts]
London, UK [Watercolour Society Exhibition]

1983 Milner Park, Johannesburg [SA Contemporary Art]
Gallery 21 [group]
Mphatlalatsane Community Hall, Sebokeng [group]

1984 University of Zululand [African Arts Festival]

1985 **FUBA** [group]

1986 Gallery 21 [contemporary African Art selections from the Pelmama Permanent Art Collection]

1987 **FUBA** [solo]

1988 Johannesburg Art Gallery, [**Vita Art Now**]

Awards

1947 School art competition for Queenstown [first prize]

1978 Marianhill Institute [first prize, painting]

1982 University of Zululand Arts Festival [second prize, sculpture]

1983 University of Zululand Arts Festival [first prize, graphics]

1986 French Government Scholarship.

Commissions

1960 Church of the Good Shepherd, Tladi, Soweto

1972 Heidelberg Anglican Church

1978 AMCOL, Witbank

1985 Almex, Elandsfontein near Islando

1986 Hulett Aluminium Ltd.

Collections

Africana Arts Museum, Johannesburg; Amcol, Witbank; Barclays Bank; De Beers, Kimberley; **FUBA**; Kasigo Hospital, Krugersdorp; National Museum and Art Gallery, Gaborone, Botswana; Standard Bank, Johannesburg and Soweto; University of Fort Hare, Alice, Ciskei.

Durant Sihlali is one of the key figures in the recent development of art among the black communities.

Teaching by example, technically gifted and always searching for new ways of working, his work ranges from murals for churches and house walls, to plein air, documentary watercolours which record the Pimville Removals during the early 1970s, to large monumental sculptures in steel and wood, to large-scale abstractions in acrylic and paper pulp.

At present Sihali is experimenting with methods of constructing images using paper pulp and pigment.

David Elliott

Penny Siopis

Born 1953, Northern Cape; lives in Johannesburg

1974 graduated, Rhodes University [Grahamstown] with B.A. Fine Arts degree

1976 graduated, Rhodes University [Grahamstown] with Master of Fine Arts degree

1978 studied Portsmouth Polytechnic [British Council scholarship].

Solo Exhibitions

1976 Hellenic Centre, Port Elizabeth

1978 Collectors' Gallery, Johannesburg

1980 Hiscock Gallery, Portsmouth, U.K.

1983 Market Gallery, Johannesburg

1987 Goodman Gallery, Johannesburg.

Joint Exhibitions

1977 N.S.A. Gallery and Settlers Museum, Grahamstown [with R. Hogge]

1981 Jack Heath Gallery, University of Natal, Pietermaritzburg [with P. Schütz]

1984 Gallery International, Cape Town [with P. Schütz]

1986 Goodman Gallery [with P. Schütz]
Basel International Art Fair, [with P. Schütz].

All dimensions in centimetres

1. Tommy Motswai
Putco Bus, 1985
charcoal and pencil on paper
52 x 71
The Goodman Gallery, Johannesburg

2. Lenyalo at home from Rockville,
1988
pastel on paper
68 x 114
Mrs L. Givon, Johannesburg

3. The Escalator, 1988
oil and pastel
103 x 69
Tatham Art Gallery, Pietermaritzburg

4. James Serole Mphahlele
Day of Trimming
[from Dialoga series part 7], 1987
linocut 6/75
34 x 78.5
Pelmama Permanent Art Collection,
Johannesburg

5. Owen & Goldwin Ndou
Man with snake, 1990
Sycamore fig wood and paint
129.7 x 31 x 36.7
Bruce Campbell-Smith, Cape Town

6. Charles Nkosi
Self Portrait, 1989
watercolour
86 x 67

7. Anthony Nkotsi
A Couple, nd.
etching, aquatint and drypoint
110.5 x 124

8. Derrick Nxumalo
Wild Coast Casino Bus, nd.
Felt tip pen on card
Durban Art Museum

9. The Vaal-Reefs Exploration and
Mining Company [Pty] Ltd, 1987
pen, ink and koki pen
61 x 86
Tatham Art Gallery, Pietermaritzburg

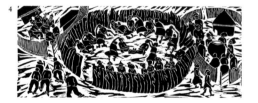

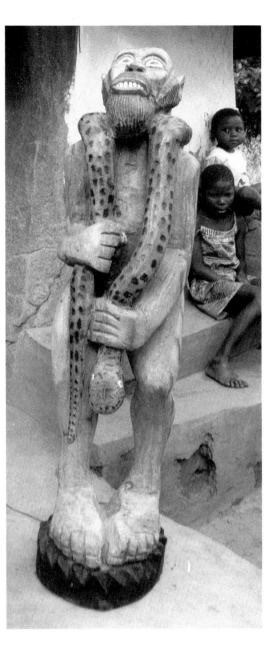

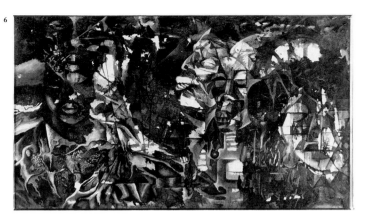

6

8

9

7

Group Exhibitions and Selected Major Exhibitions

1982 **Cape Town Triennial**, S.A. National Gallery, and Travelling S.A.

1983 Natal Lecturers Exhibition, Studio Gallery, University of the Witwatersrand, Johannesburg
Group Exhibition [with C. van den Berg and A. Botha] Café Gallery, Durban

1984 Wits Fine Arts Staff, Goodman Gallery

1985 Tributaries, S.A. Art for W. Germany
Women Artists in South Africa, S.A. National Gallery
Cape Town Triennial, S.A. National Gallery, and Travelling S.A.
100 Years of Natal Arts, NSA Gallery and Tatham Art Gallery, Pietermaritzburg

1986 Wits Fine Arts Staff, Goodman Gallery
Patrons' Trust Print Portfolio, Goodman Gallery

1987 **Vita Art Now**, Johannesburg Art Gallery
Standard Bank National Drawing Exhibition, 1820 Settlers Monument and Travelling S.A. **CASA Exhibition**, Oosterkerk, Amsterdam, Holland

1988 **Detainees' Parents Support Committee Exhibition**, Market Gallery
Vita Art Now, Johannesburg Art Gallery
Cape Town Triennial, S.A. National Gallery and Travelling S.A.
Human Rights Exhibition, Durban

1989 Basel International Art Fair [with Norman Catherine, Johannes Segogela and Peter Schütz]

1990 **Women choose Women**, Gertrude Posel Gallery, University of the Witwatersrand.

Awards

1975 HSRC Grant for Post-Graduate Research

1978 British Council Scholarship for Post Graduate Study in the U.K.

1985 **Cape Town Triennial**, Merit Award

1986 **Volkskas Atelier Award**, First Prize, CitéInternationale Des Arts, Paris

1988 **Vita Art Now**, Quarterly Award Winner
Vita Art Now, Merit Award.

Public Collections

Afrox; Chase Manhattan Bank Collection, New York; Durban Art Museum; Tatham Art Gallery, Pietermaritzburg; King George VI Art Gallery, Port Elizabeth; Pretoria Art Museum; Rembrandt van Rijn Foundation; Rhodes University; Roodepoort Museum; Sasol Collection; S. A. National Gallery, Cape Town; Technikon Natal; Trust Bank; University of the Witwatersrand Art Galleries; Unisa; William Humphreys Museum, Kimberley

Like many other South Africans I have been much affected by the way local history has been depicted - its distortions, its visual conventions. My recent work is a sort of ironical history painting.

I intend my pictures to be rhetorical. The title of one, **Piling Wreckage Upon Wreckage**..., comes from a piece of writing by Walter Benjamin. His words seem to be emblematic of the qualities or sense I would like my picture to embody - artifice, passion, the weight of history:

*A Klee painting, named **Angelus Novus**, shows an angel looking as though she is about to move away from something she is fixedly contemplating. Her eyes are staring, her mouth is open, her wings are spread. This is how one pictures the angel of history. Her face is turned toward the past. Where we perceive a chain of events, she sees one single catastrophe which keeps piling wreckage upon wreckage and hurls it in front of her feet. The angel would like to stay, awaken the dead, and make whole what has been smashed. But the storm is blowing from Paradise: it has got caught in her wings with such violence that the angel can no longer close them. This storm irresistibly propels her into the future to which her back is turned, while the pile of debris before her grows skyward. This storm is what we call progress.*

[Walter Benjamin: **Theses on the Philosophy of History**]

Penelope Siopis.

Clive van den Berg

Born 1956, Kiwe, Zambia; lives in Johannesburg.

1974-9 graduated at the University of Natal with B.A. in Fine Arts.

1985-7 Vice President of Natal Society of Arts
Council Member of Durban Arts Association
Consultant artist to Hallen Theron and Partners, and Ferreira da Silva [Architects]

1985 External Examiner, University of Durban, Westville

1987 External Examiner, University of Natal

1988 External Examiner, University of South Africa.

Solo Exhibitions

1980 N.S.A. Gallery, Durban

1982 N.S.A. Gallery, Durban

1984 Gallery International, Cape Town

1986 Loft Theater Gallery, Durban

1987 Karen McKerron Gallery, Johannesburg.

Group Exhibitions

1979 Institute of Race Relations Exhibition, University of Natal
New Signatures Exhibition, N.S.A. Gallery, Durban

1982 "Natal Artists", Durban Art Museum
2D-3D, Gallery 567, Durban
"Drawing in Natal", University of Natal, Pietermaritzburg

1983 Staff Exhibition, University of the Witwatersrand
Three Artists, Cafe Gallery, Durban

1984 Staff Exhibition, S.A.A.A. Gallery, Pretoria
"Natal Art", Durban Art Museum, Durban

1985 Natal Arts Trust Exhibition, Natal Museum, Natal
"Paperworks", N.S.A. Gallery, Durban
"100 Years of Natal Art", N.S.A. Gallery, Durban and Tatham Art Gallery, Pietermaritzburg
"Durban Pictures" 3 artists, S.A.A.A. Gallery, Pretoria
Cape Town Triennale touring South African museums
Tributaries, B.M.W. Group Exhibition, West Germany and Johannesburg

1986 **New Signatures Past Award Winners**, N.S.A. Gallery, Durban

1987 Staff Exhibition, N.S.A. Gallery, Durban
Natal Landscape, N.S.A. Gallery, Durban
Volkskas Atelier, S.A.A.A. Gallery, Pretoria
Standard Bank National Drawing Competition, South African museums
Painted Clocks, Goodman Gallery, Johannesburg
Art for Alexandra, Sotheby's, Johannesburg

1988 **Cape Town Triennale** touring South African museums
Detention Without Trial 100 Artists Protest, Market Gallery, Johannesburg
Vita Awards Exhibition, Johannesburg Art Gallery.

Awards

1979 **New Signatures** Exhibition, N.S.A. Gallery
Emma Smith Scholarship

1985 Natal Arts Trust, Natal museums, overall winner
Paperworks, N.S.A. Gallery, Durban, overall winner

1987 **Volkskas Atelier Young Artist Award**, overall winner.

Commissions

1985 Large public fountain, City of Durban, glazed, ceramic, brick, stainless steel, aluminium

1987 Three murals for Dining Halls, Mangosuthu Technikon, Umlazi, Durban

1988-90 Mosaic floor and murals for His Royal Highness Mswati III, Mbabane, Swaziland [in process].

Public Collections

S. A. National Gallery, Cape Town; Johannesburg Art Gallery; Durban Art Museum; Pretoria Art Gallery; Tatham Art Gallery, Pietermaritzburg; William Humphreys Art Gallery, Kimberley; Margate Muncipality; University of the Witwatersrand Art Galleries; University of Natal; University of South Africa; University of the Orange Free State; Technikon Natal; Mobil Oil [SA]; Volkskas Bank; Mangosunthu Technikon.

Cally van der Merwe

Born 1964; lives in Sandton, Cape Town.

1986 Graduated after studying sculpture at Michaelis School of Fine Art, Cape Town

1987 Advanced Diploma in ceramics at Michaelis School of Fine Art, Cape Town

1988 started making ceramic plates

1989 taught art at a High School

1989-90 now working on plaster prints.

Vuyile Voyiya

Born 1963, Cape Town; lives in Cape Town.

1982 matriculated Nyanga Senior School, Engcobo
1983-4 worked with social workers fro the **Students'
 Health and Welfare Centres Organisation**
 [SHAWCU] conducting surveys
1985 studied art at **CAP**, full-time
 established the Newsvendor's Advice Office [as a
 direct result of survey work] in connection with the
 MWASA.
1984-8 assistant to various chidren's art teachers
1986-90 studied at Michaelis School of Art, University of
 Cape Town, for a B.A. Fine Arts
1989-90 teaching art to children on a part-time basis
1990 additional post at **CAP**, teaching print-making.

Exhibitions
CAP Open Day Exhibitions
Art on campus, University of Western Cape
1989 **Pictorial Art from Southern Africa**, Stockholm,
 Sweden.

Awards
1985 2nd prize in **Grassroots Year of the Youth
 Competition**
1989 Won the **Matt Anderson Merit Award**.

Gavin Younge

Born 1947, Bulawayo, Zimbabwe; lives in Cape Town

Studied Fine Art at the Johannesburg School of Art and
History of Art through the University of South Africa,
Pretoria. Completed MA at the University of Cape Town
where he is presently Senior Lecturer and Head of the sculp-
ture section
1975-6 initiated a community arts programme called **The
 Workshop** in a Cape Town warehouse.
1977 this was reconstituted as the Community Arts
 Project and he served as Chairperson of the first
 board of Trustees
1979 read a paper at the **State of the Art Conference** at
 the University of Cape Town
1979-83 won major South African awards for his 85 sculp-
 tures
1986 received the **Young Artist of the Year Award**,
 sponsored by Standard Bank
1980s has worked on documentary films, two of which
 secured international distribution
1982 read a paper at the **Art and Resistance
 Conference** in Gaborone
1988 **Art from the South African Townships** published
 by Thames and Hudson, London
1988 was elected Secretary of the **UDF** affiliated,
 Cultural Workers' Congress.

Collections
Johannesburg Art Gallery; University of the Witwatersrand,
Johannesburg.

Dorothy Zihlangu

Born 1920, Alice, Ciskei; lives in Guguletu, Cape Town
Mother was a dressmaker and as a young girl she learnt to
make dolls

1939 moved to Cape Town
1940 married
1952 joined **Defiance Campaign** of the **ANC**
1958 involved in **Anti-Pass Campaign**
1960 arrested, with her two children
1976 joined rent campaign
1981 member of **United Women's Organisation** [UWO]
1982-5 Chair of **UWO**
1986 merger of Women's Front of **UWO** to form **United
 Women's Congress** [UWC]
1985-6 arrested; started embroidery, appliqué work whilst
 in prison
1986-7 in hiding
1988 re-arrested under **Emergency Detention Laws**.
 Defied restrictions and was re-imprisoned
1989 released when restrictions lifted;
 attended **International Women's Conference**,
 Amsterdam.

Tito Zungu

Born 1946, Mapumulo district, Natal; lives in Durban.

Had no formal education or art training, but as a teenager
made clay models
1957 began to draw
1960 began to sell the envelopes which he decorated to
 workers who were sending letters home
1966 went to Pinetown, Natal, worked in a dairy
 Late 1960s, worked in Durban, first as a gardener,
 then as a cook
1970 a friend of Zungu's showed his work to Mary Clarke,
 who brought it to the attention of Jo Thorpe at the
 African Arts Centre, Durban, where his work was
 first commercially marketed.

Exhibitions
1971 Durban Art Museum [**Art SA Today**]
1973 Durban Art Museum [**Art SA Today**]
1975 Durban Art Museum [**Art SA Today**]
1981 Durban [**Festival Art Exhibition**]

Collections
University of the Witwatersrand Art Galleries.

All dimensions in centimetres

1. Dubani Tiki Phungula
Leaping to People's Culture, nd.
silkscreen
33 x 25.2

2. Freddie Ramabulana
Female Figure, 1990
wood, clothes, hat, wire and stick
176.9 x 33.5 x 32.8
Private collection

3. Detail of Female Figure by
Freddie Ramabulana

4. Philip Rikhotso
Spook family, 1989
Quinine wood and PVA [7 figures]
17.2 x 20 x 6.5 [smallest],
141.3 x 46.2 x 25 [tallest]
Private collection

5. Untitled, 1989
[figure with wreath on head]
wax crayon on Shifata wood
72 x 24 x 33
Bruce Campbell-Smith, Cape Town

6. Shelley Sachs & Graham Van Wyk
Monument to the Dispossessed, 1990
mixed media; wax, pitch, oil and wood
196.5 x 123.2 x 68.6

7. Joachim Schönfeldt
To Hannah with love, Castello, 1989
wood, paint, varnish and ceramic
48.9 x 60.7 x 4.8
Hannah Le Roux

8. Lucas Seage
Found Object, 1981
mixed media
41 x 102 x 195
Pelmama Permanent Art Collection,
Johannesburg

9. Helen Sebidi
Untitled
pastel on paper
169 x 122

10. Sydney Selepe
Towards Emancipation, 1988
linocut
30 x 30

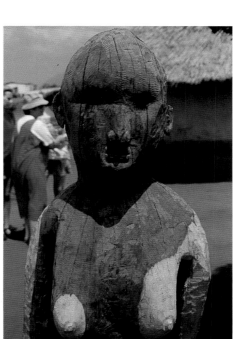

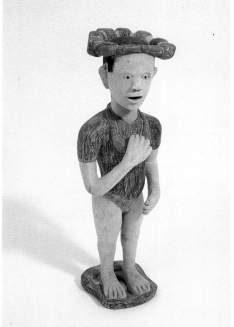

8

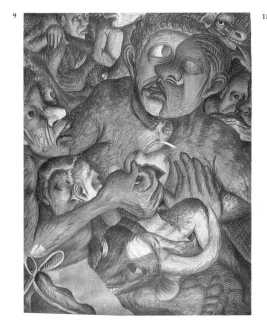

9

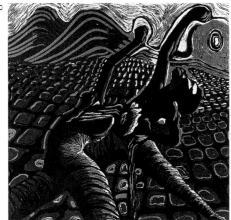

10

linocuts

graphic art production in the the transvaal, natal and the western cape

A report by the Visual Arts Group of the Cultural Workers' Congress, [CWC] **Cape town.**

While not an everyday sight, it would not be unusual to find someone carving out a linocut in a third class compartment of a train. This means of creative expression and production is a living tradition amongst many black artists in the Western Cape. Almost without exception it is used to explore and reflect the daily realities of people's lives - a scene in a train or shebeen, a domestic scene, police harrassment, even "cops and robbers". While the images may be abstracted to heighten their expressive qualities, it is very rare to see a purely abstract lino. These works, therefore, speak to many of our people as a direct expression of our lives.

Why has this tradition arisen? Generally linos are small, they can be held on a lap or worked on, at a kitchen table and machining is not necessary for the printing of the image. Where people are living in cramped conditions, often without electricity, these factors are crucial.

In economic terms, lino or wood is relatively cheap and the print image is duplicated. Duplication has a two-fold impact:
[a] one work can be sold to many people at a much cheaper price than, for example, a painting which would generally be too expensive for the majority of working people.
[b] the duplicated image ensures a much wider audience - one work can communicate with many people.

In Cape Town, the growth of the tradition has been nurtured by the **Community Arts Project,** a non-formal educational institution which has been in existence for the past thirteen years, providing skills, training and access to resources to communities which are economically, politically and socially marginalised. Most producers of linocuts have passed through **CAP** or are currently working there.

One linocut producer spoke of the fact that lino is a medium which enables him to express himself despite a limitation of skills in drawing and a practiced understanding of colour. People often work directly on the linocut rather than from a drawing and the image "develops from itself". The cutting of a lino is a totally absorbing test. Through this "dead thing [I] bring to life" striking and dynamic black and white images. These are created to assist both producer and viewer to make sense of our South African reality.

A report by Paul Sibisi for the Natal Visual Artists' Organisation, [NAVAO] **Durban.**

1. Ndalemi Art School
Art specialist teacher trainees had their first hand experience of working in any graphic media during the 1960s at this Art School. I clearly remember when we made a potato print/avocado pip print at Ndalemi Art School for the first time. We also printed with other objects such as waste materials: bottle tops, corrugated cardboard, cotton reel tops, strips of twined ropes etc. After this experience,we were introduced to linoleum cutting, incising a lino block with sharp tools, this fascinated us when we realised the variety of marks we could obtain. We test printed on newsprint, and designed logos on linoleum. We were then introduced to fabric printing, using lino, imprinting the design on white calico with fabric inks. Materials used were rollers, coates inks [usually black] and spoons. We rubbed with a spoon at the back of a print to make the imprint. We also made use of chalk powder to avoid tearing off a pressed print. All this served as an introduction to a graphic media and techniques for use in Primary Schools.

2. Rorke's Drift Art School
This Fine Arts course during the 1970s, presented further possibilities for varied productions of graphics. We worked in studios with such facilities as copper plates, etching presses, acid baths, burnishes, gas stoves, lamps, linoleum blocks and wood cut blocks. Techniques were taught, such as how to spread coates ink using a roller on a glass slide; how to construct our own tools [out of wire] to scratch marks on a copper plate; also how to use wood-cut tools. We tried using different kinds of paper when printing for editioning proofs. We learnt to use more than one block, to print a colour print. Artists developed individual and expressive styles which were widely sought after.

3. Post-Student era i.e: Natal Technikon Graphic Studies
This period provided me with new influences, better working space and technical efficiency in production. There were also broader cultural influences: the work of European artists - Rembrandt, Dürer, the German Expressionists and the approaches of modern art. Lack of facilities in our community areas forced us to appeal to lecturers at Natal Technikon for printing lino/wood blocks. We still continued to used the spoon rubbing technique. To express the conditions under which we live we prefer to use stark monochromes

A report by David Koloane, Johannesburg [1]

The linoprint technique is one of the most accessible mediums available for artists living in the crowded social conditions of the township. The technique does not require elaborate space facilities and sophisticated equipment. One of its primary virtues is that it can be executed in any place and at any time. It is this portable quality which enables the township artist to perserve in his creative experience.

The cutting tools for organizing a composition on linoleum support can be improvised in the absence of standard tools.

The linoprint techniques has for this reason become an integral aspect of tuition in the informal art centre structures such as **FUBA, FUNDA, Mofolo,** and **Katlehong.** Some of the tutors presently teaching in the centres are graduates from Rorke's Drift Centre [**ELC**] in Natal. The Rorke's Drift Centre was the first institution to give expression to the linoprint technique, a factor which enhanced the reputation of the centre nationally and internationally. Younger artists are engaged in exploring colour in linoprint.

The subject matter of linoprints within the art centre context is socio-realistic and genre scenes.

Alternative Materials
"... the non-specialist casual approach and the implicit belief that the workers have, that any one can do anything well in the workshop, tends to demystify art.

To produce art of a reasonable standard is not necessarily dependent on a well-equipped studio or workshop. It is often the resilience of the artist with the materials at hand. Granted, a well-equipped studio does facilitate the process of image-making to a large extent, yet it is essentially the artist's ingenuity in manipulating material which finally determines the aesthetic quality of the product.

The plight of the artist living in the township in the virtual absence of adequate facilities and tuition leaves him very few options as described earlier. He is often compelled to resort to unorthodox methods - which means coming to terms with his desolate surroundings.

[1] Extract from a dissertation for a diploma in museum studies certificate, 1985, University of London, Press.

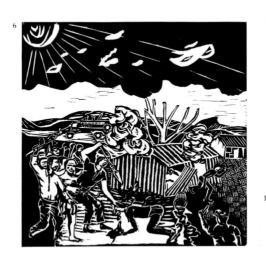

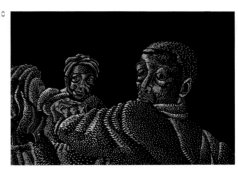

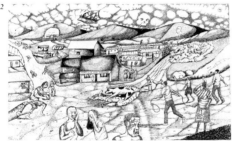

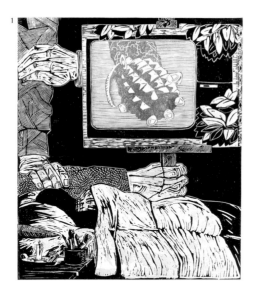

All dimensions in centimetres

1. John Berndt
Botswana Assassinations, 1985
linocut
59.5 x 49

2. Moses Buthelezi
A Day in Our Life, nd.
biro on card
47 x 73.3

3. Ricky Dyialoyi
Mandela: Release Celebration, 1990
linoprint
30 x 40

4. Billy Mandindi
Prophecy III, 1985
linoleum relief print on paper
62 x 45.5
Gavin & Glenda Younge, Cape Town

5. Xolile Mtakatya
Behind the Bars, nd.
colour linocut
23 x 31

6. Dubani Tiki Phungula
Who is your brother? nd.
linocut
30.5 x 30

7. Vuyile C. Voyiya
Rhythm in 3/4 time I, nd.
linocut
42.5 x 59.5

8. Rhythm in 3/4 time II, nd.
linocut
42.5 x 59.5

9. Rhythm in 3/4 time IV, nd.
linocut
42.5 x 59.5

10. In the coffin in my skin, nd.
linocut
42.2 x 59.5

1. Dr Phuthuma Seoka
Black Dog, 1989
velvet corkwood, enamel paint
and nails
97.5 x 101.4 x 45.8
Museum of Modern Art, Oxford

2. Dog / Leopard, 1989
corkwood, enamel paint and nails
55 x 115.8 x 32.5
Museum of Modern Art, Oxford

3. Gavin Younge
Narrap, 1986
bronze
67.5 x 21 x 21

4. Paul Sibisi
The classroom wrangle III, 1989
linocut
29 x 30.9

5. Durant Sihlali
At the Communal Tap on a Sunday,
1973
watercolour
75 x 105

6. Penny Siopis
Piling Wreckage Upon Wreckage,
1989
oil on canvas
200 x 181
S.A. National Gallery, Cape Town

7. Clive van den Berg
Sad Lady Waving Still, 1989
oil on canvas
238 x 129

8. Dorothy Zihlangu
A Woman's Place is in the Struggle,
1985
drawing on a pillowslip, appliqué
69 x 44.5

9. Tito Zungu
City Skyscape with Plane, nd.
ballpoint on paper
19.5 x 32.5
Rodney Harber, Durban

10. Made in South Africa [PTY] LTD,
1971
ball point ink on envelope
10.2 x 26.6
Gavin & Glenda Younge, Cape Town

11. Untitled, nd.
ball point ink on paper
19.5 x 46
African Art Centre, Durban

1
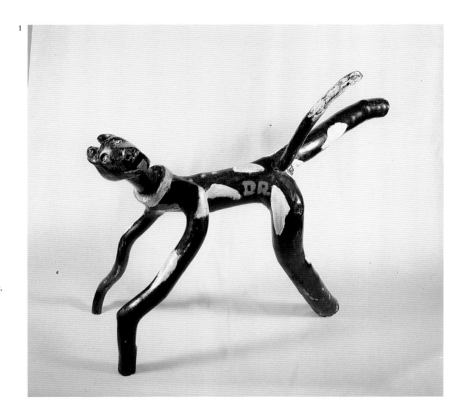

3
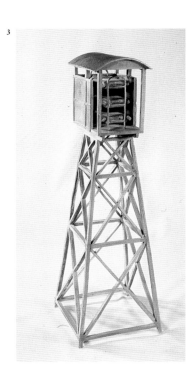

2
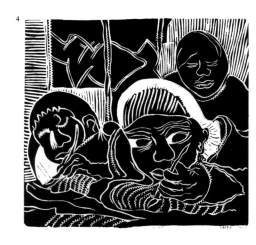

4
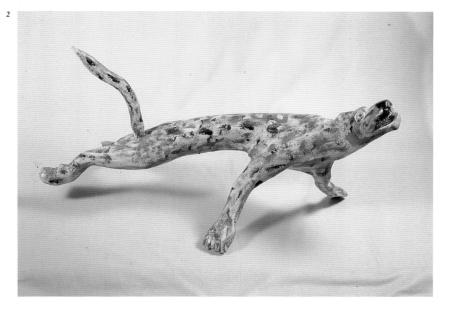

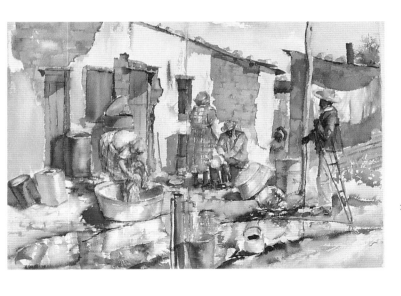

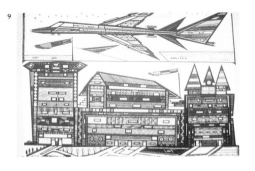

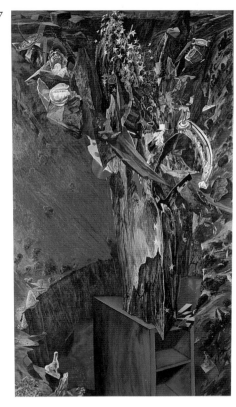

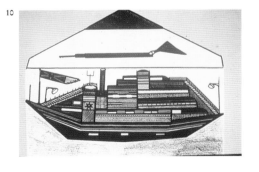

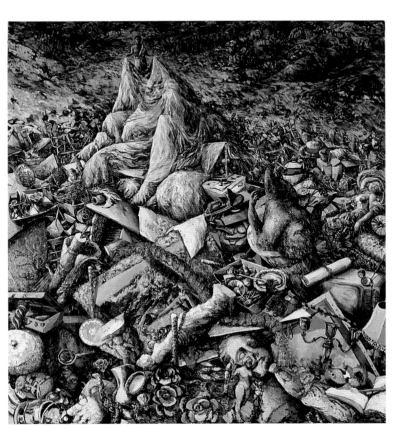

work by collectives

1. This summary comes from the introduction to an article on People's Parks which appeared in **Art Monthly**. A number of articles documenting the historical context of the parks have been written by Steven Sack: "Art in Black South African Townships", June 1989, Number 127; **Art Monthly**, "Garden of Eden or political landscape? Street Art in Mamelodi Township," published in **African Art. Traditional and Contemporary Southern African Art**, eds. Dr. A. Nettleton and Prof. D. Hammond-Tooke. Ad Donker, Johannesburg, 1989; "In the Name of Art. A reflection on fine art", **Culture in Another South Africa**, eds. W. Campschreur & J. Divendal, London, Zed Books, 1989.

2 The United Democratic Front [UDF] was formed in August, 1983 as an alliance of civic associations, trade unions, womens', students', religious and other democratic organisations.

3 Sue Williamson refers to "peace parks" in her book **Resistance Art in South Africa.**

4 See G. Jaffee, "Beyond the Cannon of Mamelodi", **Work in Progress**, 41, 1986; and Andrew Boraine, "Mamelodi: from People's Parks to People's Power. A Survey of Community Organisation in South Africa," unpub. MA dissertation, Univ. Cape Town, 1987.

5 Video documentation shows people at leisure in these open public spaces and discussion with participants reveals the intense activity which took place over days or weeks.

people's parks: street art in the townships

In 1985, during wide-spread unrest im many of the Black townships of South Africa, a spontaneous "public art" erupted in the form of small "parks" or "gardens" on patches of wasteland, heavily decorated with found materials. The author was working in an Arts Centres in Soweto at the time and saw many of the parks before they were destroyed. [1] Photographers and journalists working in the townships at that time spoke of the exceptional level of such activity in particular townships, especially street art and park buildings in Mamelodi township. A visit by the author to photograph parks in Mamelodi in December of 1985 was rudely interrupted by the inevitable meeting with the military. Since that period documentation comprising of newspaper cuttings, video footage, photographs and interviews has been sought out and brought together. This article is one of a number written by the author which documents the phenomenon of "people's parks".

People take to the streets

The struggle for control of the townships of South Africa had reached an unprecedented level in the mid-1980s. By 1985, it must have seemed to many youths as if the struggle against white supremacy was finally won, that the townships were liberated zones: many of them indeed had become effectively ungovernable as one by one local authorities [which were State-controlled] collapsed or abdicated. But, while conditions of ungovernability were a real thorn in the side of State policy, these very conditions confronted activists with a range of problems, inlcuding high levels of lawlessness. The children were no longer attending school, and were getting caught up in dangerous confrontations with the police. *Agents provocateurs*, informers and rival political groups created a climate of instability. This was both destructive to alternative community organisation and was used to misrepresent and undermine the legitimate complaints of the black community.

The strategy of ungovernability, leading as it did to the resignation of many Mayors and Councillors and the almost complete breakdown of essential services, meant that the alternative community organisations were confronted by a new set of circumstances: effectively a power vacuum had developed. Progressive community organisers perceived the need for a new structure of "people's power". The primary aim was to bring unity to the townships and tackle the problem of lawlessness. The **United Democratic Front** [UDF] [2] issued a call to the police to set up street committees, block committees and disciplinary courts. Part of the question of political power, was the need to engage with problems of environmental, cultural and recreational activity in black residential areas. And so, one aspect of the **UDF**'s call was the creation of people's parks [also referred to as *peace parks*]. [3]

This process took place in a number of townships in

the Transvaal from November 1985 until the first months of 1986. Sadly, the grip of the State of Emergency took hold, and so stifled this creative and responsible burgeoning of social action on the part of ordinary citizens.

A campaign called "Operation Clean-up", was initiated by community organisations in Mamelodi township. Youth and adults in large numbers took to the streets in an unprecedented show of community solidarity. They not only cleared the debris but embarked on the takeover of undeveloped public spaces. It is relevant to note that when many of the townships were planned and laid out to play lots were included, most of which were never developed. Money that should have been spent on such facilities for the black urban communities had always been used in the implementation of apartheid and the homelands policy. It was these disused and neglected public spaces that were occupied by the community and transformed in many different ways, using minimal resources.

People's parks were built in townships such as Mamelodi, Alexandra, Kagiso, Oukasie, Mohlakeng and Soweto. Although political graffiti now tattooed the walls of townships all over South Africa, the parks appear to have been built only in townships in the Transvaal. The State of Emergency outlawed what could have possibly mushroomed into a national event.

While research thus far does suggest that the parks were a response to a **UDF** programme of action, [4] by their very nature they were community-based, group activities and so were informed by a variety of localised needs and viewpoints. [5]

It is in the nature of township life, where homes are small and recreational facilities are few, that many people spend their leisure hours on the streets and pavements. At this time when unemployment was high, and children were boycotting school, street life was particularly lively and active. Artists, gardeners, community workers, school children, traders...all joined in this activity, intent on beautifying and reconstructing the township environment. Some local business men provided trucks, which were used to remove vast quantities of rubbish.

Part of the mood of that recreation was a sense of the taking of political power, expressed in their inclusion of symbols and slogans of resistance.

Funerals, political gatherings and trade union meetings have increasingly included cultural performances of one kind or another: songs, militant dances such as the *toyi-toyi*, poetry recitals and plays. In the 1980s the youth added street murals, signs, monuments, and sculpture to this repertoire of engaged art: an art that tackled both the need to transform the physical environment and to participate in the process of mass-mobilisation and democratisation of culture. The people's parks too, were seen as places where people could gather to pursue cultural and political activities. Short-

lived as they were, they form part of the history of overt political culture which captured the imagination of many in the struggle against apartheid.

The parks were more than just playgrounds and more than landscape gardens. They were a first step towards the process of healing the divisions and wounds inflicted by past events. They were an attempt to redefine the townships to provide the townships with a civic identity that celebrated and respected the imprisoned and deceased heroes of the struggle. A popular, and participatory, event in which youth tested their inventiveness in transforming detritus into monuments. Here for a moment the artistically talented had an opportunity to entertain and engage township residents. Prior to this virtually all visual imagery produced by black artists was made for sale and exposure to a predominantly white and suburban audience.

In a televison interview, a Mamelodi resident/activist explains that the "people's parks" had three distinct purposes: to transform and beautify the environment, including the provision of essential services, such as garbage removal, that had broken down during the unrest; to keep the youth occupied and out of the way of the police; and to draw upon the support of parents so as to overcome antagonisms that had developed between parents and youth. The parks were not only intended as land-reclamation projects, although a fairly extensive amount of landscaping, including the building of pavements, road islands, paddling ponds and monuments, took place in Mamelodi [all work done voluntarily and paid for by the local community]. A primary objective was to bridge differences between parents and youth and to show the parents that youth were not acting irresponsibly. In fact the actions of the police against defenceless people and the shooting of seventeen elderly residents in Mamelodi township in November 1984, incensed the black adult community, who began to acknowledge the legitimacy of the anger of the youth. Parents began to recognise the need to support their children in the resistance campaigns.

Politicised youth had developed a clear understanding of the nature and purpose of their activities as part of the struggle for democratic rights: they refused, for example, to allow their activity to be commercialised or to be turned into a competition. Businessmen in Mamelodi who offered prizes for the "best garden" were turned down with the words "We are not launching an individual struggle here but a united one".

Television interviews document the many different visions of those who built the parks: for some they were meeting places, a place to "get together and share" [Hlangarani], for others there were rudimentary youth centres, where a makeshift clubhouse was built, playgrounds for children with paddling pools shaped in the map of Africa, or outdoor "art studios". The critical lack of venues in the

townships for cultural and recreational activities was aptly highlighted by the action of artists and cultural workers working in the streets.

Most of the documentation available is from Mamelodi township, a township in which the sheer scale of activity resulted in a noticable change in the environment. Although the parks were mostly communal projects, there were many individual voices that spoke out through the form of "people's parks" and many different ideological and cultural symbols were used. The references were both local and international, from slogans associated with political struggle, e.g. *Mayibuye Africa*, ["Come Back Africa"], to references to the then current musical hit *We are the world, we are the children*, from Las Vegas Park and Casablanca Park to Unity Park, Biko Park and Luthuli Park. In some streets, house after house had some form of painted rocks, painted words or images, or words made up of small painted pebbles. Whatever came to hand was employed as part of the embellishment and the junk available revealed something of the history and sociology of the place. Gumboots and hardhats remind us of the working-class background of the youth. Symbols of Africa, such as the map of the continent or an African shield were fairly common. Cattle-horns established, perhaps, connection to slaughter rituals.

Many symbols recurred in all the townships and one of the most common was the cannon, built out of a variey of debris and given pride of place in the newly created "town squares". The numerous ways in which cannons were constructed, may be illustrated by two examples. The first involved the transformation of a drive shaft from a motor car with a back axle and wheels attached. Round rocks painted white, served as "cannon balls". Another was made out of tyres with a barrel made out of a bundle of grass. In Mamelodi there were apparently a number of these cannons, all of which pointed towards the police station.

In recent times home-made "cultural weapons" have been produced, usually wooden AK47s built and carried by men and boys. [These should be differentiated from the so-called cultural weapons carried by **Inkatha** members in Natal. They are in fact weapons, but they are allowed by the State under the guise of being called "cultural weapons"]. In fact, it was sometimes alleged that some of the so-called parks were readily usable arsenals. Rocks and tyres, in the context of the township under seige, have come to carry notorious evocations. The army removed all rocks and tyres from the townships, and in the process maliciously destroyed many of the parks. For a while the youth attempted to protect the parks and constantly rebuilt the monuments. The police and army drove them off the streets, and when I returned to Mamelodi Township a year later all the parks were gone.

Steven Sack

imvaba and the 'big posters'

April 1989, New Brighton, Port Elizabeth. We were still under a State of Emergency and as Cultural Workers we were all looking for a way to express opposition to the State, to the Emergency, and generally, to the oppressive society in which we were trying to be creative. We wanted to express our support for the struggle, for the then banned political organisations and for the trade unions. We were looking for a way

[**Imvaba** is an artists' group based in Port Elizabeth.]

to give heart to those who felt disheartened, to make something where so much had been destroyed and, especially, to show that, even with all the the oppressive legislation and forces, we were bold and full of ideas.

Not only was it necessary to be creative but we also needed to be inventive. We decided to use single face corrugated cardboard, which could be rolled up quickly and transported with ease. We set about creating a "big poster".

May Day, 1989 was our first intervention, we unrolled ten metres of images of toiling masses followed by the slogan - Forward to socialism!

The response was immediately positive and we were approached by **NUMSA** [The National Union of Metalworkers of South Africa,] to produce a similar poster for their national congress, to be held in Johannesburg.

For this we had a little more time to prepare ourselves and as a result were more ambitious. We produced a 20m x 1.5m work in five days.

The month of June was soon upon us and as young people who had all experienced the impact of June 16 1976, we needed to make our contribution to this day of remembrance. Our original June 16 mural repeated the image of the child, brutally shot in Soweto, being carried away by his horrified and tearful comrades. This image was repeated at least 8 times across the 10m mural.

FAWU [The Food and Allied Workers' Union] approached us to produce a mural for the national rally to be held at Dan Qeqe Stadium in Port Elizabeth. We produced the image of the assembly line covering the main areas of food production: dairy, meats, beverages, bread, with the assembly line forming a huge red fist of workers' power.

For National Women's Day, August 9th, 1989 we were requested by a student drama group to produce a backdrop for a play on Women's Struggle. We used the image of women activists together with that of a mother - the mother of children, the mother of a nation.

This poster was later again used, together with the June 16 poster and a poster of workers, at a **Congress of South African Trade Unions'** [COSATU] rally to protest against the introduction of the new Labour Relations Act.

In September 1989 we were approached by the Human Rights Trust to produce a mural for a conference to be held in Port Elizabeth. The content was to depict the people of South Africa and to express hope for the future. During this period we were again approached by **NUMSA**, this time to decorate permanently the windows of a proposed canteen at the Co-operative Centre in Port Elizabeth, a centre housing all the **COSATU** Trade Unions and some service organisations. We were to decorate the windows, an area of approximately 10m x 2m in such a way that the image would be seen from the outside and would prevent the passerby seeing into the kitchen area of the canteen. We requested the participation of a **NUMSA** member, a worker who would have experience in the use of a spray-gun and compressor. Thus with the help of Franz, who worked in the paint shop at the Volkswagen Motor Plant, we created a painted window of *toyi-toying* workers in 3 days.

April 1990, one year later, we still have the State of Emergency, but our organisations are unbanned and many of our leaders have been released from prison. To celebrate and welcome comrade Nelson Mandela to Port Elizabeth we

painted a huge poster 10m x 6m depicting figures symbolising the clauses of **The Freedom Charter** against a background of black, green and gold; we emblazoned it with the slogan: **We Shall Govern**.

Why we made the Big Posters [Murals]:

Imvaba has produced murals collectively and for specific purposes. The production of the murals has been multifaceted in its aims and objectives. Imvaba only produces murals for organisations who share our belief in a non-racial, democratic, non-sexist South Africa. Political education through the medium of murals for both the muralists and our audience is crucial. We at **Imvaba** feel that art and culture should be understood within a political context. Murals, or as we prefer to call them "big posters", serve as an ideal medium through which a political idea can be conveyed both in aesthetic and political terms. Our objectives are primarily educational and political and **Imvaba** is regarded as a training ground for both cultural activists and future muralists.

Imvaba feels that murals are easily accessible and relevant to the masses. The large cardboard works serve as huge transportable and re-usable posters which are easily displayed at rallies, meetings and backdrops for plays. Our murals have always strived to convey a positive message, highlighting worker and community struggles within South Africa.

Producing the "Big Posters"

The murals are painted collectively. They undergo various stages which are important as each reinforces the following. Firstly, the murals are discussed, i.e. in terms of their political message and how that message can be conveyed in a satisfactory and aesthetic way. All **Imvaba** members contribute ideas: for example the mural for the Mandela Rally held in Port Elizabeth, April 1990 attempted to convey the message of **The Freedom Charter**. Various symbols were put forward and eventually an appropriate symbol was decided on for each of its clauses. The mural was then drawn roughly to scale and once again contributions and ideas were accepted from all members. The overall aesthetic design was controlled by one or two people using the ideas contributed by the group. The mural was then drawn onto the cardboard rolls, usually by one or two persons in order to achieve a homogeneous effect. As the outlines are drawn the rest of the group follows with colour and detail. We are able to produce murals quickly and harmoniously. Conditions for the production of these works are unsatisfactory, space in the townships is always limited, precious and over-used.

The future of "Big Posters"

Mural-painting will have an important role to play in the new culture of South Africa. **Imvaba** sees itself as participating in various projects which will project our understanding of a new South Africa. Inevitably buildings, public squares and such like will need decorations which are not only aesthetic but also enlightening.

We as **Imvaba** muralists will continue to contribute to the building of a democratic, non-racial and non-sexist culture in South Africa.

Imvaba Artists' Group

All dimensions in centimetres

1. People's Parks
Crossroads People's Park,
Oukasie Township, Brits
photograph by David Golblatt.

2. The Garden of Peace,
Alexandra Township,
Johannesburg
photograph by Gill de Vlieg
[Afrapix]

3. Imvaba Artists' Group
NUMSA Mural [detail], 1989
PVA and acrylic on cardboard
2000 x 150
Painted for NUMSA 1989 National
Congress held at Gosforth Park,
Johannesburg, May 1989

4. June 16 Mural, 1989
PVA and acrylic on cardboard
300 x 450
First mural painted for June 16
Rally and later lost at the
COSATU Cultural Weekend in
Johannesburg. This mural painted
as a backdrop for a play performed
by **Imvaba** members

5. FAWU Mural, 1989
PVA and acrylic on cardboard
1000 x 150
Painted for FAWU Special
National Rally held at Dan Qeqe
Stadium, Port Elizabeth, July 1989

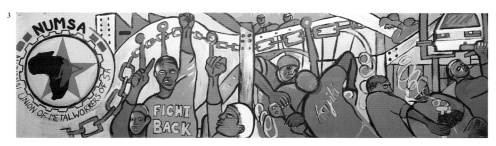

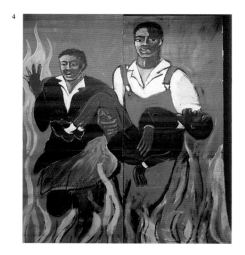

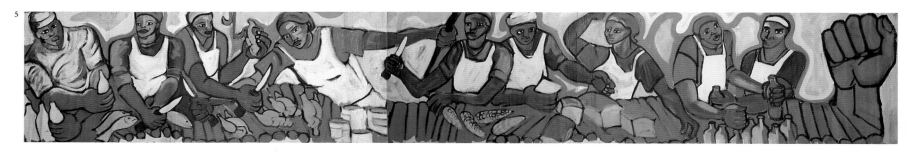

beadwork and blankets

Beaded Blankets - *[Irari]*

Beaded blankets are also known by other vernacular names. "Ndebele beadwork is a visual expression of a communications system which operates on a number of different levels - both within and without Ndebele society, and in the past and present contexts. Historical and contemporary factors have contributed to, and continue to determine, the way the beadwork functions on these levels" - [Diane Levy, Wits. Catalogue, 1986].

The beaded blankets are one of the largest and most intricate forms of beadwork found in the South African region. Entire blankets can be covered in beadwork. More typically, however, strips of beadwork are made separately and then attached in horizontal strips to the blanket. Earlier beadwork is characterised by the dominant use of white, while in more recent work other colours predominate. Other changes have occurred with the forms and images used. Lettering, houses and aeroplane images, amongst others are evident in the blankets on exhibition. A similar kind of range appears in other forms of Ndebele beadwork and in the murals. Ndebele is the most popular and best known of all the beadwork production in South Africa, probably because Ndebele speakers live close to major urban areas, such as Pretoria, and because of certain kinds of promotion. Ndebele murals are particularly well-known abroad and the only artist from South Africa represented in the **Magicians of the Earth** exhibition in Paris in 1989 was, Esther Mahlangu, a Ndebele muralist.

New research suggests that the style and appearance of Ndebele art is due as much to historical as cultural conditions. The emergence of an individualised style appeared at about the time of the dispersal of the Ndebele in the post-Mapoch war decades at the end of the nineteenth century.

Wrap-around cloths

Nceka [singular] **Minceka** [plural]

The Tsonga-speaking women living in the north-eastern Transvaal wear **minceka**. Two are usually worn around the body, under one arm and tied on top of the opposite shoulder. The **minceka** covers the torso. Often a fully gathered underskirt is worn which the **minceka** covers as well, creating a fully rounded appearance to the figure of the wearer.

The **minceka** are rectangular and can be cut or made from any fabric. Printed fabrics are often used and the most highly coloured are preferred. The use of black as a base colour dates probably from the fifties and the decorated black cloths are sometimes made for special occassions. The ways of decorating the fabric vary as can be seen from the three on exhibition, from embroidery, to bead-work, to virtual collage. The rectangular piece acts as a kind of format inviting design and as a non-ritual garment allows for free invention. Images range enormously from the geometric, to signs or symbols, to the directly representational which depict such images as birds, stars and lettering. Often the maker identifies herself by including her name, settlement and a date [of her birth or of the date of the production of the **nceka**]. The combinations are equally varied. Invention is not restricted to the images but extends as well to the addition of materials not usually found or used in clothing. Included is a **nceka** made almost entirely of safety pins and some other added materials. The pins are in a sense, quick, highly coloured stitches. At the same time the pin says something about the transformation of the commonplace in its adoption and adaptation from one part of the South Africa community to another.

Rayda Becker

All dimensions in centimetres

The Thupelo Art Project

1. David Koloane
Untitled, 1988
oil on canvas
74 x 165
Private collection

2. Durant Sihlali
Mapoga wall series - Ndebele Murals,
1990
handmade paper pulp
98 x 50

Beadwork and Blankets

3. Sophie and Lettie Jiyana Skosana
Beaded Blanket [Irari Ndebele],
acquired 1988
wool, beads and textile
143.9 x 136.4
University of the Witwatersrand Art
Gallery, Johannesburg

Unknown Artists

4. Wrap around cloth [Nceka Tsonga],
acquired 1987
embroidered textile and safety pins
118 x 142.5
University of the Witwatersrand Art
Gallery, Johannesburg

5. Beaded Blanket [Irari Ndebele],
acquired 1988
textile and beads
80.5 x 147
The Standard Bank Foundation
Collection of African Art, University
of the Witwatersrand Art Gallery,
Johannesburg

6. Beaded Blanket [Irari Ndebele],
acquired 1986
textile and beads
87 x 162
The Standard Bank Foundation
Collection of African Art, University
of the Witwatersrand Art Gallery,
Johannesburg

7. Wrap around cloth [Nceka Tsonga],
acquired 1986
textile and beads
112 x 128
University of the Witwatersrand Art
Gallery, Johannesburg

5

6

4

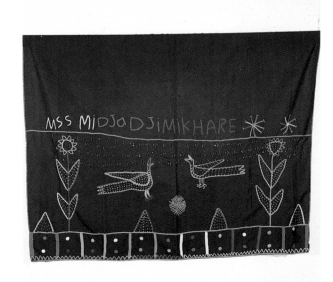

7

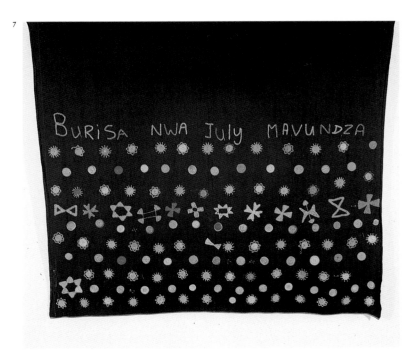

eighty years 1910 - 1990

A chronology compiled with reference to **An Illustrated History of South Africa: The Real Story**, C. Saunders [consultant ed], Cape Town, The Reader's Digest Association, 1988; Esmé Berman, **Art and Artists of South Africa**, Cape Town, 1983; Nicholaas Vergunst, **Visual Arts Calendar of Cultural Initiatives in the 1980s, [with particular reference to the Western Cape]**, unpublished, 1990.

White Politics

1910 Union of South Africa comes into being, Louis Botha as Prime Minister. The new government wins first General Election. **South African [National] Party** [SAP] launched. Parliamentary Select Committee suggests limits on African landownership and on squatting.

1912 Botha resigns after clash with Barry Hertzog; drops Hertzog from Cabinet when asked to form new Government. Land Bank established to help struggling farmers.

1913 **Natives' Land Act** passed. Beaumont Commission asked to investigate ways of expanding African Reserves. Hertzog and supporters quit **SAP**.

1914 **National Party** [NP] formed in Bloemfontein. First World War Breaks out. Leading Boer generals plan coup; Botha crushes Boer rebellion. Amendment to **Riotous Assemblies Act.** Union Defence Force invades German SWA; Germans surrender.

1915 D.F. Malan heads new Cape branch of **NP.**

1916 Beaumont Commission reports that it is too late to expand African Reserves. **Native Affairs Administration Bill** confirms segregation. Battle of Delville Wood.

1918 Formation of **Afrikaner Broederbond** [Brotherhood]. SANLAM Insurance Company established.

1919 Botha dies; Jan Smuts becomes Prime Minister

1920 **Native Affairs Act** creates separate administrative structures for Reserve inhabitants. South Africa granted League of Nations mandate over SWA.

Resistance politics

1910 Gandhi purchases Tolstoy Farm to maintain families of jailed resisters to **South Africa Act.**

1911 Lawyers Pixley Seme, Alfred Mangena and George Montsioa plan a national congress for Africans.

1912 **South African Native National Congress** (SANNC, later ANC) founded. **SANNC** delegation meets government ministers to discuss issue of Passes for women.

1913 **Natives' Land Act** passed. African women in Orange Free State (OFS) choose jail rather than carry Passes. Split between Gandhi and Natal Indian Congress. Start of another Indian passive resistance campaign.

1914 **SANNC** delegation goes to London to protest against **Natives' Land Act.** First World War breaks out. Gandhi returns to India.

1916 South African Native College (later Fort Hare University) opened.

1919 **SANNC** sends delegation to signing of Treaty of Versailles.

1920 **Transvaal Native Congress** launches anti-Pass law campaign.

Visual Culture

1910 Hugh Lane assembles **Johannesburg Art Gallery** collection.

1911 Establishment of **Durban Art Museum.**

1912 First Art School in Johannesburg opened in Public Library (later incorporated into Johannesburg School of Art).

1913 **Michaelis Collection** presented to Cape Town. Johannesburg School of Art established in Old Market Building.

1918 Formation of E.P. Society of Arts & Crafts.

1920 **First South African Academy Exhibition.** Sir Max Michaelis endows Chair of Fine Arts, University of Cape Town.

	1921 Dozens of members of African religious sect, the Israelites, gunned down by police at Bulhoek in the Eastern Cape.	1921 **South African Akademie** incorporated.
1922 Bondelswarts Rebellion crushed in SWA.	1922 Rural Africans in Herschel, Eastern Cape, boycott shops.	
1923 **Natives [Urban Areas] Act** extends segregation to towns.	1923 **SANNC** changes name to **African National Congress** (ANC). Wellington Buthelezi becomes leading opponent of Transkei administration.	
1924 National/Labour Party alliance wins general election.		1924 Leo Francois proposed formation of **South African Institute of Art.**
1925 Afrikaans becomes an official language. Hertzog offers to increase size of Reserves in return for removal of voting rights to Cape Africans.		
1926 Hertzog places three "native" Bills before Parliament. SWA granted partial self-government [adult white suffrage].		1926 **South African Institute of Art** established.
1927 Compulsory segregation proclaimed in 26 urban areas; 64 locations established in terms of **Natives [Urban Areas] Act.** Carnegie Foundation funds commission into "poor whites". **Native Administration Act** gives Governor-General wide powers of control over Africans.	1928 Communist Party adopts plan for a "native republic". **ANC** begins organising workers in Western Cape rural areas.	
1929 Wall Street crash. Hertzog's **NP** wins overall majority in General Election.	1929 Communists form **African League of Rights**; contest two seats in general election and lose badly.	
	1930 **ANC** executive resigns in protest at President Josiah Gumede's close ties with Communists; Pixley Seme replaces Gumede as President; **ANC** "radicals" in Western Cape form **Independent ANC**. Communists launch **Pass-burning campaign**; Communist leader Johannes Nkosi killed during protest in Durban.	1930 **First Annual Exhibition of Contemporary South African Art,** National Gallery, Cape Town.
1932 South Africa goes off gold standard.		1932 National Art Convention, Cape Town.
1934 Hertzog and Smuts form the **United South African National Party**; Malan breaks away to form the **"Purified" National Party**; disgruntled former **SAP** MPs form the **Dominion Party**. Volkskas Bank established.	1935 **All-African Convention** founded.	1935 First South African Akademie Medal of Honour to Pierneef. A.C.Bouman publishes *Kuns in South Africa.*
	1936 Cape African franchise abolished.	1936 **Empire Exhibition**, Johannesburg.
1937 Department of Social Welfare set up.		1937 Formation of **Transvaal Art Society.**
1938 Centenary celebrations of Great Trek.		
1939 Start of Second World War. Hertzog resigns as Prime Minister; new Premier Smuts leads South Africa into Second World War. Hertzog returns to a **Herenigde [Reunited] National Party**. Launch of the **Ossewabrandwag** [Ox-wagon Sentinel].		
1940 Hertzog forced out of the **NP**.	1940 Alfred Xuma becomes President of **ANC.**	
	1940-5 Series of **bus boycotts** in Johannesburg's townships.	
	1942 Government relaxes influx control measures.	1942 Appointment of **War Art Advisory Committee.**
1943 **United Party** wins general election.	1943 Leading middle-class Africans outline black political demands in a document entitles **African Claims in South Africa**. Communist Party of South Africa	1943 **Pretoria Art Centre** established.

draws 7,000 votes in the General Election. Formation of the **ANC Youth League** (CYL). Communists launch **anti-Pass Campaign. Coloured Advisory Council** (CAC) established; anti-CAC group allies with **All-African Convention** to form **Non-European Unity Movement.**

1944 James Mpanza starts the **Sofasonke** squatter movement.

Post-1945 United Nations refuses to allow South Africa to incorporate SWA; Ja Toivo, Kapuuo and Nujoma emerge as resistance leaders.

1945 South African Arts Association reconstituted as **South African Association of Arts.**

1946 **Asiatic Land Tenure Act.** Fagan commission deliberates on "native policy".

1946 **Indian Representation Act** offers Indians limited representation (by whites) in Parliament and Natal Provincial Council.

1947 Lembede dies; Peter Mda becomes new President of the **CYL.**

1948 Fagan Commission tables report. **Herenigde [Reunited] National Party** [HNP] wins election.

1948 Mda proposes a militant Programme of Action at the 1948 **ANC** conference. M.K.Gandhi assassinated in India.

1948 **Overseas Exhibition of South African Art,** Tate Gallery, London. Formation of International Art Club, South Africa.

1949 **Prohibition of Mixed Marriages Act.**

1949 James Moroka ousts Xuma as **ANC** President. Militant Congress Youth League-inspired Programme of Action adopted at **ANC** Congress.

1950s **Bus boycotts** on Reef after fare increases.

1950 **Population Registration, Immorality and Group Areas Acts. Suppression of Communism Act.**

1950 **CPSA** disbanded ahead of Suppression of Communism Act. J.B.Marks, a Communist, elected President of Transvaal **ANC.** Indian Representation Act scrapped.

1950 31st and last South African Akademie Exhibition. South Africa participates in **Venice Biennale.**

1951 Malan's first assault on coloured franchise: **Separate Representation of Voters Bill** enacted, tested in court. **Prevention of Illegal Squatting Act;** labour bureaux created. **HNP** renamed **National Party** [NP].

1951 **Franchise Action Committee** formed; War Veterans **Torch Commando** stages marches in support of coloured voters. **Bantu Authorities Act** abolishes Natives' Representative Council and introduces system of tiered authorities.

1952 **Native Laws Amendment Act; Abolition of Passes Act** introduces reference book for Africans.

1952 **ANC** launches **Defiance Campaign.** Riots lead to passage of **Public Safety Act and Criminal Law Amendment Act. ANC** membership rises from 7,000 to 100,000. **Congress of Democrats** and **Coloured People's Organisation** formed.

1952 **Van Riebeeck Tercentenary Exhibition,** Cape Town. First formal South African entry to Venice Biennale. **William Humphreys Gallery, established** in Kimberley.

1953 Government wins General Election with mandate to remove coloured people from common voters' roll in Cape. **Reservation of Separate Amenities Act.**

1953 **Torch Commando** cooperates with **United Party** against **NP** in general election. **Bantu Education Act.**

1953 **Rhodes Centenary Exhibition,** Bulawayo.

1954 Strijdom succeeds Malan as Prime Minister; expands Appellate Division to include Government sympathisers. Tomlinson tables report on Reserves. Moves to expel Africans from Western Cape.

1954 Formation of **Contemporary Art Society,** Johannesburg.

1955 Sophiatown subjected to forced removals.

1955 **Freedom Charter** adopted at Congress of the People. Crackdown on extra-Parliamentary organisations by Security Police leads to **Treason Trial.**

1956	**Senate Act** enables Government to pack Senate with supporters and remove coloured people from common voters' roll. Right of appeal of Africans against influx control denied. **Riotous Assemblies Act** amended.	
1958	Verwoerd becomes Prime Minister.	
1959	**Extension of University Education Act** paves way for "non-white" universities.	
1960-1	**State of Emergency declared;** later lifted except in Pondoland.	
1960	White referendum on establishment of a republic.	
1966	Verwoerd assassinated; B.J.Vorster becomes Prime Minister.	
1966-72	Cape Town's District Six declared a white area.	

1956-60	**Treason Trial** of 156 activists.
1959	Anti-Coloured Affairs Department group withdraws from Non-European Unity Movement; African group under I.B.Tabata forms **All African People's Democratic Union. Pan-Africanist Congress** (PAC) formed under Robert Sobukwe. **PAC**'s "status campaign" falters.
1960	**Anti-Pass law campaign.** Sobukwe arrested; sentenced to three years, but held for six more. **Sharpeville shootings**; march on Cape Town led by Philip Kgosana of **PAC** who later flees into exile. **ANC and PAC banned**; leaders flee into exile; both set up military wings; attempt to reunite **ANC** and **PAC** unsuccessful.
1961	Nelson Mandela proposes adoption of armed struggle to achieve African aims of **ANC** executive; Lilliesleaf farm, Rivonia, acquired for armed wing's operations; sabotage begins. Albert Luthuli awarded Nobel Peace Prize.
1962	Mandela receives guerilla training in Algeria; arrested on his return. Potlako Leballo moves to Lesotho to reorganise **PAC**, but Security Police break the organisation. **Sabotage Act.**
1963	**"Ninety-Day Act"** to crush Poqo and Umkhonto we Sizwe. Police swoop on Rivonia base of Umkhonto: **Rivonia trial.**
1969	**South African Students' Organisation** founded under Steve Biko.
1972	**Black People's Convention** set up to co-ordinate black consciousness adherents.

1956	**First Quandrennial of South African Art,** coincident with Johannesburg Arts Festival.
1957	First South African entry to **São Paulo Biennale.**
1959	First **Artists of Fame & Promise** Competition.
1960	**Second Quadrennial of South African Art.**
1961	"Our Art" series - South African BC
1963	Opening of TPA Building, Pretoria - R200,000 commissioned art work. First **South African Art Today** Biennial Exhibition, Durban.
1964	**Third Quadrennial of South African Art.** Opening of **Pretoria Art Museum.** South African Akademie Medal to Battiss.
1966	Opening **Hester Rupert Art Museum, Grahamstown.** First **South African Breweries Art Prize.**
1968	Gulbenkian Foundation Exhibition, Lisbon. Interim National Council for Plastic Arts.
1969	**First Quinquennial of South African Art.**
1970	"Art & Artists of South Africa" by Esmé Berman- 1st Edition.
1971	**Republic Festival Exhibition**, Cape Town. Johannesburg Art Gallery Diamond Jubilee 1st South African "Multiple" Competition.
1972	**National Art Congress**, Pretoria.

	1972-3 Wave of strikes against low wages in face of spiralling inflation.	**1974** **Contemporary South African Art** exhibition, Athens.
	1975 Bantu Education Minister M.C.Botha maintains Afrikaans as teaching medium.	**1975** Visit to South Africa by Clement Greenberg, US critic.
1976 Anti-Squatting Laws tightened.	**1976** Report of **Theron Commission** on coloured people tabled. **Secondary schoolchildren march in Soweto** in massive protest against use of Afrikaans; hundreds killed in violence. Schools unrest spreads to Western Cape. First members of "Class of '76" leave South Africa for training in armed resistance.	
	1977 **Biko dies in detention;** inquest. **17 organisations and 2 newspapers banned.**	**1977** **South African Art,** National Gallery of Rhodesia.
	1977-9 **Wiehahn Commission** enquiries into industrial relations. **Riekert Commission** enquiries into manpower utilisation.	
1978 Auditor-General exposes misuse of funds by Department of Information; Vorster resigns. P.W.Botha succeeds Vorster as leader of the **NP** and Prime Minister; launches **Total Strategy.** Mulder resigns.	**1978** Subukwe dies.	
1979 Vorster forced to resign as State President.	**1979** **Wiehahn Commission** advocates official recognition of African Trade Unions; **Council of Unions of South Africa** and **Federation of South African Trade Unions** formed. **Industrial Conciliation Act** embodies Wiehahn recommendations.	
1980 **Republic of South Africa Constitution Fifth Amendment Act.**	**1980** SASOL refinery sabotaged.	
		1981 **Republic Festival Exhibition,** Durban. Commencement of Presidential Commission of Enquiry into Creative Arts.
		1982 **Art Towards Social Development: Culture and Resistance Conference**, Gaborone. **Cultural Voice of Resistance Festival**, Amsterdam. **Cape Town Triennial**.
1983 **Coloured Labour Party** decides to participate in **new tricameral Parliament.** Right-wing **NP** members expelled; form **Conservative Party** under Treurnicht. Republic of South Africa Constitution Act. White referendum to gauge support for constitution.	**1983** **National Forum** inaugurated by "Africanists" at Hammanskraal. **United Democratic Front** (UDF) formed at rally outside Cape Town.	**1983** **Schutts Commission of Enquiry** into the Promotion of the Visual Arts. Standard Bank National Arts Festival.
1984 Last sitting of whites-only Westminster-style Parliament. Elections held for House of Representatives and House of Delegates. **New constitution comes into force.** Nkomati Accord between South Africa and Mozambique.	**1984** Violent African response to new constitution. **National Union of Mineworkers** founded**.**	
1985 P.W.Botha's **"Rubicon" speech** sparks economic crisis. **1985-6** **State of Emergency** in 36 magisterial districts.	**1985** **Congress of South African Trade Unions** launched. Proposed march from Athlone to Pollsmoor prevented by police. Township opposition leads to emergence of "street committees". Clerics issue **Kairos Document.**	**1985** Cape Town Triennial. **Art for Peace** as part of **End Conscription Campaign,** Rondebosch.

1986	**Prohibition of Political Interference Act. Mixed Marriages Act and Section 16 of Immorality Act repealed. Pass laws repealed.**	1986	**Pass Laws abolished.**	1986	**Volkskas Atelier Award** Competition. **Breaking the Silence** Cultural Festival organised by UDF, Cape Town. **Images of Our Times: Towards a New Culture** exhibited; banned in Cape Town under State of Emergency regulations; exhibition re-opened under name **Untitled.**
1986-7	Kwa-Natal Indaba deliberates multiracial dispensation.				
1987	**Conservative Party** becomes official opposition after House of Assembly elections.			1987	**ANC** amends Blanket Boycott to Selective Boycott, Lusaka. Formation of **UDF** cultural wing following Lusaka pronouncement. **People's Culture Symposium** at University of Western Cape. **Standard Bank National Drawing Competition**, Grahamstown. Biennale of Art, Valparaiso, Chile **Re-writing the Art and Architectural History of Southern Africa Conference**, Stellenbosch; South African Association of Art Historians. **Culture in another South Africa Festival**, Amsterdam.
1987-8	New tier of local government introduced: provincial executives and regional services councils.				
		1988	Government clamps down on opposition organisations.	1988	**Cultural Conservation: Changing Contexts and Challenges Conference**, Cape Town. National Monuments Council **et al.** Launch of **Cultural Workers' Congress**, a **UDF** affiliate, Cape Town. **87 Artists Against Apartheid** exhibition cut short, Johannesburg. Formation of UDF Interim Cultural Desk. Women's Cultural Festival, Athlone. **Human Rights Exhibition,** Black Sack, Durban. **Culture in South Africa Symposium**, Athens.
1989	P.W. Botha resigns as Prime Minister to be replaced by F.W. de Klerk.	1989	Walter Sisulu and other leaders released.	1989	**Foundation for the Creative Arts** set up by Department of National Education to promote visual arts by distribution of financial aid projects. **Facing the Challenges of the 1990s. Organising for Democracy in the Western Cape Conference**, Bellville. **Building a National Culture Festival**, CAP, Cape Town. Biennale of Art, Valparaiso, Chile. **Artists' Alliance** founded in Johannesburg
1990	Government starts negotiations with **ANC**.	1990	**ANC, PAC, SACP** and other organisations unbanned. Nelson Mandela released.	1990	**Images of our Lives** exhibition of postcard sized artworks by women sent to New York; project coordinated by VAG of **CWC** and the **Artists' Alliance. Preparing Ourselves for Freedom**, paper by Albie Sachs, is published in South Africa; causes great controversy about the role of culture in the struggle. **Standard Bank National Drawing Competition**, Grahamstown.

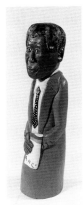

All dimensions in centimetres

Johannes Maswanganyi
Mandela, 1990
wood and enamel paint
112.5 x 27.5 x 30.8
The Goodman Gallery, Johannesburg

acknowledgements

The Museum of Modern Art would like to thank warmly the many individuals, organisations, artists, collectors, museums and galleries listed below, who through their help and commitment have enabled this exhibition to take place.

Fieke Ainslie, Johannesburg
Louise Almon, Port Elizabeth
The Artists' Alliance, Johannesburg
Jill Addleson, Durban Art Gallery
African Art Centre, Durban
Rayda Becker, Johannesburg
David Bellamy, London
Linda Bernstein, London
Richard Burnett, Johannesburg
Adam Butcher, Oxford
Bruce Campbell-Smith, Cape Town
The Catholic Mission, Botshabelo
Vanessa Devereux Gallery, London
Durban Art Gallery
The Goodman Gallery, Johannesburg
Mr & Mrs Clive Cope
Cultural Workers' Congress [CWC] Visual Arts Group, Cape Town
Lorna Ferguson, Pietermaritzburg
Mrs L. Givon, Johannesburg
F.F. Haenggi, Johannesburg
Professor Michael Hallier, University of Fort Hare
Rodney Harber, Durban
Mr & Mrs Nicolas Haysom
Claus Henning, London
Father Brian Ivers, Botshabelo
Robert Loder, London
Johan Kriel & Migiel Heyns
Katlehong Art Centre Collection, Germiston
Marilyn Martin, Cape Town
Tanki Mokhele, Orlando
Jacqui Nolte, Cape Town
Pelmama Permanent Collection, Johannesburg
Fiona Rankin-Smith, Johannesburg
David Roussouw, Johannesburg
Hannah Le Roux, Pretoria
Shelly Sachs, Johannesburg

Mongane Wally Serote, London
South African National Gallery, Cape Town
Mr & Mrs Simon Stanford
Tatham Art Gallery / Kunsmuseum, Pietermaritzburg
Jo Thorpe, Durban
U.D.F. Interim Cultural Desk, Johannesburg
The Standard Bank Collection of African Art, housed at the University of the Witwatersrand Gallery, Johannesburg
Gertrude Posel Gallery, University of the Witwatersrand, Johannesburg
Gavin & Glenda Younge, Cape Town
Zabalaza Festival, London

selected biblography

[In Chronological order]

Black Art Today, cat., Johannesburg, nd. late 1970s.

Fransen, H., **Three Centuries of South African Art**, Johannesburg, A.D. Donker, 1982.

Berman, E., **Art and Artists of South Africa**, Cape Town, 1983.

Tributaries : A View of Contemporary South African Art, cat., Johannesburg, BMW, 1985.

Omer-Cooper, J.D., **History of Southern Africa**, London, Heinemann, 1987.

Manaka M., **Echoes of African Art. A Century of Art in South Africa**, Johannesburg, Skotaville, 1987.

Bunn, D., Taylor, J. [eds], **From South Africa : new writing, photographs and art**, -

Tri-Quarterly Magazine, Special Issue, Evanston Ill., Northwestern University, Spring / Summer, 1987.

Younge G., **Art from the South African Townships**, London, Thames and Hudson, 1988.

Soweto 1989, cat., Tour d'Aigues [Vaucluse], Le Carrefour International des Estampes, 1989.

The Neglected Traditon: Towards a new history of South African Art, cat., Johannesburg Art Gallery, 1988-89.

Images of Wood: **Aspects of the History of the Sculpture in the 20th Century, South Africa**, cat., Johannesburg Art Gallery, 1989.

Williamson S., **Resistance Art in South Africa**, London, David Philip, 1989.

Saunders, C. [ed], **An Illustrated History of South Africa : The Real Story**, Cape Town, The Reader's Digest Association, 1988.

Campschreur, W. and Divendal, J. [eds], **Culture in Another South Africa**, London, Zed Books, 1989.

Ten Years of Collecting [1979-1989], cat., Johannesburg, University of the Witwatersrand, 1989.

Nettleton, A. and Hammond-Tooke, D., **African Art in Southern Africa**, Johannesburg, A.D. Donker, 1989.

THE
MUSEUM
OF
MODERN
ART
OXFORD

25

1965-1990

ANNIVERSARY